More praise for *Seven Days in the Art World*

Named one of the best art books of the year by
the *New York Times* and the *Sunday Times* (London)

Translated into fifteen languages worldwide

A *Los Angeles Times* bestseller

A *Maclean's* Canadian bestseller

An Indie Next List Notable Book

A Barnes & Noble "Discover Great New Writers" Selection

"*Seven Days in the Art World* . . . seems destined to outlive its moment. . . . Thornton offers an indelible portrait of a peculiar society, simultaneously cutthroat and curious . . . glamorous yet filled with people who would have been unpopular in high school." —Leslie Camhi, *Vogue*

"This is an entertaining and lucid account of the mysterious ways of contemporary art. . . . [Thornton] does well to resist the temptation to draw any glib, overarching conclusions. There is more than enough in her rigorous, precise reportage . . . for the reader to make his or her own connections."

—Peter Aspden, *Financial Times*

"Finely wrought and thoroughly researched . . . [with] an ingenious structure . . . and spot-on characterizations. . . . The author draws readers into the experience . . . [with her] infectious curiosity and meticulous reporting." —Annie Buckley, *Artweek*

"A terrific book—detailed, gossipy, and insightful. . . . By the end of the book, you almost understand how [Steve] Cohen could shell out $8 million for a rotting 14-foot shark pickled in formaldehyde." —Thane Peterson, *BusinessWeek*

"'The contemporary art world is a loose network of overlapping subcultures held together by a belief in art,' writes Thornton, and we are fortunate that she was able to penetrate all of these opaque, protected, and often secretive groups." —Barbara Fisher, *Boston Globe*

"Thornton has performed the admirable service of preserving the extreme social comedy of the global art world, circa 2007, for historians of the future." —Carly Berwick, Bloomberg

"An astute and often entertaining ethnography of this status-driven world. . . . Thornton offers an elegant, evocative, sardonic view into some of the art world's most prestigious institutions." —*Publishers Weekly*, starred review

"The bubble described in the book has been deflated and set loose to the mercy of new winds. That the book ends just before the financial crisis is not bad luck, to the contrary: it closes the circle. Each chapter, a complete epic. These years can be viewed as the chronicle of a gilded age." —*Página 12* (Argentina)

"Thornton [is] an art historian and sociologist with moxie and a brilliant game plan. . . . An astute observer and stimulating storyteller whose crisp sentences convey a wealth of information . . . her uniquely clarifying dispatches from the art front

glimmer with high-definition profiles of artists, dealers, critics, and collectors, and grapple with the paradoxes inherent in the transformation of creativity into commodity."

—Donna Seaman, *Booklist*

"It's like having your own spy in the art world. Thornton parachutes the reader into the fascinating nitty gritty of how it all works." —Alan Yentob, creative director, BBC

"[A] brilliantly readable and wonderful and didactic-without-lecturing book." —Eva Hagberg, Flavorwire

"A deliciously voyeuristic account of art's entire mise-en-scène. . . . In Thornton's capable hands, this sophisticated and smart subculture is open to us all. . . . An entertaining, witty, and vibrant look at contemporary art in its new role as mass entertainment."

—Barnes & Noble, "Discover Great New Writers"

"Thornton captures the essence, appeal, complexity and the mass of contradiction that permeates the rarefied art world, and often fascinates outsiders." —Chris Michaud, Reuters

"A book that is entertaining, instructive and compelling from start to finish, written like a thriller that has you wondering on every page whether you won't stumble upon a murder on the next." —Nathalie Heinich, *Non-Fiction* (France)

"[Thornton] is equally at home on the phone to designer Marc Jacobs (discussing Murakami's collaboration with the Louis Vuitton brand) as she is squeezed into the backseat of an art

student's beat-up red Honda during a burrito run. Rather than skewering the snobs or scoffing at the scruffs, which would be too easy, Thornton calmly records and collects."

—Kelly McMasters, *Newsday*

"Hundreds of smart voices and insights. Sarah Thornton is a brilliant writer and story-teller." —*Hauptsache Kultur* (Germany)

"Thornton's eye for detail is uncanny. . . . [She] refuses the lure of being an authority: her material is quicksilver, and she's wise enough to know it." —Andrew Decker, *artnet Magazine*

"Thanks to Thornton we may now experience what it is like to be part of the world-wide network of authoritative people in art. The fact that she actually succeeded in penetrating this world makes [this] a unique book."

—*NRC Handelsblad* (Netherlands)

"Spirited, informative, well-written and leaving you feeling that you have been at the centre of things, even as you close the book in the comfort of your armchair." —*New Zealand Herald*

"In this deftly assembled expose, Thornton probes the nooks and crannies of the art world . . . in all its simultaneously inspiring and repellent glory." —Matt Hendrickson, *Details*

"[Thornton] has a sociologist's concern for institutional narratives as well as the ethnographer's conviction that entire social structures can be apprehended in seemingly frivolous patterns of speech or dress." —Andras Szanto, *Artworld Salon*

"Thornton's narrative moves gracefully across international boundaries, cultures, languages and genres. . . . An exhilarating guided tour of some very exclusive circles." —*Kirkus Reviews*

"This is, hands-down, the single best guide for outsiders to the inner life of the art world." —S. McGee, thebookbeat.com

"A smart, engagingly written insider's look at today's art world. . . . A great read." —Annalyn Swan, winner of the Pulitzer Prize

"A great page-turner. I worry that the book demystifies things so much that the next generation of artists will be overinformed."
—Grayson Perry, artist

"Her reportage . . . constructed as a true journey of its own, is unusual in showing the entire cycle of art, from creation to criticism to market." —*D, la Repubblica delle Donne* (Italy)

"A sparkling and entertaining read. . . . [Thornton] lets no opinion, spiteful remark or gesture of intolerance show through . . . and yet she doesn't glorify or pander to this highly cocooned world either . . . leaving readers to draw their own conclusions."
—Luca Beatrice, *Libero News* (Italy)

"If the art world . . . has always seemed a mystery behind a locked door, then here is the key. . . . Thornton's book is full of answers to the questions . . . Who are the people who pay $13m for a work of art? How do auctions work? How important are art critics? How do [artists] become successful?"
—*Sydney Morning Herald*

"An absolute must-read for all art lovers."

—*La Vie en Rose* (Netherlands)

"[*Seven Days in the Art World*] will survive as a hard-thinking but high-spirited memorial. . . . Thornton brings to light the bizarre machinery that keeps studio showbiz on the road, and in the headlines." —*The Independent*, "20 Best Books of the Year"

SEVEN DAYS IN THE

Art World

SEVEN DAYS IN THE

Art World

SARAH THORNTON

W. W. NORTON & COMPANY NEW YORK LONDON

For information about permission to reproduce selections from this book,
write to Permissions, W. W. Norton & Company, Inc.,
500 Fifth Avenue, New York, NY 10110

For information about special discounts for bulk purchases, please contact
W. W. Norton Special Sales at specialsales@wwnorton.com or 800-233-4830

Manufacturing by LSC Harrisonburg
Book design by Chris Welch
Production manager: Devon Zahn

Library of Congress Cataloging-in-Publication Data
Thornton, Sarah.
Seven days in the art world / Sarah Thornton. — 1st ed.
p. cm.
Includes bibliographical references and index.
ISBN 978-0-393-06722-4 (hardcover)
1. Art—Marketing. 2. Art—Exhibitions.
3. Art—Competitions. 4. Art criticism. I. Title.
N8600.T485 2008
709.05—dc22

2008035056

ISBN 978-0-393-33712-9 pbk.

W. W. Norton & Company, Inc.
500 Fifth Avenue, New York, N.Y. 10110
www.wwnorton.com

W. W. Norton & Company Ltd.
15 Carlisle Street, London W1D 3BS

17 18 19 20

For Glenda and Monte

Contents

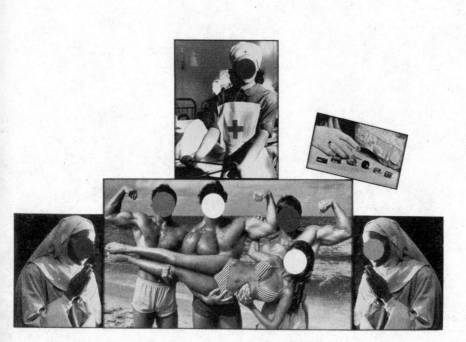

JOHN BALDESSARI

Beach Scene/Nuns/Nurse (with Choices), 1991

Introduction

*S*even Days in the Art World is a time capsule of a remarkable period in the history of art during which the art market boomed, museum attendance surged, and more people than ever were able to abandon their day jobs and call themselves artists. The art world both expanded and started to spin faster; it became hotter, hipper, and more expensive. With the global economic downturn, this ecstatic moment is over, but the deeper structures and dynamics remain.

The contemporary art world is a loose network of overlapping subcultures held together by a belief in art. They span the globe but cluster in art capitals such as New York, London, Los Angeles, and Berlin. Vibrant art communities can be found in places like Glasgow, Vancouver, and Milan, but they are hinterlands to the extent that the artists working in them have often made an active choice to stay there. Still, the art world is more polycentric than it was in the twentieth century, when Paris, then New York held sway.

Art world insiders tend to play one of six distinct roles: artist, dealer, curator, critic, collector, or auction-house expert. One encounters artist-critics and dealer-collectors, but they admit that

it isn't always easy to juggle their jobs and that one of their identities tends to dominate other people's perceptions of what they do. Being a credible or successful artist is the toughest position, but it's the dealers who, channeling and deflecting the power of all the other players, occupy the most pivotal role. As Jeff Poe, a dealer who appears in several chapters of this book, sees it, "The art world isn't about power but control. Power can be vulgar. Control is smarter, more pinpointed. It starts with the artists, because their work determines how things get played out, but they need an honest dialogue with a conspirator. Quiet control—mediated by trust—is what the art world is really about."

It's important to bear in mind that the art *world* is much broader than the art *market*. The market refers to the people who buy and sell works (that is, dealers, collectors, auction houses), but many art world players (the critics, curators, and artists themselves) are not directly involved in this commercial activity on a regular basis. The art world is a sphere where many people don't just work but reside full-time. It's a "symbolic economy" where people swap thoughts and where cultural worth is debated rather than determined by brute wealth.

Although the art world is frequently characterized as a classless scene where artists from lower-middle-class backgrounds drink champagne with high-priced hedge-fund managers, scholarly curators, fashion designers, and other "creatives," you'd be mistaken if you thought this world was egalitarian or democratic. Art is about experimenting and ideas, but it is also about excellence and exclusion. In a society where everyone is looking for a little distinction, it's an intoxicating combination.

The contemporary art world is what Tom Wolfe would call a "statusphere." It's structured around nebulous and often contradictory hierarchies of fame, credibility, imagined historical

importance, institutional affiliation, education, perceived intelligence, wealth, and attributes such as the size of one's collection. As I've roamed the art world, I've been habitually amused by the status anxieties of all the players. Dealers who are concerned about the location of their booth at an art fair or collectors keen to be first in line for a new "masterpiece" are perhaps the most obvious instances, but no one is exempt. As John Baldessari, a Los Angeles–based artist who speaks wisely and wittily in these pages, told me, "Artists have huge egos, but how that manifests itself changes with the times. I find it tedious when I bump into people who insist on giving me their CV highlights. I've always thought that wearing badges or ribbons would solve it. If you're showing in the Whitney Biennial or at the Tate, you could announce it on your jacket. Artists could wear stripes like generals, so everyone would know their rank."

If the art world shared one principle, it would probably be that nothing is more important than the art itself. Some people really believe this; others know it's de rigueur. Either way, the social world surrounding art is often disdained as an irrelevant, dirty contaminant.

When I studied art history, I was lucky enough to be exposed to a lot of recently made work, but I never had a clear sense of how it circulated, how it came to be considered worthy of critical attention or gained exposure, how it was marketed, sold, or collected. Now more than ever, when work by living artists accounts for a larger part of the curriculum, it is worth understanding art's first contexts and the valuation processes it undergoes between the studio and its arrival in the permanent collection of a museum (or the dumpster, or any one of a vast range of intermediate locations). As curator Robert Storr, who plays a key role in the Biennale chapter, told me, "The function of museums is to make

art worthless again. They take the work out of the market and put it in a place where it becomes part of the common wealth." My research suggests that great works do not just arise; they are made—not just by artists and their assistants but also by the dealers, curators, critics, and collectors who "support" the work. This is not to say that art isn't great or that the art that makes it into the museum doesn't deserve to be there. Not at all. It's just that collective belief is neither as simple nor as mysterious as one might imagine.

One theme that runs through the narratives of *Seven Days in the Art World* is that contemporary art has become a kind of alternative religion for atheists. The artist Francis Bacon once said that when "Man" realizes that he is just an accident in the greater scheme of things, he can only "beguile himself for a time." He then added: "Painting, or all art, has now become completely a game by which man distracts himself . . . and the artist must really deepen the game to be any good at all." For many art world insiders and art aficionados of other kinds, concept-driven art is a kind of existential channel through which they bring meaning to their lives. It demands leaps of faith, but it rewards the believer with a sense of consequence. Moreover, just as churches and other ritualistic meeting places serve a social function, so art events generate a sense of community around shared interests. Eric Banks, a writer-editor who appears in Chapter 5, argues that the fervent sociality of the art world has unexpected benefits. "People really do talk about the art they see," he said. "If I'm reading something by, say, Roberto Bolaño, I'll find very few people to discuss it with. Reading takes a long time and it's solitary, whereas art fosters quick-forming imagined communities."

Despite its self-regard, and much like a society of devout followers, the art world relies on consensus as heavily as it depends

on individual analysis or critical thinking. Although the art world reveres the unconventional, it is rife with conformity. Artists make work that "looks like art" and behave in ways that enhance stereotypes. Curators pander to the expectations of their peers and their museum boards. Collectors run in herds to buy work by a handful of fashionable painters. Critics stick their finger in the air to see which way the wind is blowing so as to "get it right." Originality is not always rewarded, but some people take real risks and innovate, which gives a raison d'être to the rest.

The art market boom is a backdrop to this book. In asking why the market soared in the past decade, we might start with the different but related question: Why has art become so popular? The narratives in this book repeatedly allude to answers, but here are some bald, interrelated hypotheses. First, we are more educated than ever before, and we've developed appetites for more culturally complex goods. (The percentage of the U.S. and U.K. populations with university degrees has increased dramatically over the past twenty years.) Ideally, art is thought-provoking in a way that requires an active, enjoyable effort. As certain sectors of the cultural landscape seem to "dumb down," so a sizable viewing audience is attracted to a domain that attempts to challenge tired, conventional ways. Second, although we are better educated, we read less. Our culture is now thoroughly televisualized or YouTubed. Although some lament this "secondary orality," others might point to an increase in visual literacy and, with it, more widespread intellectual pleasure in the life of the eye. Third, in an increasingly global world, art crosses borders. It can be a lingua franca and a shared interest in a way that cultural forms anchored to words cannot.

Ironically, another reason why art gained in popularity is that it became so expensive. High prices command media

headlines, and they in turn popularized the notion of art as a luxury good and status symbol. During the boom, the most affluent slice of the global population became even wealthier and we saw the rise of the billionaire. As Amy Cappellazzo of Christie's told me, "After you have a fourth home and a G5 jet, what else is there? Art is extremely enriching. Why shouldn't people want to be exposed to ideas?" Certainly the number of people who don't just collect but stockpile art has grown from the hundreds to the thousands. In 2007, Christie's sold 793 artworks for over $1 million each. In a digital world of cloneable cultural goods, unique art objects are compared to real estate. They are positioned as solid assets that won't melt into air. Auction houses have also courted people who might previously have felt excluded from buying art. And their visible promise of resale engendered the idea that contemporary art is a good investment and brought "greater liquidity" to the market.*

During the bull market, many worried that the validation of a market price had come to overshadow other forms of reaction. Now that record prices are few and far between, other forms of endorsement, like positive criticism, art prizes, and museum shows, may hold greater sway, and artists are less likely to get knocked off course by an uninhibited desire for sales. Even the most businesslike dealers will tell you that making money should be a byproduct of art, not an artist's main goal. Art needs motives that are more profound than profit if it

*Even in a recession, art has investment value. Who would have thought that a drawing by Willem De Kooning would be a safer asset than shares in Lehman Brothers? By autumn 2008, this would clearly be the case.

is to maintain its difference from—and position above—other cultural forms.

As the art world is so diverse, opaque, and downright secretive, it is difficult to generalize about it and impossible to be comprehensive. What is more, access is rarely easy. I have sought to address these problems by presenting seven narratives set in six cities in five countries. Each chapter is a day-in-the-life account, which I hope will give the reader a sense of being inside the distinct institutions integral to the art world. Each story is based on an average of thirty to forty in-depth interviews and many hours of behind-the-scenes "participant observation." Although usually described as "fly on the wall," a more accurate metaphor for this kind of research is "cat on the prowl," for a good participant observer is more like a stray cat. She is curious and interactive but not threatening. Occasionally intrusive, but easily ignored.

The first two chapters mark out antithetical extremes. "The Auction" is a blow-by-blow account of a Christie's evening sale at Rockefeller Center in New York. Auctions tend to be artist-free zones, which act as an end point—some say a morgue—for works of art. By contrast, "The Crit" explores life in a legendary seminar at the California Institute of the Arts—an incubator of sorts, where students transform themselves into artists and learn the vocabulary of their trade. The speed and wealth of the auction room couldn't be further away from the thoughtful, low-budget life of the art school, but they are both crucial to understanding how this world works.

Similarly, "The Fair" and "The Studio Visit" have an oppositional rapport; one is about consumption, the other production. Whereas the studio is an optimal place for understanding the work of a single artist, an art fair is a swanky trade show where

the crowds and the congested display of works make it difficult to concentrate on any particular work. "The Fair" is set in Switzerland on the opening day of Art Basel, an event that has contributed to the internationalization and seasonality of the art world. Artist Takashi Murakami, who makes a cameo appearance in Basel, is the protagonist of "The Studio Visit," which takes place in his three workspaces and a foundry in Japan. With an enterprise that outdoes Andy Warhol's Factory, Murakami's studios are not simply buildings where the artist makes art but stages for dramatizing his artistic intentions and platforms for negotiations with visiting curators and dealers.

Chapters 4 and 5, "The Prize" and "The Magazine," tell stories that revolve around debate, judgment, and public exposure. "The Prize" investigates Britain's Turner Prize on the day that its jury, overseen by Tate director Nicholas Serota, decides which of the four shortlisted artists will ascend the podium to accept a check for £25,000 in a televised awards ceremony. The chapter examines the nature of competition between artists, the function of accolades in their careers, and the relationship between the media and the museum.

In "The Magazine," I explore different perspectives on the function and integrity of art criticism. I start by observing those who edit *Artforum International*, the glossy trade magazine of the art world, then move on to conversations with influential critics such as Roberta Smith of the *New York Times*, then crash a convention of art historians to investigate their views. Among other things, this chapter considers how magazine front covers and newspaper reviews contribute to the way art and artists enter the annals of art history.

The final chapter, "The Biennale," is set in Venice amid the mayhem of the oldest international exhibition of its kind. A con-

founding experience, the Venice Biennale feels like it should be a holiday opportunity, but it's actually an intense professional event that is so strongly social that it is hard to keep one's eye on the art. As a result, this chapter pays homage to the curators who do. It also reflects on the essential role of memory in making sense of the contemporary and of hindsight in determining what's great.

The seven-day structure of the book reflects my view that the art world is not a "system" or smooth-functioning machine but rather a conflicted cluster of subcultures—each of which embraces different definitions of art. Everyone with a voice in the book agrees that art should be thought-provoking, but in "The Auction," art is positioned principally as an investment and luxury good. In "The Crit," it is an intellectual endeavor, lifestyle, and occupation. In "The Fair," it is a fetish and leisure activity—a slightly different commodity to that seen at the auction. In "The Prize," art is a museum attraction, media story, and evidence of an artist's worth. In "The Magazine," art is an excuse for words; it's something to debate and promote. In "The Studio Visit," it's all of the above—that's one reason Murakami is sociologically fascinating. Finally, in "The Biennale," art is an alibi for networking, an international curiosity, and, most importantly, the chief ingredient in a good show.

Although *Seven Days in the Art World* offers a whirlwind week of narratives, it was a long, slow undertaking for me. In the past, for other ethnographic projects, I've immersed myself in the nocturnal world of London dance clubs and worked undercover as a "brand planner" in an advertising agency. Though I took a fervent interest in the minutiae of these milieus, I eventually became weary of them. Despite exhaustive research, however, I still find the art world fascinating. One reason is no doubt that it is tre-

mendously complex. Another relates to the way this sphere blurs the lines between work and play, local and international, the cultural and the economic. As such, I suspect it indicates the shape of social worlds to come. And even though many insiders love to loathe the art world, I have to agree with *Artforum* publisher Charles Guarino: "It's the place where I found the most kindred spirits—enough oddball, overeducated, anachronistic, anarchic people to make me happy." Finally, it must be said that when the talk dies down and the crowds go home, it's bliss to stand in a room full of good art.

SEVEN DAYS IN THE
Art World

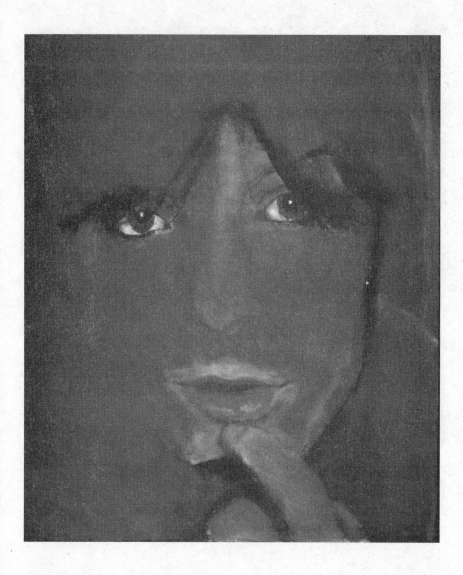

MARLENE DUMAS

Jule-die Vrou, 1985

1

The Auction

It's 4:45 on a November afternoon in New York. Christopher Burge, Christie's chief auctioneer, is doing a sound check. Five workmen kneel on the floor, using rulers to calculate the distance between chairs in order to pack the room with as many well-heeled clients as possible. Paintings by blue-chip artists such as Cy Twombly and Ed Ruscha hang on the beige fabric walls. Detractors describe the interior as a "high-class funeral home," but others like its 1950s retro-modernist feel.

Burge leans on the dark wood rostrum, calling out prices into the void in a relaxed English accent. "One million one. One million two. One million three. It is with Amy's bidder on the phone. It is not with you, sir. Nor with you, madam." He smiles. "One million, four hundred thousand dollars, to the lady at the back . . . One million five. Thank you, sir." He looks to the imaginary bank of telephones that will be manned by Christie's staff in two hours' time, wondering whether to expect another bid. He waits patiently, nods to affirm that the phone bidder will go no higher, and turns his attention back to the room to get a

final psychological reading of his two other fantasy buyers. "All done?" he inquires in an affectionate tone. "I am selling . . . One million, five hundred thousand dollars, to the gentleman on the aisle," and he raps his gavel with such short, sharp violence that it makes me jump.

The hammer punctuates and passes judgment. It acts as a full stop to the end of every lot, but it is also a little punishment for those who didn't bid high enough. In the subtlest of ways, Burge dangles the carrot: *This unique work of art could be yours, isn't it beautiful, see how many people want it, join the club, enliven yourself, don't worry about the money* . . . Then, in a blink, he hits everyone but the highest bidder with a stick, as if all the seduction and violence of the art market were represented in the rhythm of a single lot.

An empty room is the mise-en-scène of an anxiety dream that auctioneers share with actors. They both also dream of being caught naked before an audience. However, in the nightmare Burge has most frequently, he can't take the sale because his auction notes are an indecipherable jumble. "There are hundreds of people out there, getting restless," explains Burge. "For actors, their cue is being called but they just can't get out onstage. For me, I can't start because I can't make heads or tails of my book."

Many would die to get their hands on Burge's highly confidential "book." It's a sort of script for the sale. Tonight's contains sixty-four pages, one for each lot of art. A single page contains an annotated chart of where everyone is sitting, marked with who is expected to bid and whether that person is an aggressive buyer or a "bottom-feeder" looking for a bargain. On each page Burge has also recorded the amounts left by absentee bidders, the seller's reserve (the price under which the work will not sell), and, for

almost 40 percent of the lots, the guarantees, or sums assured to each vendor whether the work sells or not.

Twice a year in New York (in May and November) and three times a year in London (February, June, and October), Christie's and Sotheby's respectively hold their major sales of contemporary art. Together they control 98 percent of the global auction market for art. The word *sale* suggests discounts and bargains, but auction houses aim to make the highest price possible. What's more, it is precisely these extraordinary sums that have turned the auctions into a high-society spectator sport. Tonight's estimates range from $90,000 to prices so high that they are available only "upon request."

"By the time of the sale," explains Burge, "I just go full steam ahead. I will have rehearsed this fifty times, driving myself mad, going through all the possibilities of what might happen." Burge adjusts his tie and straightens his dark gray suit jacket. His haircut is so normal it defies description. He has perfect diction and restrained gestures. "At these evening sales," he continues, "the audience is potentially hostile. It is a real coliseum waiting for the thumbs. They want them to go either up or down. They want a total disaster, lots of blood, and to yell, 'Drag him off!' Or they want record prices, great excitement, lots of laughs—a happy night at the theater."

Burge is considered to be the best auctioneer in the business. He has a reputation for being genuinely charming and having tight control over the room. I envisage him as the confident conductor of an orchestra or an authoritative master of ceremonies, not the victim of some gladiatorial spectacle. "If you only knew how terrified I am," he explains. "An auction is one of the most boring things known to humankind. People sit there for two hours with this idiot droning on. It's hot. It's uncomfortable.

People are falling asleep. It is very stressful for our staff and an experience of rank terror for me."

But you look like you are having such a good time, I counter.

"That is the scotch," he says, sighing.

Burge has an imagination that goes well beyond the prices he calls out. Even in the straightest part of the art world, the players have character. Burge looks meticulously conventional, but as it turns out, his surface ordinariness is at least in part studied: "I'm always worried that one gets mannered and begins caricaturing oneself. We have this little army of trainers and voice coaches who watch us. We are videoed and given a 'crit' afterwards, so that we can stop verbal tics, overused hand movements, and other mannerisms from slipping in."

The pressure of the public eye is relatively new for those dealing in contemporary art. Art by living artists was not sold publicly with any fanfare until the late 1950s. The career of an artist like Picasso was made in the private sphere. People might have known him as a famous artist and said things like "My child can paint that," but they were never shocked by the prices fetched by his work; they didn't know them. Now artists can make the front page of national newspapers simply because their work has achieved a high price at auction. Moreover, the lag between the time works leave the studio and the time they hit the resale market is getting shorter and shorter. Collector demand for new, fresh, young art is at an all-time high. But as Burge explains, it is also a question of supply: "We are running out of earlier material, so our market is being pushed closer to the present day. We are turning from being a wholesale secondhand shop into something that is effectively retail. The shortage of older goods is thrusting newer work into the limelight."

Burge takes his leave to go to the crucial presale summit, where he will confirm every amount and add last-minute details to his play-by-play book of market secrets. "Right before the auction, we usually have an accurate sense of how the sale will play out," says a Christie's rep. "We've taken note of every request for a condition report about repairs and restoration to the work. We know most of our buyers personally. We might not know how hard they will push the pedal, but we know pretty well who is bidding on what."

The auction houses used to have an unwritten rule to "try" not to sell art that was less than two years old. They didn't want to step on the toes of dealers, because they didn't have the time or the expertise to market artists from scratch. Moreover, with a few important exceptions, like Damien Hirst, living artists are perceived as unpredictable and inconvenient. As a Sotheby's staffer told me in a cavalier moment, "We don't deal with artists, just the work, and it's a good thing too. I've spent a lot of time with artists, and they're a bloody pain in the arse." Accordingly, an artist's death can be opportune insofar as it cuts off the supply, creates a finite oeuvre, and clears the way for a well-defined market.

Most artists have never attended an art auction and have little desire to do so. They're disappointed by the way auction houses treat art like any other exchangeable commodity. In the auction world, people talk about "properties," "assets," and "lots" as much as paintings, sculptures, and photographs. They do "evaluations" rather than "critiques." A "good Basquiat," for example, was made in 1982 or 1983 and contains a head, a crown, and the color red. Primary concern is not for the meaning of the artwork but its unique selling points, which tend to fetishize the earliest traces of the artist's brand or signature style. Paradoxically, auc-

tion house staff members are also the most likely art world play-
ers to evoke romantic notions such as "genius" and "masterpiece"
as part of their sales rhetoric.

Primary dealers, who represent artists, mount exhibitions of
work fresh out of the studio, and attempt to build artists' careers,
have tended to view the auctions as amoral and almost evil. As
one put it, "Only two professions come to mind where the build-
ing in which transactions take place is referred to as a house."
Secondary-market dealers, by contrast, have little to do with
artists, work closely with the auction houses, and carefully play
the sales.

Primary dealers usually try to avoid selling to people who will
"flip" artworks at auction, so they don't lose control of their art-
ists' prices. Although high values at auction may allow a primary
dealer to raise the prices of an artist's current work, these mon-
etary ranks can play havoc with the artist's career. Many perceive
the auctions as the barometer of the art market. Artists may be
in high demand when they have a solo show at a major museum,
but three years later their work may fail to reach its reserve price
and suffer the indignity of being "bought in" (the expression used
when a work fails to sell). By publicizing the fact that people
were willing to pay half a million dollars one year but not even a
quarter of a million for a similar piece by the same artist the next,
auctions exacerbate these harsh swings in taste. A record price
breathes life into the perception of an artist's oeuvre, whereas a
buy-in is like a visit from the grim reaper.

It's now 5:30 P.M. I'm supposed to be half a block away, inter-
viewing an art consultant called Philippe Ségalot. I fly past Gil,
Christie's much-loved doorman, through the revolving doors
onto West Forty-ninth Street and manage to enter the café thirty

seconds ahead of my interviewee. Ségalot used to work at Christie's and now co-owns a powerful art consultancy called Giraud, Pissarro, Ségalot. He is the kind of player who, aided by the financial clout of his clients, can "make markets" for artists.

We both decide on fish carpaccio and sparkling water. Although Ségalot is wearing a conventional navy suit, his hair stands on end, thick with gel, neither in nor strictly out of fashion but in its own universe of style. Ségalot never studied art. He acquired an MBA, then worked in the marketing department of L'Oréal in Paris. As he explains, "It is not by chance that I went from cosmetics to art. We are dealing with beauty here. We are dealing in things that are unnecessary, dealing with abstractions."

Ségalot talks very quickly and passionately in intense Franglais. He is a long-standing adviser to the self-made billionaire François Pinault, who, as both the owner of Christie's and a leading collector, wields a double-edged sword in the art market.* When Pinault guarantees a work for Christie's, he either makes money on the sale or, if it's bought in, adds another piece to his collection. "François Pinault is my favorite collector," confesses Ségalot. "He has a true passion for contemporary art and a unique instinct for masterworks. He understands quality. He has an incredible eye." Building up the mystique of the collections on which you work is an essential part of a consultant's job. Any piece of art acquired by Pinault receives the value-added stamp of his provenance. The artist is the most important origin of a work, but the hands through which it passes are essential to the

*In 2007, Pinault was ranked thirty-fourth in *Forbes*'s list of world billionaires. He has many luxury goods holdings, including the brands Gucci, Yves St. Laurent, Sergio Rossi, Balenciaga, and Château Latour.

way in which it accrues value. As a matter of course, everyone involved in the art market talks up the provenances with which he or she is affiliated.

Pinault is one of twenty collectors that Ségalot and his partners work with on a regular basis. "The best situation in the art world—by far—is to be a collector," explains Ségalot. "The second-best situation is ours. We have people acquire the works that we would buy ourselves if we could afford them. We live with the works for a couple of days or weeks, but eventually they go, and that is an enormous satisfaction. In some cases we are very jealous, but it is our job to marry the right work to the right collector."

How does Ségalot know when he has encountered the right work? "You feel something," he says with fervor. "I never read about art. I'm not interested in the literature about art. I get all the art magazines, but I don't read them. I don't want to be influenced by the reviews. I look. I fill myself with images. It is not necessary to speak so much about art. I am convinced that a great work speaks for itself." A faith in gut instinct is common to most collectors, consultants, and dealers, and they love to talk about it. However, it is rare to find an art professional willing to admit that he doesn't read about art. It takes bravado. The vast majority of subscribers to art magazines do simply look at the pictures, and many collectors complain that art criticism, particularly that found in the dominant trade magazine, *Artforum*, is unreadable. Most consultants, however, pride themselves on their thorough research.

People who buy at auction say that there is nothing like it: "Your heart beats faster. The adrenaline surges through you. Even the coolest buyers break out in a sweat." If you bid in the room, you are part of the show, and if you buy, it's a public victory. In

auction-house parlance, you actually "win" works. Ségalot says he never gets nervous, but he does acknowledge a sense of sexual conquest: "Buying is very easy. It is much more difficult to resist the temptation to buy. You have to be selective and demanding, because buying is an extremely satisfying, macho act."

The psychology of buying is complex, if not perverse. Ségalot tells his clients, "The most expensive purchases—the purchases where you suffer the most—will turn out to be the best ones." Whether it is because of the intense competition or the financial stretch, there is something irresistible about art that is hard to get. Like love, it fuels desire. "Give me a bid, but be prepared for me to exceed it," Ségalot warns his clients. "I have created situations where I was anxious to speak to the collector after a sale because I had spent twice as much as agreed on *major* purchases."

I try to formulate a question about the correlation between making money as a consultant and overpaying for art. When consultants are on commission, they don't earn anything unless they buy. When they're on a retainer, no such conflict of interest gets in the way of the job. But as I struggle for the right words to broach this delicate subject, Ségalot looks at his watch. A flash of alarm crosses his face. He apologizes, stands up, pays the bill, and says, "It has been my pleasure."

I sit, finishing my water and collecting my thoughts. Ségalot is infectiously zealous. We had been sitting for almost an hour and he had spoken with absolute conviction the entire time. This is a talent essential to his job. On one level, the art market is understood as the supply and demand of art, but on another, it is an economy of belief. "Art is only worth what someone is willing to pay for it" is the operating cliché. Although this may suggest the relationship between a con artist and his mark, the people

who do well believe every word they say—at least at the moment they say it. The auction process is about managing confidence on all levels—confidence that the artist is and will continue to be culturally significant, confidence that the work is a good one, confidence that others will not withdraw their financial support.

6:35 P.M. The doors in the two-story glass wall of Christie's lobby revolve continuously with a steady flow of ticket holders. Many dealers and consultants are already here, as the evening sale is an opportunity to meet and greet "the money." In the queue for the coat check, and again in the line to pick up paddles for bidding, people speculate about which objects are going to do well and who is likely to buy what. Everybody knows something. People drop their voices when they utter a name or a lot number, so you tend to hear only the verdict: "That's going to fly" or "That estimate is way off." As people part ways to go to their seats, collectors say to each other "Good luck" and "See you in Miami." It's all gleaming smiles.

The crowd is international. You hear a lot of French in an array of Belgian, Swiss, and Parisian accents. Belgium and Switzerland probably have the highest per capita ratios of contemporary art collectors. Until World War II, France was the center for buying and selling art. From after the war to the early 1980s, London was the auction capital, but now the British city is a secondary site, where the buyers tend to bid over the phone. Looking at this busy scene, it is hard to believe that New York was a provincial outpost of the art business until the late 1970s. Christie's started holding auctions here only in 1977, but now, in the words of one Christie's expert, "The market is alive—all the major players are in the room."

I see David Teiger, a New York–based collector in his late seventies. He is talking to a well-preserved woman close to his own age.

"What period do you collect?" she asks.

"This morning," he responds.

"You like art by young artists?" she asks earnestly.

"I don't necessarily like it, but I buy it," he jokes.

"So . . . are you bidding tonight?"

"No. I don't come here to buy. I come to smell the perfume— the aroma of what is in the oven—to gauge where the public is going. That is nothing to do with where I might go. I'll go somewhere overlooked or undervalued."

Teiger prides himself on his independence; auctions have too much of a pack mentality for him. He bought Andy Warhol out of the Stable Gallery's show in 1963. "You know how much I paid for it?" he says. "Seven hundred and twenty dollars! Do you know when MoMA bought their first Warhol? 1982!" Having done that, why would he want to spend $10 million on a lesser Warhol now? It wouldn't sit right with his adventurous self-image. He's not that kind of collector.

So who buys at auction? Many "serious" collectors of contemporary art buy from primary dealers. It's a lot cheaper, if a lot riskier, to be ahead of the curve. On the secondary or resale market, the risk is lower, because the work has been market-tested. All art is "priceless," but assurance is expensive. A small percentage of collectors buy only at auction. "They like the discipline of the deadline," explains a Sotheby's director. "They're very busy, so the sale makes them get their act together. They like the open nature of the auction, especially if there is a visible underbidder willing to pay a similar price. They also like the certainty that they've paid a market price on a given day in a given location."

One reason to buy at auction is to avoid the time-consuming politicking expected by primary dealers, who, in the interest of building their artists' careers, try to sell only to collectors who have the right reputation. The lines to buy work, particularly by painters with limited annual output, can be very long—so long, in fact, that many may never be deemed elite or erudite enough to be "offered a work." Some auction house people complain of the "complete lack of material on the market" and the "undemocratic" way in which primary dealers go about their business. "Quite frankly," declares a Sotheby's expert, "I think the waiting lists are obscene. An auction gets rid of these hierarchical lists, because you can jump straight to the head of the queue just by putting your hand up last."

At 6:50 P.M. I climb the stairs to the salesroom and join the members of the press, who are herded into a cramped standing-room area cordoned off by a red rope. The spatial arrangement suggests that the press should know its place. At a Sotheby's Old Masters sale, we were given humiliatingly huge white stickers that said PRESS. In the hierarchy of this world of money and power, the reporters are visibly at the bottom. As one collector said of a particular journalist, "He obviously doesn't get paid very much. He doesn't really have access to important people, so he's reliant on scraps to put his articles together. It's not much fun hanging around at the big table when you're not wanted there."

One journalist, who writes for the *New York Times*, is an exception to the rule. Carol Vogel has an assigned seat in front of the red cordon that allows her to get up and strut up and down in front of the press pack in her high-heeled boots and gray bob. She is the haughty embodiment of the power of her newspaper. I see Ms. Vogel talking to some of the top dealers and collectors. She obtains access because they want to influence her reports,

even if their tips and insights amount to little more than generous helpings of spin.

In the center of this jostling press pen is Josh Baer. He is not actually a journalist, but for over ten years he's been sending out an electronic newsletter called *The Baer Faxt* that reports on, among other things, who is buying and underbidding at the auctions. Baer looks a bit like Richard Gere; he's a cool New Yorker with thick silver hair and black-rimmed glasses. His mother is a minimalist painter of some repute and he ran a gallery for ten years, so he knows the milieu well. "The newsletter contributes to the illusion of transparency," he admits. "People are overinformed and undereducated. They have this veneer of knowledge. They look at a painting and they see its price. They think the only value is an auction value." Although the art world in general and the art market in particular are opaque, when you are part of the confidential inner circle, there are fewer secrets. As Baer explains, "People like to talk about themselves and to show that they know what they know. I'm fighting that urge right now—I have to fight the impulse to try to impress you that I am important."

Most of the reporters here are interested in a narrow band of information. They take note of the prices and try to see who is bidding and buying. None of them are critics. They don't write about art, but trade in the currency of knowing who does what. One journalist is "paddle spotting," or writing down the numbers of people's paddles as they walk in so that later, when people are bidding, he can tell who bought the work when the auctioneer confirms the number aloud. Others are trying to clock who is sitting where. The reporters grumble about their cramped quarters and their difficult sight lines. They laugh at the pompous collector who has been given a "bad seat" and banter about the best way to describe someone who is making his way to his chair.

"Distinctive," says the understated British correspondent. "Vulgar," says Baer. "A clown," says an emphatic voice from the back of the pack.

The salesroom seats a thousand people, but it looks more intimate. One's seat is a mark of status and a point of pride. Smack dab in the middle of the room sit Jack and Juliette Gold (not their real names), a pair of avid collectors, married with no kids, in their late forties. They fly into New York every May and November, stay in their favorite room at the Four Seasons, and arrange to have dinner with friends at Sette Mezzo and Balthazar. "The truth is," confides Juliette later, "you've got standing room, the terrible seats, the good seats, the very good seats, and the aisle seats—they are the best. You've got the big collectors who buy—they're at the front, slightly to the right. You have serious collectors who don't buy—they're toward the back. Then, of course, you have the vendors, who are hiding up in the private skyboxes. It's a whole ceremony. With few exceptions, everyone sits in exactly the same spot they did last season." Another collector told me that the evening sale was like "going to synagogue on the High Holidays. Everyone knows everybody else, but they only see each other three times a year, so they are chatting and catching up." Anecdotes abound about unnamed collectors who became so immersed in gossip that they forgot to bid.

Part of the pleasure of the auctions is the opportunity to be seen. Juliette is wearing a Missoni dress with no jewelry except for a whopping vintage Cartier diamond ring. ("It's dangerous to wear Prada," she warns. "You might get caught in the same outfit as three members of Christie's staff.") Jack sports a discreetly pinstriped Zegna suit with a cobalt-blue Hermès tie. Sometimes Jack and Juliette buy, sometimes they sell, but mostly they come because they love the sales. Juliette is a romantic whose Euro-

pean parents collected art, and Jack is a pragmatist whose stock and property business influences his perspective. Juliette told me that "an auction is like an opera with a language that you need to decipher." Jack seems to agree but ultimately describes a very different event: "Yes, even if you don't have a direct interest in the sale, you're emotionally involved because you'll own similar works by ten of the artists. An auction is an instant evaluation."

Tonight's auction is more than a series of sixty-four straightforward business deals; it is a kaleidoscope of conflicting interpretations and financial agendas. When I asked the couple why they thought collecting had become so popular in recent years, Juliette spoke about how so many more people were coming to understand that art could enrich their lives. Jack, by contrast, thinks it's because art has become an accepted way of "diversifying your investment portfolio." Although it offends the sensibilities of older "pure collectors," he says, the "new collectors, who have been making their money in hedge funds, are very aware of alternatives for their money. Cash pays so little return now that to invest in art doesn't seem like such a dumb idea. That's why the art market's been so strong—because there are few better options. If the stock market had two or three consecutive quarters of large growth, then, perversely, the art market might have a problem."

The art world is so small and resolutely insular that it is not much affected by political problems. "At the sales after September eleventh," explains Juliette, "you had absolutely no sense of the reality of the world outside. None whatsoever. I remember sitting in the sale that November and saying to Jack, 'We're going to come out of this room and the Twin Towers will be standing and everything will be good with the world.'"

Major disasters may not have an impact, but casual gossip has

the power to break a work. Jack told me a story about friends who
sold off their grandmother's collection. "There was this beautiful
Agnes Martin painting, but somehow the word got around that
if you looked at it upside down, in a certain light, with your eyes
closed, it was damaged. So the whole art world suddenly took
that as gospel. That probably knocked half a million dollars off
the price—just because some idiot started a rumor. Conversely,
when word gets out that an artist is going to move to Larry, every-
one wants to buy a work before the prices go nuts." He was refer-
ring to Larry Gagosian, one of the most powerful art dealers in
the world, with galleries in New York, Los Angeles, London, and
Rome, who invariably raises an artist's prices by 50 percent when
he starts representing him or her.

Most people confess to enjoying the intrigue. However, the
competitive underside to the conversations is unbearable for
some. A London dealer who wishes he could avoid the auctions
explained: "Between you and me, everyone is so full of shit. The
people are all running after each other. The chat is full of subter-
fuge and sleazy art world stories. It's like a tableau vivant of pre-
tentious greed. You walk in, and everyone's so happy and 'How
are you?' when all they want to do is screw you."

At 7:01 P.M., as a few stragglers struggle to their seats, Chris-
topher Burge whacks his gavel. "Good evening, ladies and gentle-
men. Welcome to Christie's and to this evening's sale of postwar
and contemporary art." He reads out the rules about conditions
of sale, commission fees, and taxes. Burge calls out "Lot one" and
starts the bidding off: "Forty-four thousand, forty-eight thousand,
fifty thousand, fifty-five thousand." He seems more relaxed than
he was when the room was empty. To his left, a large black-and-
white scoreboard or currency converter records the sums in U.S.
dollars, euros, pounds sterling, Japanese yen, Swiss francs, and

Hong Kong dollars. To his right, a screen depicts a color slide so the audience can be certain which work is on the block. To both sides of Burge are rows of Christie's staff standing in two wooden enclosures that look like jury boxes. Many of them are on the phone, talking to people who are, or soon will be, bidding. Some buyers are not in town, and others want to protect their anonymity. Someone like Charles Saatchi, the advertising mogul turned secondary-market art dealer, never comes to the sales. Very conscious of publicity, he either bids on the phone or sends someone to bid in the room. If he wins a work, particularly for a record price, he can make it well-known after the fact. If he loses one, no one is the wiser and he doesn't lose face.

Lot 1 is bought for "$240,000 hammer"; the buyer's premium (a 19.5 percent commission fee up to $100,000 and a 12 percent fee over $100,000) means that the final price for the work is actually $276,300. From the first to the final bid, the deal took just over a minute and a half. Deals are quicker when works sell near their low estimate, but when the final price is three times the high estimate, as was the case with this lot, it takes a little longer. Either way, an auction is a staggeringly swift way to sell art.

"Lot two is next," says Burge. "The Richard Prince showing there on my right. In this case ninety thousand starting. Ninety thousand for it. Ninety-five thousand, one hundred thousand, thank you. One hundred ten, one hundred twenty, sir? Yes, one hundred twenty, one hundred thirty . . ."

It's no coincidence that none of the evening auctioneers of art in New York are American. Tobias Meyer, Sotheby's chief auctioneer, is German, while Simon de Pury, the auctioneer and co-owner of the smaller specialist contemporary art auction house Phillips de Pury, is French-Swiss. Burge, of course, is British. They bring a measure of European urbanity to a series of crude trans-

actions. In another gesture toward Old World gentility, auction house sales personnel are officially called "specialists" and informally referred to as "experts." They apply art-historical knowledge to market trends in order to evaluate works, bring them into a sale, and then drum up interest in the lots. In the words of one expert, however, "we're really analysts and brokers."

Amy Cappellazzo, a specialist who is also the codirector of the Post-War and Contemporary Art Department at Christie's, is an animated brunette with twinkling eyes and a no-nonsense way of talking. She is one of the few Americans in the upper echelons of the company and currently the only female head of a "major grossing" department. During our presale interview, she was high-energy, but now she looks almost serene. "I never get jitters during the sale itself," she says. "At that point, all our hard work is done. We spend about eighty percent of our time getting great things for sale and twenty percent of our time lining up buyers. Obtaining great work is the key. We increasingly have to remind clients that if they turned a work on their wall into a liquid asset, it could be worth more than their entire home."

The bidding on Prince's *Untitled (Cowboy)*, an artist's proof being "sold to benefit Tibet House," has stopped, and Burge is attempting to squeeze another bid out of the audience. Eye contact is essential. He looks at each individual bidder as if that person were the only one in the room. "Two hundred and sixty thousand. Two hundred seventy, madam? Still against you standing. One more from you at the back? No. At two-sixty on the telephone and against you all here. I'm selling, fair warning, at two hundred and sixty thousand dollars."

Burge raps his hammer, and half the crowd lean over their catalogues to write down the price. "One thing you do learn from experience," says Burge, "is when a bidder has more life in them

than they're saying. Sometimes they shake their head to say no. An inexperienced auctioneer will take them at their word and not look back, but an old hand knows that this collector has really got another bid in them. When some dealers or private collectors shake their heads, it's clear you don't have to deal with them anymore. They're very controlled. That was it, not a penny more. Others, you can feel that they are still wavering. They are talking to a spouse or a friend. He's very eager and she's doing the bidding. Or he said no and she wants to go on. You see all of that from the rostrum."

We're on Lot 3, but Josh Baer and the correspondent from the *New York Times* are still conferring on who was bidding on the Prince. "I hate this salesroom," says Vogel. "You can't see the bidders." The reporters don't have the benefit of Burge's elevated face-on view, nor do they have access to his confidential book. Four names go back and forth, but they are still not sure. Sometimes an auction feels like a whodunit where thrills are provided by the large sums and mystery created by the shy or shady bidders who avoid the eye of the press.

Burge's astute psychological reading of the room is essential to the way he does his job. His perspective on the behavioral minutiae of the bidders is second to none. "About two lots before someone bids," he reveals, "they will start doing small things that signal to me that they are interested in a lot. People sit up straighter in their seats, they adjust their jacket, begin to look a little nervous. Even if they have been doing this all their lives, hardened professionals give something away. It means that in a lot or two, they're going to bid on something. I pick that up, because their body language is so different from the regular slump."

"But," I press, "some of the most powerful collectors and dealers, like the Nahmads, are so casual. They apathetically raise a

finger as if it just occurred to them to bid." The Nahmad family reputedly once owned 20 percent of the world's privately held Picassos, but they now buy huge quantities of post-war art. Rumor has it that they never spend cash, because when they are buying one or four lots, they are usually selling several others—constantly rotating old for new stock.

"They have been around for a long time," says Burge, "but there is usually some sort of family conference going on as we head into the lot, so I know something is afoot. Moreover, we know what they bid on. David Nahmad loves to buy things back that he has owned before, and in some cases I will know exactly what he is planning because I will have talked to him at length before the sale."

We're already on Lot 4, a painting by Marlene Dumas. Josh Baer leans over: "You notice they started the bidding *above* the high estimate." One bidder has just left his paddle in the air. He's "steamrolling," an aggressive tactic to put others off. The bids are coming in at an incredible pace. Burge barely has time to breathe: $550,000, $600,000, $650,000, $700,000—"several of you"—$750,000, $800,000, $850,000. "What's that? Eight hundred eighty thousand." Someone has offered a split bid. He or she is trying to slow down the sale by cutting the bidding into smaller increments. "Nine hundred thousand dollars in the room. Against you all on this side." Auctioneers don't like to accept cut bids, because the sale can lose momentum. However, at the moment, the bidding is three times over the high estimate and well over the artist's record price, so Burge decides to be gracious.

When the bidding hits $980,000, there is a long pause. Large amounts of money command hushed respect, and unexpected amounts create a stunned stillness. Everyone wonders, will the painting get over the psychological hurdle of the million mark?

That would make Marlene Dumas one of three living women artists to trade for over $1 million—the other two are Louise Bourgeois and Agnes Martin.* Is Dumas going to join them? One of Christie's spotters signals to Burge that there is a new bidder, standing at the very back of the room. "One million dollars," Burge says with subtle triumph.

"Where'd that bid come from?" whispers Baer insistently. The press pack wants to know, and even collectors turn around in their seats to catch a glimpse of the mysterious bidder who has entered the fray at the eleventh hour. Some people like to come into the bidding late because it suggests that there is no limit to how high they can go. Auctions are full of ego and posturing. It's important to bid with style.

"One million dollars," repeats Burge with a faint trace of amusement. "One million fifty . . . one million one." It's back to the late entrant hidden from view at the back. "One million, one hundred thousand dollars. Fair warning now. Not yours. Last chance. One million one. Selling to you at the back." Bang. The volume of chat surges with the hammer. "Paddle four-oh-four. Thank you," says Burge. I hear laughing. A couple of people shake their heads in disbelief. A voice deep from within the press pit exclaims, "One point one! Will anyone know who she is in twenty years?" Other people exchange affirmative nods as if to say, "Yes, we're backing the right horse." The reporters are hav-

*Agnes Martin died shortly after this sale. Since then, Cecily Brown, Yayoi Kusama, Bridget Riley, Jenny Saville, Cindy Sherman, and Lisa Yuskavage have joined the ranks of living women artists whose work has broken the million-dollar mark at auction. One might think that the art world was at the vanguard of gender equality, but the disparities in price in an auction room are quite extreme. Although one finds many powerful women dealers and curators, the bulk of the big-spending collectors are male—a fact that no doubt contributes to the complex dynamic of undervaluation that befalls women's artwork.

ing a mini-conference about who could have bought the Dumas. There are clear differences in how high people are willing to bid, depending on whether they are "crazy committed collectors" or dealers buying for long-term inventory. Everyone assumes that only a crazy collector would have paid that price. But who?

From her position among the rows of Christie's people, Amy Cappellazzo gives a knowing wink to someone in the audience. The Dumas painting is medium-sized and predominantly red. It appears to depict a woman looking expectantly out from under her bangs at the viewer. Her finger is phallic and coquettishly touches the lower of her gently open lips.

Cappellazzo is refreshingly unpretentious. When I asked her, What kind of art does well at auction? her answer was uncannily appropriate to this lot. First, "people have a litmus test with color. Brown paintings don't sell as well as blue or red paintings. A glum painting is not going to go as well as a painting that makes people feel happy." Second, certain subject matters are more commercial than others: "A male nude doesn't usually go over as well as a buxom female." Third, painting tends to fare better than other media. "Collectors get confused and concerned about things that plug in. They shy away from art that looks complicated to install." Finally, size makes a difference. "Anything larger than the standard dimension of a Park Avenue elevator generally cuts out a certain sector of the market." Cappellazzo is keen to make clear that "these are just basic commercial benchmarks that have nothing to do with artistic merit."

So what's the relationship between aesthetic value and economic value? I ask.

"It's not fully correlative. There are lots of wonderful artists who don't have strong markets. What is the correlation between good looks and good fortune in life? It is that kind of discussion.

It's moot. It's nihilistic." Hmm. Both good looks and aesthetic value are in the eye of the beholder, but beholders are social animals that tend to (consciously *and* unconsciously) cluster into consensuses. Cappellazzo doesn't apologize for the market. It is what it is. "I used to be a curator," she says. "When I run into academics that I knew back then who ask what I'm doing now, I say, 'I do the Lord's work in the marketplace at Christie's.' It's one of my personal jokes."

The bidding on Lot 5, a classic Gilbert and George from 1975, went up to $410,000, while the bidding for Lot 6, a Maurizio Cattelan sculpture from 2001, has started at $400,000. Gilbert and George may be Britain's most important conceptual artists, but on this occasion they are no competition for the less prolific, hip-and-happening Italian. The catalogue is the auction house's main marketing tool. It's a full-color, glossy tome on which the images on the front and back covers are part of the negotiations meant to entice vendors to consign their art with Christie's. This Cattelan work, a self-portrait in which he peers through a hole in the floor, not only graces the back cover of the catalogue but is also reproduced on the invitation-only ticket.

The "Maurizio market" (it's de rigueur to refer to living artists by their first name) is much debated. Cattelan is a cynical prankster who polarizes opinion. Some people think he is the Marcel Duchamp of the twenty-first century, others say he is the over-hyped Julian Schnabel of our time. It can initially be difficult to distinguish innovators from charlatans, because the former challenge extant versions of artistic authenticity in such a way that they can easily look like pretenders. The test is in the perceived depth and longevity of their "intervention" in art history. Some heavyweight collectors buy Cattelan's work in such serious bulk that it leads others to complain that his market is manipulated.

However, as one consultant puts it, "It's not manipulation—it's more unconditional support."

The bidding on the Cattelan is "fast and furious," as the auction cliché goes, and the work sells for $1.8 million, twice Cattelan's previous auction record. "William Acquavella," mutters Baer as he scribbles in his catalogue. Acquavella is a wealthy second-generation dealer whose gallery is located in a plush townhouse on East Seventy-ninth Street—one of the few who can afford to buy at that price for inventory. For consultants and dealers, buying in the room acts as an advertisement for their services.

Lot 7 is one of three Ed Ruscha paintings for sale this evening. It "flies" for $680,000. Baer grumbles "Meltzer" and "Gagosian," the buyer and underbidder. Gagosian represents Ruscha on the primary market and "protects" his artists at auction. If Ruscha were to go out of favor, Gagosian would probably buy key paintings and sit it out until the artist came back into fashion.

Lot 8 is a Gursky photograph. It exceeds its high estimate but sells for well below the artist's record. It is not one of his more celebrated works. Lot 9, Dan Flavin's elegant *Untitled Monument for Tatlin*, sets a new record for the artist.

In general, this auction is bearing witness to an incredibly strong market. "Every season we wait for the big correction," says Jack Gold. "No boom lasts forever," adds Juliette. It's not a bubble until it bursts, say those in the business.

I ask Josh Baer about the "endless bull market." As he peers over the crowd, he replies nonchalantly, "Without auctions, the art world wouldn't have the financial value it has. They give the illusion of liquidity." He stops to jot down the starting bid of Lot 10, then continues. "A liquid market is the New York Stock Exchange. Someone will buy your IBM stock at a price. There is no law to say that someone will buy your Maurizio, but the

auctions give a sense that most of the time, most things will sell. If people thought they couldn't resell—or that if they died, their heirs couldn't sell—many wouldn't buy a thing."

Lot 10 is bought with a nod for a flat $800,000. Baer turns to me and adds, "We live in a climate where everyone expects prices to go in one direction only. But a lot of artists who are doing well now will be worth zero in ten years. You should look back at old auction catalogues. People have short memories."

Amy Cappellazzo is laughing with someone on the phone. The Christie's staff are gearing up for the next two lots of "museum pieces"—Lot 11, a ready-made sculpture of three Hoovers, guaranteed to make a collector's housekeeper laugh, by auction darling Jeff Koons, and Lot 12, a large-scale 1960s history painting by the king of postmodern art, Andy Warhol.

The estimate-leaping and record-setting of the first ten lots partly relate to the way Christie's has constructed the flow of the sale. People need to feel secure when they are spending extraordinary sums of money on luxury goods. As Cappellazzo explains, "We lay out a sale commercially. If we laid it out art-historically—chronologically or thematically—it would probably bomb. The first ten lots all have to go well. We tend to put things in there that will soar past the high estimate—young, hot, contemporary things that get the room going. At around Lot twelve or thirteen, we'd better be entering a serious price point."

The Koons "sells in the room" for $2,350,000.

"Time for the big kahuna," says Baer.

"Lot twelve. The Andy Warhol. *Mustard Race Riot* . . . of 1963," says Christopher Burge. Most works are not referred to by title. They are simply "The Gursky," "The Flavin," "The Nauman." The time-wasting gesture toward the subject matter of the work is reserved only for the most expensive lots. Very slowly, Burge says,

"And . . . eight . . . million . . . to start." The bids are unhurried and come in increments of $500,000. A sober silence descends on the room. It takes about a minute to get to $12 million, and Burge threatens to sell: "Fair warning. Twelve million dollars." In ten seconds, with three alternating finger waves worth half a million each, the price jumps to $13.5 million. There it stays. Burge manages to linger for a laid-back forty seconds, hoping to elicit another half-million with inviting eye contact, but it doesn't happen. *Whack* goes his hammer. "Sold for thirteen million, five hundred thousand dollars."

"Rafael Jablonka . . . probably for Udo Brandhorst," Baer asserts confidently.

When I asked Amy Cappellazzo, What is the art market? she was matter-of-fact. "Art is more like real estate than stocks. Some Warhols are like studio apartments in midblock buildings with northern exposures, while other Warhols are penthouse properties with 360-degree views. A share of Cisco, however, is always just a share of Cisco." Judging from the rhythm of the bidding on *Mustard Race Riot*, the painting may have been a penthouse, but the lobby was poorly renovated and some eyesore must have been obstructing the view. The painting is made up of two panels, and connoisseurs were concerned that the two sides weren't exactly the same shade of mustard. One rumor had it that the panels had not been painted at the same time, while another suggested that the difference was entirely intentional. Either way, as Juliette Gold said, "It's a great historical piece, but it's not a very appealing color and it's too large to hang easily in one's home."

The Warhol market is probably the most complex market in the field of contemporary art. The hierarchy of works reflects a fine balance between rarity and popularity, size and subject matter. The most expensive years are 1962, 1963, and 1964, but

the quality of the silkscreen factors into the price. Whether the picture is "fresh to market" or has been repeatedly resold also has an impact on its desirability.

Warhol is a globally recognized brand with a fair distribution of works around the world, but a handful of super-rich dealers and collectors with vast Warhol holdings are said to move his market. Peter Brant, a newsprint mogul who knew Warhol (and owns *Art in America* and *Interview* magazines), is considered to have the best collection, but the Mugrabi family, reputed to own around six hundred Warhol works, is likely to have the biggest. Then there are the Nahmads and high-rolling dealers like Gagosian and Bob Mnuchin, who buy and sell Warhol as well. These top-echelon players are, in the words of one insider, "willing to overbid in order to keep up the overall value of their holdings." Their opaque activities make a joke of the auction houses' claims to bring transparency and democracy to the art market.

Warhol once said, "Buying is much more American than thinking, and I'm as American as they come." This week, Christophe van de Weghe, one of the few secondary-market dealers in Chelsea, is hosting an exhibition of Warhol's large, colorful dollar-sign paintings. Is the show a homage to or a parody of the art market? The irony that no doubt accompanied the making of the paintings has dissipated some twenty years after the artist's death.

In New York, the divide between galleries that focus on the primary market and those that are principally secondary has a geographical dimension. Most of the primary galleries are in Chelsea between West Nineteenth and West Twenty-ninth, and most of the secondary galleries are on or just off Madison Avenue, between East Fifty-ninth and East Seventy-ninth Streets. Dealers like Gagosian, PaceWildenstein, and David Zwirner have shops in both locations, one for each kind of dealing.

While secondary-market dealers need to have a "good eye," a command of art history, an instinct for the market, an ability to take risks, and a steady circle of supportive clients, the thing that most distinguishes them from primary dealers is their need to be "cashed up." The strongest players have the capital to buy with no financial pressure to sell. They take control of the object rather than acting as a go-between. As one dealer laments, "I've always suffered from not being able to hang on to things for long enough. I absolutely love buying things and I hate selling things. If you're extremely rigorous about the objects you buy and buy only the best, then you don't want to let them go."

Few like to admit that they enjoy selling art. The experience certainly contrasts markedly with the glory of buying. For collectors, the traditional reasons for selling are the "three D's"—death, debt, and divorce—so the act has been associated with misfortune and social embarrassment. Today, says Josh Baer, there are "four D's—because you've got to take account of the collectors who are effectively dealing." Many collectors are in the practice of rotating their collection, much as dealers rotate their stock. They sell overvalued objects whose prices have moved up at rates that are historically unsustainable and buy undervalued works that they think are more likely to stand the test of time. Or they sell off objects by less fashionable artists before the works are worth nothing at all, in order to "upgrade" their collection. As one Sotheby's specialist explained, "Many collectors who consign works to auction are of-the-moment people who have a very plastic approach to their collection."

Plastic is a peculiar word. It reminds me of something an older female collector said to me after a couple of glasses of champagne: "An auctioneer is like a plastic surgeon. You want to go to someone you can trust." Sitting a couple of seats away, I notice

a young, long-haired blonde writing in her catalogue with an old arthritic hand. Upon closer inspection, I realize she is withered but immaculately unwrinkled; her scalp is dotted with hair implants; her body is draped with distracting jewelry and animal pelts. She's seventy-two going on twenty-two. A "plastic" sense of art collecting may indeed relate to the pursuit of youth and to a determined attempt to rejuvenate oneself through owning novelties.

Compared to the pleasures and victories of buying, selling is an uncomfortable chore. Many collectors say they never sell when they actually do, partly because being known as a seller inhibits their ability to buy work from primary dealers. When Jack and Juliette Gold sold a work that was on the cover of an auction catalogue several years ago, they regretted the experience. As usual, Jack is pragmatic: "Selling at auction was unpleasant. I had a buzz in putting the deal together, getting the guarantee, negotiating the cover, but once it came to it, I didn't like the publicity. I would rather have sold it privately through a dealer. The only problem would have been that whatever price we got from a dealer, I would have had a nagging suspicion that we could have got more at auction." For Juliette, selling was much more of a trauma: "It was horrible. I wanted to hyperventilate and die. It felt like I was being undressed. The work was guaranteed, so we didn't have to worry about anything financially, but what if nobody wanted it? We had lived with that painting for a long time. It was something we loved, so it felt like we were being personally assessed. We had a private room upstairs where, thank God, you could drink. I had three scotches in forty-five minutes and I was still dead cold sober."

Baer passes out some Ricola lozenges. Many lots have whizzed by—three Twomblys, two Calders, another Warhol, another Koons. I lose track of the prices as I take note of the full range of

gestures people use to participate in this ritual. Among clients in the room, you have the full-hand waves, the two- and one-finger salutes, the paddle punches and bunts, nervous nods and double-blinking. Cappellazzo jokes, "I've always suspected that people's bidding strategies are connected to their sexual performance. Some bidders are not afraid to let the auctioneer know what they want. They're transparent about their needs. Others tease you and keep you guessing." The Christie's reps on the telephones have no doubt been told to heighten the sense of excitement, so their bidding styles are more expressive. Some adopt an aerobic full-arm extension with wrist flick, while others yell out a slightly hysterical "Bidding!" or make a stopping-traffic hand signal to indicate that they are anticipating a bid from a collector who is lounging on the sofa at home with a glass of wine, oblivious of the sense of urgency in the salesroom.

"Lot thirty-three. The Cindy Sherman showing on my right," says Burge. "And one hundred and forty thousand starts. One-fifty, one-sixty, one-seventy, one-eighty, one-ninety—new bidder. The bid is at the back now with one hundred and ninety thousand. The gentleman's bid, and selling at one-ninety. All done." Wham. The deal is done in thirty-five seconds.

For people who are passionate about art, selling is often associated with a sense of a loss, and this is compounded when the selling is spurred by the loss of a loved one. During a Christie's contemporary sale in London, I sat next to Honor James (not her real name), a tall, slim, upright woman who had consigned ninety-nine works from her parents' collection of six hundred. As paintings and sculptures from her family home came up on the block, she would tell me, "That was in my parents' bedroom" or "That was on the table in the hall."

James comes from a different world from most auction-goers

and espouses markedly different values. She is not an art world jetsetter but a social worker from the Midwest. Upon her father's death, she was made executor and charged with liquidating her parents' $100 million estate so the proceeds could be entirely donated to a local community foundation. "None of us was upset about the fact that there was no inheritance. We weren't surprised," explains James. "When you make your own way in life, it has more meaning. Inherited wealth can ruin people. My mother raised us with the adage 'From those to whom much is given, much is expected.'"

James's parents were active members of the International Council at the Museum of Modern Art (MoMA) but kept their collection very private. Nevertheless, "it was very important for my father to meet the artist. He met every living artist whose work he owned except for Jackson Pollock," James tells me. And although "there was a story behind every piece," the status of these objects was never emphasized. "I remember sitting in my Art 101 class, my freshman year at Duke. It was a survey course where we went through the centuries, and at the end of the year we got up to the modern era. All of a sudden an Arshile Gorky came up on the screen and I said, 'Oh my God. We have one of those.' All these slides went by of artists whose work we had in the house. We had never been told that they were valuable or famous. I had no idea."

Selling the first few works from the collection was tough. "It was really difficult to see the Pollock and the Rothko being packed up to leave. It was like having your children leave home," says James. "I didn't have any appreciation of the huge sense of personal loss that I'd feel. Then it was really weird to see my parents' pieces hanging in the Christie's showrooms. The whole thing seemed like a dream. People were touching them and tak-

ing them off the wall. When we were growing up, we weren't allowed to go near anything.

"For the first auction, in New York, I wore my mom's blazer and her favorite pin, but I still felt awful. I was so nervous. I had to run to the ladies' room to have an anxiety attack. At the second sale, in London, I was nauseous with anxiety." After that, James went through a phase in which selling became easier and more rewarding. "It was such a thrill to walk in my parents' footsteps. I felt so connected to them. It was a cathartic experience for me." James admits that she has since tired of the process. "It's been a real loss of innocence. When you think of all the good that money could do . . . Nobody in the auction room thinks about that."

It's 8:05 P.M. and we're on Lot 36, a work by the expensive conceptual painter Gerhard Richter. Last night at Sotheby's evening sale a major Richter didn't sell, and it looks like this Richter may not sell either. A few years ago, particularly around the time of his MoMA retrospective, Richters were selling like hotcakes. Burge taps his gavel and mutters "Pass" under his breath. What happened? I ask Baer. "It's been bought in because the bidding didn't hit the seller's reserve. The heat is off in the Richter market. The people who wanted Richters have got them."

The boom in the art market has been fueled by the arrival of many more art buyers. As Ségalot explains, "People want to become part of the lifestyle. Buying contemporary art is about going to the Basel and Frieze art fairs, the Venice Biennale, and, of course, the evening auctions in New York. The life of a contemporary art collector moves according to these events. To collect contemporary art is to buy a ticket into a club of passionate people who meet in extraordinary places, look at art together, and go to parties. It is extremely appealing."

When people are motivated to buy art for social reasons, their

tastes and spending patterns are more likely to be swayed by the vagaries of fashion. Collecting art has increasingly become like buying clothes. As a Sotheby's specialist explains, "We buy a pair of trousers and we wear them for three years and then move on. Is it right that the trousers sit in the cupboard for the next twenty-five years? Our lives are constantly changing. Different things become relevant at different times in our lives. We are motivated by our changing sensibilities. Why can that not be applied to art as well?"

Art used to embody something meaningful enough to be relevant beyond the time in which it was made, but collectors today are attracted to art that "holds up a mirror to our times" and are too impatient to hang on to the work long enough to see if it contains any "timeless" rewards. Experts say that the art that sells most easily at auction has a "kind of immediate appeal" or "wow factor."

Lot 44. A Jasper Johns numbers painting from his heyday, 1960–65, gets bought in, despite the fact that Johns is the most expensive living artist.* Baer explains why it didn't sell: "Some people think that Jasper's signature color is gray, and that painting is black. Plus it's so dark that it's impossible to see the numbers."

This is ironic. Numbers are what auctions are about. Lot numbers, dates, bidding increments, hammer prices. On and on,

*Jasper Johns's *False Start*, which sold for $17.7 million at Sotheby's in 1988, held the record for the highest price ever paid for a work by a living artist at auction on and off for nineteen years, until Damien Hirst's *Lullaby Spring* sold for $22.7 million in June 2007. The Hirst work was knocked off the top spot when Jeff Koons's *Hanging Heart (Magenta/Gold)* sold for $23.6 million in November 2007, and the Koons was cast aside when Lucian Freud's *Benefits Supervisor Sleeping* sold for $33.6 million in May 2008. The buyers of these recent record-priced works were later revealed to be, respectively, the Sheikha Al Mayassa, Victor Pinchuk, and Roman Abramovich—three billionaires for whom these sums would seem to be small change.

Burge rattles off the figures. Auctions are unremittingly quantita-
tive. They are a black-and-white version of the gray world of art.
Artists and writers tend to revel in ambiguity. It is the gray areas
that invite and challenge them to represent the world. A hammer
price, by contrast, is so final and definitive. It really means, "Say
no more."

Baer yawns. The *New York Times* correspondent is sitting in
her chair looking wilted. The air is stale. My mind is numb.
The works start to blend one into the other. People are leav-
ing, mostly in pairs. The sale, as Burge predicted, has become
boring. Then . . . all of a sudden the room wakes up. We're into
the bidding on Lot 47, an Ed Ruscha painting called *Romance*.
People are sitting bolt upright and looking around. The dynamics
of the auction have shifted, and the air is tense. I can't tell what
is going on. "Someone is signal bidding," says Baer. "They don't
want it known that they're bidding, so they've caught the eye of
a Christie's rep, who is relaying their bids to Burge. It's a little
choreography—a bit of a drama."

As I survey the small club of people through whom the ener-
gies of the market flow, I see a shaggy-haired, burly man leaving
his seat. He looks a bit like Harry Potter's friend Hagrid, and I
realize it's Keith Tyson, a British artist who won the Turner Prize
in 2002. As he makes his way out of the salesroom, I slip out of
the press enclosure. I find him in the hall in front of a Maurizio
Cattelan. It's Lot 34, a sculpture of a big gray elephant under a
white sheet, which sold for $2.7 million. It's a surreal "elephant
in the room" titled *Not Afraid of Love*.

I tell him that I didn't expect to see an artist here.

"Everyone from the gallery was coming. Was I going to sit in
a bar on my own? I wanted to see what the phenomenon was
all about. I'm interested in economics. Other artists are worried

about their purity. It's a huge social faux pas for an artist to go to an auction—so they tell me. But I don't give a shit."

What do you think is going on in there? I ask.

"The auction is the symptom of something much more complex, like a rash. It is vulgar, in the same way that pornography is vulgar," he replies.

I guess that is what people mean when they refer to "obscene" amounts of money. How does it feel? I press.

"At about thirteen million on the mustard Warhol," says Tyson, "I had a massive urge to put my hand up. But then I thought, 'I'm sure it has been done before.' The sale is infectious. You feel the thrill of capitalism and you get into a sort of alpha-male mentality."

Capitalism—it's not a word you hear in an auction room.

"I don't have any problem with the market for art," he continues. "It is an elegant Darwinian system. Some collectors are effectively buying futures options on a work's cultural significance. The high price is right for the number of users who will ultimately appreciate it. The logic is that the people coming into my private mausoleum/museum are going to be thrilled by this painting. There are ten million people on the face of the planet that are willing to pay ten pounds to see it, so it is worth a hundred million pounds. In the long run, economic and cultural values correlate. In the short term, you get fictional markets."

It's unusual to meet an artist who has such confidence in the ultimate accuracy of the market's aesthetic judgments. Paradoxically, Tyson is also adamant that art is not reducible to a commodity. "Unlike gold and diamonds, art has this other value, and that's what makes it fascinating. Everything else is trying to sell you something else. Art is trying to sell you yourself. That's what is different about it. Art is what makes life worth living."

It's 8:30 P.M. and the sale is almost over. A skinned bull's head immersed in formaldehyde by Damien Hirst is up on the block. Last month in London, Sotheby's raised $20 million selling off the artwork and ephemera of Hirst's restaurant, Pharmacy. It was the first time a living artist had openly consigned work directly to an auction house. Hirst got 100 percent of the hammer price—a much better split than any deal he could have carved up with his dealers. He also received front-page newspaper coverage and consolidated his position as one of the most famous living artists in the world.

Oliver Barker, the Sotheby's specialist who came up with the Pharmacy auction concept, enjoyed his first experience working with an artist: "Damien is very inspirational, quick-minded, hardworking. He was completely on board approving marketing schedules and the like. He has a keen business sense, but he's also a risk-taker. It's an awesome combination."

Many of the artists who sell well at auction are artist-entrepreneurs. It may be because collectors who've made their money in business like to see reflections of themselves in the artists they buy. Or as Francis Outred, a post-war and contemporary art specialist, put it, it may be because "a lot of artists today are succeeding on sound business principles." Here Warhol and his Factory are the model. Like Warhol, Hirst has developed production strategies to ensure that there is always enough material to keep up with collector demand; for instance, he's made about a thousand "unique" spot paintings.*

*In September 2008, on the day that Lehman Brothers collapsed, Hirst sold over two hundred works directly out of the studio in a two-day sale at Sotheby's titled "Beautiful Inside My Head Forever." The auction raised a total of £111 million; it was the last big blowout of the boom. In spring 2009, Hirst told me, "The auction definitely felt like the end of something. I was planning to finish the series [of spots, spins, butterflies, etc.], but it's been a much more brutal shutdown. I've been doing these new [hand-painted blue] paintings very quietly and the auction was loud. That loudness ended it all for me."

The last couple of lots sell without a hitch. When the sale is over, it is just over. There is no grand finale, no clapping, just another rap of the hammer and a quick "Thank you" from Burge. Knots of people walk and talk their way out of the room. I hear a few young dealers who work in secondary-market galleries laughing about how "insane" the market is before they get into a fractious argument about whether Richard Prince will ever trade for over a million dollars.*

In the line for our coats, I bump into Dominique Lévy, an art consultant who once worked at Christie's and knows how to see through the smoke and mirrors of an auction. So what is your verdict? I ask. "For works that sell below five million, the market is astonishingly deep—deeper than ever," she says. "But I was surprised that the market for expensive works was thinner tonight," she adds in a quieter voice. "Very often I was about to write *pass* in my catalogue when Christopher—it was one of his most masterful sales—was able to dig out one more bid."

As I walk through the revolving doors into the cold New York air, the celebratory expression "making a killing" and Burge's gladiatorial metaphor of the "coliseum waiting for thumbs" come to mind. Even if the people here tonight were initially lured into the auction room by a love of art, they find themselves participating in a spectacle where the dollar value of the work has virtually slaughtered its other meanings.

*In May 2005, Richard Prince's *A Nurse Involved* sold for $1,024,000, and in just over three years (July 2008), a different nurse painting (*Overseas Nurse*) would sell for $7.5 million. By July 2009, they were back down to trading for under $3 million.

CHRIS BURDEN

Shoot, 1971

2

The Crit

On the other side of America, at the California Institute of the Arts, or CalArts, as it is affectionately known, a very different part of the art world looks for multiple meanings in artworks whose financial worth is—at this moment, anyway—negligible. I'm sitting alone in F200, a windowless classroom with cement walls in which long-life fluorescent lights cast a gray glow. The CalArts building feels like an underground bunker meant to protect those within from the mindless seductions of the Southern California sun. I survey the thin brown carpet, forty chairs, four tables, two chalkboards, and lone jumbo beanbag, trying to imagine how great artists get made in this airless institutional space.

At precisely 10 A.M., Michael Asher enters. He has a stoop and a bowlegged gait. Asher is the longtime teacher of the legendary crit class that takes place in this room. (A "crit" is a seminar in which student-artists present their work for collective critique.) Ascetic and otherworldly, Asher comes across as a monk in street clothes. He peers at me through his dark-rimmed glasses with greatly magnified eyes and neutral curiosity. He has given me

permission to audit today's class, but I'm forbidden to speak, because to do so would disturb "the chemistry."

The classroom reminds me of an Asher installation. At the 1976 Venice Biennale, Asher filled a corner of the Italian Pavilion with twenty-two folding chairs. He wanted the space to be a "functional" lounge where "visitors communicate with each other on a social level." The chairs were dispersed at the end of the exhibition and the work was documented with a few obligatory black-and-white photographs.

Until recently I had not seen an Asher piece in the flesh. In fact, most of his students have never seen his work, and Asher's "situational interventions" (as he calls them) or "institutional critiques" (as others label them) are often invisible. One of Asher's signature works consisted of removing the gallery wall that divided the office from the exhibition space, thereby focusing attention on the moneymaking business behind "priceless" art. That exhibition took place at Claire Copley Gallery in Los Angeles in 1974, but people still talk about it. In another piece, considered quintessentially Asher, the artist made a catalogue listing all the art that had been "deaccessioned" from, or removed from, the permanent collection of, the Museum of Modern Art in New York. Although it was on view in the 1999 MoMA exhibition "The Museum as Muse," word of mouth subsequently emphasized the fact that the catalogue was kept behind the counter of the gift shop and was available for free to those in the know.

Asher has no dealer; his work is not generally for sale. When I asked the artist during an interview on another occasion whether he resists the art market, he said dryly, "I don't avoid commodity forms. In 1966 I made these plastic bubbles. They were shaped like paint blisters that came an inch off the wall. I sold one of those."

Although Asher has a steady museum career, the real importance of his art lies in the way it has inspired a dynamic oral culture. His work lives on in anecdotes recounted from one artist to the next. The visual documentation of his ephemeral art is rarely very stimulating, and because his works have no title (they are not "Untitled" but actually have no name whatsoever), they can't be invoked quickly and easily. They demand verbal description. Not surprisingly, Asher's overriding artistic goal has always been, in his words, "to animate debate."

Asher has been running this crit class since 1974. Artists with international reputations, like Sam Durant, Dave Muller, Stephen Prina, and Christopher Williams, describe it as one of the most memorable and formative experiences of their art education. The lore around the class is such that incoming students are often desperate to have the once-in-a-lifetime-experience. As one student told me, they "arrive with pre-nostalgia."

The three students who will be presenting their work on this last day of the term trudge into F200, carrying grocery bags. They're all between twenty-eight and thirty years old and in the second year of the master of fine arts (MFA) program. As Josh, wearing a beard, baseball cap, and jeans, unpacks his large black portfolio, Hobbs, a slim tomboy in a pink T-shirt and jeans, claims a seat and rearranges some chairs. Fiona, who evokes the ghost of Frida Kahlo in a long green skirt with a red hibiscus flower in her hair, starts laying out extra-large containers of Safeway's generic cola, chocolate chip cookies and mini-muffins, and grapes. The people "being critted" provide the snacks. It's an acknowledged peace offering to their peers.

Since the 1960s, MFA degrees have become the first legitimator in an artist's career, followed by awards and residencies, representation by a primary dealer, reviews and features in art

magazines, inclusion in prestigious private collections, museum validation in the form of solo or group shows, international exposure at well-attended biennials, and the appreciation signaled by strong resale interest at auction. More specifically, MFA degrees from name art schools have become passports of sorts. Look over the résumés of the artists under fifty in any major international museum exhibition and you will find that most of them boast an MFA from one of a couple of dozen highly selective schools.

Many people think that the extraordinary vibrancy of the L.A. artistic community results from the presence of so many top-ranking schools. Outstanding programs at CalArts, the University of California at Los Angeles (UCLA), Art Center, the University of Southern California, and Otis College of Art attract artists who then never leave the area. The schools, combined with relatively cheap rents, the warm climate, and the liberating distance from the dominant art market in New York, foster an environment where artists can afford to take risks. Significantly, in L.A., teaching does not stigmatize an artist's career in the way it does elsewhere. In fact, many L.A. artists see teaching as a part of their "practice," and a full-time contract is not just a money-earner but a credibility-enhancer.

A number of students flood the room and a wave of greetings follows. No one arrives empty-handed. One student holds a laptop, another a sleeping bag; a third clutches a Tempur-Pedic pillow.

People remember what they say much more than what they hear. In some MFA programs, a crit consists of five experts telling a student what they think about his or her work. In crits at the L.A. art schools, students do most of the talking while instructors bear witness. Group critiques offer a unique—some say "utopian"—situation in which everyone focuses on the student's

work with a mandate to understand it as deeply as possible. Crits can also be painful rituals that resemble cross-examinations in which artists are forced to rationalize their work and defend themselves from a flurry of half-baked opinions that leave them feeling torn apart. Either way, crits offer a striking contrast to the five-second glance and shallow dollar values ascribed to works at auctions and fairs. Indeed, crits are not normally considered art world events, but I think that the dynamics in this room are vital to understanding the way the art world works.

A black terrier trots into the classroom with his pale-faced owner in tow. He is followed by a white husky who bounds in, tail swishing, and stops for a long slobbery lick of my toes. "Dogs are allowed in crit class as long as they are quiet," explains a student. "I have a French bulldog, but she snores, so I can't bring her to class. Virgil—he'll be here today—occasionally makes loud noises. He voices our frustration when the class gets tedious. Dogs are emotional sponges. They're attuned to the mood."

Josh has hung two large, well-crafted pencil drawings on the wall. They're executed in the style of Sam Durant, one of the higher-profile artists on staff at CalArts. One picture is a self-portrait next to someone who looks like an African chief or a black rabbi in a prayer shawl. Josh has inserted himself into the frame in a manner reminiscent of Woody Allen's chameleon Zelig character, who repeatedly pops up in famous documentary footage.

At 10:25 A.M. everyone is seated. Michael Asher, legs crossed, clipboard in hand, emits an odd grunt and nods in Josh's direction. The student starts: "Hello, people," he says, and then takes a painfully long pause. "Well, I guess most of you know that I've had some shit goin' on . . . Some family stuff happened the first week of semester and I only came out of my funk about two

weeks ago. So . . . I'm just going to workshop some ideas that have been going through my head . . ."

Asher sits motionless, with a poker face. Students stare impassively into space, swirling their coffee, their legs dangling over the arms of chairs. A guy with stained fingernails keeps looking up and down from his sketchpad. He's using the crit as an opportunity to do a little life drawing—a subject that has never been on the Art School curriculum at CalArts. (Tellingly, they teach it over in the animation department.) Two women are knitting. One sits upright, working on a beige scarf. The other sits cross-legged on the floor, with a stack of green and yellow wool squares to her left, an eye-catching vintage suitcase to her right. "A patchwork quilt," she explains, and then, keen to clarify, she adds, "It's just a hobby. Not a work."

Each student has set up camp, staked out some territory, and distinguished him- or herself with a pet, a pose, or a signature activity. Crits are performances in which the students aren't so much acting as searching for the public face of a real artistic "me." Many have put down more money than they have ever had. Tuition alone is $27,000 a year; even with the help of government grants, teaching-assistant positions, and other part-time jobs, some students find themselves nearly $50,000 in debt after completing the two-year program. In more senses than one, it costs a lot to be an artist.

Twenty-four students—half male, half female—are sprawled around the room. A latecomer in a business suit and hair gel saunters in. He offers a shocking contrast to the jeans and sweatshirts that are the male norm. He's from Athens, apparently. Hot on his heels is a blond guy in a lumberjack shirt, looking like the Hollywood version of a farmhand. He stands at the front of the class, examines the drawings, drifts to the back, surveys the

room, puts his knapsack on a chair. He then moseys over to the food table, where he kneels to pour himself an orange juice. He's Asher's TA, or teaching assistant. His emphatically casual behavior is a mark of Asher's tolerance. Two more men park themselves at the food table. They graze but do not talk. The room is full of activity, but there is no whispering or note-passing. Asher maintains that his crit has no rules except that students have to "listen to and respect each other." Nonetheless, a chimp could sense the enduring layers of convention.

Josh is sitting forward with his elbows resting heavily on his knees, stroking his beard with one hand and hugging his chest with the other. "I was doing work on race and identity in my undergrad, then I went to Israel and had the same feeling of displacement . . ." He sighs. "I think I'm gonna call the work I'm doin' now 'Anthro-Apology.' I've been researchin' African Jewry and their different ancestral stories. I've also been writing myself into the traditions of non-Jewish tribes. There's a Nigerian tribe who drink palm wine out of horns and lose consciousness. I put myself in the story. It was like trying to fit a circle into a square." Josh emits another long sigh. A dog collar jingles lightly as one of the mutts has a halfhearted scratch. "I identify with hip-hop culture rather than klezmer culture," Josh says with a glum chuckle. He started loose, but now he is unraveling. "Sorry, I am doing this badly. I don't really know why I am here."

A high proportion of students are looking at their feet. Asher clears his throat and leans toward Josh but says nothing. The knitters' needles slow down, and the room comes to a standstill. Silence. Finally a woman's voice cuts through the air. "I'm so conscious of the fact that Jews are totally uncool. Where do we see 'Jewish art'? At the Skirball Cultural Center, not MOCA or the Hammer Museum," she says emphatically. "And why do

so many white kids want to be symbolically black? I think it is because they can displace their frustrations and validate them somehow. They can speak with the critical voice of the under-dog . . . Maybe you could tell us more about how you <u>displace</u> <u>your dislocation onto Africans</u>?"

Falling apart in a crit is not as shameful as one might expect. <u>Intellectual breakdown</u> is an <u>essential component</u> of <u>CalArts</u> <u>pedagogy</u>, or at least an expected part of the MFA student experience. Leslie Dick, the only writer with a full-time position among the artists of the art department, tells her students, "Why come to grad school? It's about paying a lot of money so you can change. Whatever you thought was certain about how to make art is dismantled. You wobble. You don't make any sense at all. That's why you are here." Yesterday Leslie and I had coffee on the terrace outside the cafeteria next to the desert pines and eucalyptus trees that surround CalArts. She was wearing a no-nonsense white shirt hanging loose over an Agnès B skirt, and no makeup except for some plum lipstick. She admitted that faculty members can be complacent about the pain of the situation, as they've seen it happen so many times. "Everything goes to pieces in the first year and it comes together in the second year. Often the people who are making sense are the ones for whom it hasn't started working yet. They've still got all their defenses up. Some-times the person is simply uneducable and there is nothing you can do."

During my stay in Los Angeles, I asked all sorts of people, <u>What is an artist?</u> It's an <u>irritatingly basic question</u>, but <u>reactions</u> were so <u>aggressive</u> that I came to the conclusion that I must be violating some taboo. When I asked the students, they looked completely shocked. "<u>That's not fair!</u>" said one. "<u>You can't ask</u> <u>that!</u>" said another. An artist with a senior position in a university

art department accused me of being "stupid," and a major cura-
tor said, "Ugh. All your questions are only answerable in a way
that is almost tautological. I mean, for me, an artist is someone
who makes art. It's circular. You tend to know one when you
see one!"

Leslie Dick couldn't believe that anyone had taken offense.
"The work you do as an artist is really play, but it is play in the
most serious sense," she said. "Like when a two-year-old discov-
ers how to make a tower out of blocks. It is no halfhearted thing.
You are materializing—taking something from the inside and
putting it out into the world so you can be relieved of it."

Twelve forty-five P.M. The crit class discussion has been mean-
dering for over two hours. About half the students have spoken,
but Asher hasn't said a word, and no one has discussed Josh's
drawings directly. Although the talk is intelligent, it is difficult to
feel fully engaged. I have clearly parachuted into the middle of
a very abstract and often inchoate ongoing debate. Many of the
comments are rambling affairs, and it is impossible not to drift
off into one's own thoughts.

A few days ago, I drove out to Santa Monica to see John Bal-
dessari, the gregarious guru of the Southern California art scene.
Baldessari is six-foot-seven, a giant of a man with wild hair and a
white beard. I once heard him referred to as "Sasquatch Santa,"
but he makes me think of God—a hippie version of Michelan-
gelo's representation of the grand old man in the Sistine Chapel.
Baldessari set up the Post-Studio crit class in 1970, the year that
CalArts opened, and has continued to teach despite a lucra-
tive international career. Although he was hired by CalArts as a
painter, he was already exploring conceptual art in other media.
As we sat, with our feet up, and drank ice water in the shade of an
umbrella in his backyard, he explained that he didn't want to call

his crit "Conceptual Art" because it sounded too narrow, whereas "Post-Studio Art" had the benefit of embracing everybody who didn't make traditional art. "A few painters drifted over, but mainly I got all the students who weren't painting. Allan Kaprow [the performance artist] was assistant dean. In those first years, it was him and me versus the painting staff."

Baldessari has mentored countless artists, and although he now teaches at UCLA, he is still seen to embody the think-tank model that exists in one of its purest forms at CalArts, even if it has spread all over the United States. One of his mottos is "Art comes out of failure," and he tells students, "You have to try things out. You can't sit around, terrified of being incorrect, saying, 'I won't do anything until I do a masterpiece.'" When I asked how he knows when he's conducted a great crit class, he leaned back and eventually shook his head. "You don't know," he said. "Quite often when I thought I was brilliant, I wasn't. Then when I was really teaching, I wasn't aware of it. You never know what students will pick up on." Baldessari believes that the most important function of art education is to demystify artists: "Students need to see that art is made by human beings just like them."

At 1:15 P.M. we're in a definite lull, and Asher speaks his first words. With his eyes closed and hands tightly clasped in his lap, he says, "Pardon me." The students raise their heads. I sit in anticipation, expecting a short lecture. A straight-talking moment. Or a lightning epiphany. But no. Asher looks up at Josh's drawing, and true to his minimal art about absence, he says, "Why didn't you enter the project through language or music?"

One of the early mantras of CalArts was "No technique before need." It used to be said that some art colleges instructed their students only "up to the wrist" (in other words, they focused on

craftsmanship) while CalArts educated its artists only "down to the wrist" (its concentration on the cerebral was such that it neglected the fine art of the hand). Today at CalArts the faculty is diverse—"We all contradict each other," says Leslie Dick—but the prevailing belief is that any artist whose work fails to display some conceptual rigor is little more than a pretender, illustrator, or designer.

Following Asher's question, there is a conversation about the concept of drawing. At 1:30 P.M., Josh peels an orange. Someone's stomach grumbles. Asher vaguely raises a finger. I expect he is going to adjourn for lunch, but instead he asks, "What do you want, Josh? Put the group to work." Josh looks exhausted and dejected. He reluctantly pushes an orange segment into his mouth; then his face brightens. "I guess I'm wondering about the viability of political activism in my work." The room wakes up to this topic. Politics is central to the conversations that go on in Post-Studio. A mature Mexican student who has already done a lot of posturing on the "Israelification of the U.S. with this homeland security bullshit" seizes the opportunity to launch into a new rant. After his five-minute sermon, a woman of mixed race on the other side of the room delivers a quiet but seething response. The two students have a dazzling rivalry. Their hatred is so passionate that I can't help but wonder if they're attracted to each other.

Crits may be opportunities to hash out communal meanings, but that doesn't mean that students finish the semester with uniform values. The character of Asher's crit varies from week to week (and from one semester to the next), because each artist sets the agenda for his or her own session. This tendency is no

doubt enhanced by the way Asher effaces his authorship: "Ultimately, Post-Studio is the students' class, not mine."

Group crits are such an established part of the curriculum in the United States, and to a lesser extent in Europe and elsewhere, that only a few teachers reject them. Dave Hickey, an art critic who describes his pedagogic style as "Uncle Buck—Hey, smoke this," is one of the few. "My one rule," he says in his freewheeling southwestern drawl, "is that I do *not* do group crits. They are social occasions that reinforce the norm. They impose a standardized discourse. They privilege unfinished, incompetent art." He tells his students, "If you're not sick, don't call the doctor." Hickey is not alone in thinking that there is undue pressure on artists to verbalize. Many believe that artists shouldn't be obliged to explain their work. As Hickey declares, "I don't care about an artist's intentions. I care if the work looks like it might have some consequences."

It is curious that a form of oral exam has become the chief means of testing visual work. Mary Kelly, a feminist conceptualist who has taught at a range of institutions, including Goldsmiths (University of London), CalArts, and UCLA for more than forty years, thinks it's fine for artists to have crits where they give an account of their intentions, but it shouldn't be the only way. Kelly wears her hair swept back in an odd 1940s pompadour that one writer assumed must be her "auxiliary brain." She initially comes across as a stern headmistress, but during our interview, which took place in her kitchen over homemade soup, I encountered a soft-spoken, maternal intellectual. At CalArts in the mid-eighties and now at UCLA, Kelly hosts an alternative group critique where the only person who is *not* allowed to speak is the presenting artist.

Kelly tells her students, "Never go to the wall text. Never ask

the artist. <u>Learn to read the work.</u>" In her view, <u>works of art pro-</u>
<u>duce arguments,</u> so "when you ask an artist to explain it in words,
it is just a <u>parallel discourse</u>." Moreover, <u>artists often don't fully</u>
<u>understand what they've made</u>, so other people's readings can
help them "see at a conscious level" what they have done. Kelly
believes in preparing to view the work properly: "It is a bit like
yoga. <u>You must empty your mind and be recep</u>tive. It's about
being open to the possibility of what you could know." Once
everyone is in the right frame of mind, the class starts with the
phenomenological, then moves on to deciphering the "concrete
signifying material of the text." You tend to "read things very
quickly by their transgression of codes," says Kelly. The most cru-
cial question is when to stop, so she asks, "Is this in the text? Or
is this what you are bringing to it?" She stops the interpretation
at the point when she thinks "we might be going too far."

As an exercise in refining the work's communicative connota-
tions, Kelly's crit method would seem to be exemplary, but most
crits espouse a more complex mix of goals. In the context of
an expanded market for concept-based work, the integrity and
accountability of artists are as important as the specific aesthet-
ics of their work. William E. Jones, a filmmaker who studied with
Asher and then taught the course on two occasions when Asher
was on leave, is a staunch defender of crits that interrogate the
artist about his or her intentions. He feels they prepare students
for a professional career because "negotiating interviews, con-
versations with critics, press releases, catalogues, and wall texts
are part of the responsibility of the artist." When artists are put
on the spot, Jones feels, it helps them "develop thick skins and
come to see criticism as rhetoric rather than personal attack."
Finally, art students need to understand their motivations deeply,
because in grad school it's imperative to discover which parts of

their practice are expendable. As Jones explains, "You have to find something that is true to yourself as a person—some non-negotiable core that will get you through a forty-year artistic practice."

Howard Singerman, the author of a compelling history of art education in America called *Art Subjects*, argues that the most important thing that students learn at art school is "how to be an artist, how to occupy that name, how to embody that occupation." Even though many students don't feel 100 percent comfortable calling themselves "an artist" upon graduation—they often need the further endorsement of a dealer, museum show, or teaching job—in many countries the roots of that social identity lie in the semipublic ground of the crit.

2:00 P.M. A long silence. Josh is looking at his hands. Laughter tumbles distantly along the hall. Next to me, a petite woman with mousy brown hair has made a double-page spread of inky doodle hearts. A clean-shaven chap stares at his mute laptop, discreetly scrolling through e-mails downloaded from the room's one Ethernet connection. At the back of the class, a guy and a girl lean against the wall, looking at each other.

"Let's think about winding this down now," says Asher. "Josh, do you have any thoughts?"

"I really appreciated everyone's comments," Josh says lightly. "I'd like to see you all for individual meetings next week. Please sign up on my office door," he jokes. Josh looks better than he has all day. He has survived the ordeal. There were moments when his crit might have turned into a group therapy session, but the cool discipline of his fellow students kept the conversation in check.

"Class to resume at three o'clock," says Asher.

The exodus is smooth. We're all desperate for fresh air. Hobbs, one of the three students set to present work today, offers me a lift to Whole Foods Market, where the students customarily pick up their lunch. Four students and I squeeze into her beat-up Honda. In the middle of the back seat, I listen to the ping-pong of their dialogue. First they have a debate about one of the most vocal men in the class. "He's so arrogant and patronizing," says one of the women. "When he says, 'I don't understand,' he really means, 'You are an idiot, you're not making any sense.' And why does every observation he makes have to begin with a position statement and end with a list of recommended reading?"

"I think he's great," counters one of the men. "He's very entertaining. We'd go to sleep without him."

"He's overinstitutionalized, domineeringly PC, and macho, all at the same time," intercedes a third student, who then turns to me and declares with glee, "He got ripped to shreds when he had his crit."

Then they talk about Asher. "He certainly gives you enough rope to hang yourself," says one.

"Michael is so minimal and abstract that sometimes I think he might dematerialize before our very eyes," quips another.

"You gotta love him," says a third. "He's seriously good-willed, but he's also lost in a world of his own calculations. He should wear a lab coat."

We drive past bland houses with two- and three-car garages, green lawns, and deciduous trees that defy the desert landscape. Apparently these Valencia neighborhoods inspired CalArts alumnus Tim Burton's vision of suburban hell in the film *Edward Scissorhands*.

What do the students want to do when they finish their MFA?

"I came to grad school because I want to teach at college level. I was an installer in a gallery, but I'm interested in ideas. I think my work will be better as a result of teaching," says the fellow to my left.

"My work is going to fly off the shelves. It is not de rigueur to create commodities, but it is part of my work to create this fantasy economy which overtly tries to sell things," says the male student in the front seat.

"What to do when finished? That's *the* big question. Go back to Australia and drink. I don't want to teach. I'd rather waitress," muses Hobbs as she takes a left into the parking lot of the grocery store.

"MFA stands for yet another Mother-Fucking Artist," says the girl to my right as we climb out of the car. "I will just try to graduate as preposterously as possible. One year twins received their diplomas while riding matching white horses. Another year a student walked up onstage with a mariachi band. But my favorite story is when a male student locked the dean in a full kiss on the lips."

Whole Foods Market is an emporium of fresh smells and vanguard taste tests. As I load up with guacamole and black beans at the create-your-own-burrito bar, I think about how difficult it is to be an art student looking into the abyss of graduation. Two or three of the lucky ones will find dealer or curator support at their degree shows, but the vast majority will find no immediate ratification. For months many of them will be out of a job. Mary Kelly used to think it was depressing that so few students could sustain themselves as full-time artists, but then she realized "it is not sad at all. I believe in education for its own sake, because it is deeply humanizing. It is about being a fulfilled human being."

Faculty members may understand that the value of art educa-

tion goes beyond the creation of "successful" artists, but students are uncertain. Although CalArts students distance themselves from UCLA students, who they say "have dollar signs in their eyes," they don't want to languish in obscurity. Hirsch Perlman is a sculptor-photographer who has known market highs as well as many difficult years of enduring the relative poverty of part-time teaching. Now a full-time professor at UCLA, he still talks like an outsider. As he sees it, "The art market simmers underneath all of these schools. Every student thinks that he can jumpstart his career by being in one of these programs. But nine out of ten times the student is in for a big surprise, and nobody wants to talk about it. Whenever I open up the conversation to that aspect of the art world, you can see how hungry the students are. They are dying to know."

Most art schools turn a blind eye to the art market, but CalArts seems to turn its back. Some faculty members are pragmatic; they think students need to develop artistic projects that are independent of the fickle swings of the marketplace. Others occupy a left-wing position that believes the neo-avant-garde should subvert the commerce of art. Steven Lavine has been the president of CalArts since 1988. A bespectacled diplomat who talks about the school like a proud parent, Lavine says that "everybody talks a pretty good left game," but he doesn't know how far left CalArts really is. "We've all made our compromises with the world, so center-left is all we can compliment ourselves with." President Lavine embodies the distinctly high-minded and down-to-earth attitude that typifies CalArts. "We're idealistic. We don't prepare students to do jobs that already exist. Our mission is to help every student develop a voice of his or her own," he explains. "There is a soul to every great institution, and you go wrong if you betray that. At CalArts, people want to make work

that has a relationship to what is under discussion rather than what is hot for sale at the moment."

Back on campus, Hobbs and I walk over to the second-year grad studios—two rows of small industrial units facing a sidewalk that an undergrad (Peter Ortel) had transformed into a "Walk of Fame." Gold stars inscribed with the names of well-recognized CalArts alumni refer to the famous strip on Hollywood Boulevard and to the otherwise unmentionable problem: artists need to make a name for themselves. Hovering over the stars like halo afterthoughts are black spray-painted Mickey Mouse ears that deflate the self-aggrandizement and pay mock homage to CalArts' unlikely founder, Walt Disney.

Hollywood affects the horizons of the L.A. art world in subtle ways. After graduation, artists who don't support themselves through sales or teaching can work in the ancillary industries of costumes, set design, and animation. Sometimes the communities of artists and actors overlap. Ed Ruscha, who admits that "art is show business," used to date the model Lauren Hutton. Actors like Dennis Hopper, who is also a photographer and collector, or artists like CalArts graduate Jeremy Blake, who made abstract digital works for Paul Thomas Anderson's film *Punch-Drunk Love*, move between the worlds. Here on campus, however, one feels that most artists are openly hostile to commercial spectacles, as if CalArts were set up as the conscience or doppelgänger of the entertainment industry.

Hobbs unlocks her studio. All the doors have been customized with oversized names, cartoon numbers, collages, and even bas-relief sculptures. "Every grad has a space of their own that they are allowed to use twenty-four hours a day. I live in mine. You're not supposed to, but a lot of us do," she says as she points to a fridge, a hotplate, and a couch that turns into a bed. "There's

a shower down by the workshop," she adds. The cube is twelve by twelve feet, with dirty white walls and a cement floor, but it has twelve-foot-high ceilings and north-facing skylights, which give the workspace some dignity.

A few doors down and across the walk, the class is viewing the installation in Fiona's studio called *Painting Room II*, which will be the subject of this afternoon's discussion. Paint flies beyond the edges of four canvases onto the wall and floor. Pale scribbles evoke the work of Cy Twombly, while the paint on the floor recalls Jackson Pollock's drip method. The writing desk in the corner and the hard-to-pinpoint femininity of the space suggest Virginia Woolf's *A Room of One's Own*. Ironically, given the name of the crit class (Post-Studio Art), the installation is a forceful reassertion of the importance—even the romance—of the studio. It feels as if a restrained outburst or cool tantrum has taken place here. It's not grandiose or heroic but private and insistent. You can feel Fiona's diminutive height and the lonely hours. And on one of the canvases, you can almost make out the word *learning*.

Back in subterranean F200, the students sit in a different configuration from this morning. It's 3:15 P.M. and Fiona, with a hibiscus flower still tucked behind her ear, has chosen to sit behind a table. One of the knitters has abandoned her needles and lies on her stomach, chin in hands, looking at her intently, while a guy lies on his back with his hands behind his head, staring at the ceiling. Fiona is setting out the parameters of the discussion. "I have a schizophrenic practice. I do dry sociopolitical work, but I always have, and always will, paint. I like the process. All the decisions that I made while making the *Painting Room* were formal. I didn't want to work 'critically,'" she says, sweetly but defiantly, as she pulls in her chair and straightens her skirt. "There is a real masculine aggression to iconic 1950s abstract

expressionism. I wanted to revisit abstraction and explore the poetics of space with my own hand."

Shortly after Fiona's introduction, a woman who is sitting on the floor and wearing her flip-flops on her hands says, "I find it interesting the length to which you conceptualize your work. A painting room requires a lot of justification in this class." Her comment lingers until Asher says, "You see institutional limits? It would be good to be specific." The woman, not a talker, fumbles for the right words, eventually spitting out something about the "ideological biases of CalArts."

A few days ago, a handful of students were loitering in the makeshift living room of the art department, a wide point in the hallway outside the dean's office where a couch and a coffee table lend the feeling of an outpatients' waiting room. There I took the opportunity to probe the jargon I'd heard on campus. *Criticality* was at the top of my list. "It shouldn't be confused with being harsh or hostile, because you can be unthinkingly negative," said a young photographer slumped on the couch. "It's a deep inquiry so as to expose a dialectic," explained an MFA student keen on doing a PhD. "If you're on autopilot, you're not critical," said a performance artist, with a nod from her boyfriend. During our conversation, an African-American man of about sixty emerged from one of the offices. He turned out to be the conceptual artist Charles Gaines. The students flagged him over to pose the question on my behalf. "Criticality is a strategy for the production of knowledge," he said plainly. "Our view is that art should interrogate the social and cultural ideas of its time. Other places might want a work to produce pleasure or feelings." Of course! Conceptualism arose in the 1960s in part as a reaction to abstract expressionism. *Criticality* is the code word for a model

of art-making that foregrounds research and analysis rather than instincts and intuition.

After Gaines took his leave, I explored another word: *creativity*. The students wrinkled their noses in disgust. "*Creative* is definitely a dirty word," sneered one of them. "You would *not* want to say it in Post-Studio. People would gag! It's almost as embarrassing as *beautiful* or *sublime* or *masterpiece*." For these students, *creativity* was a "lovey-dovey cliché used by people who are not professionally involved with art." It was an "essentialist" notion related to that false hero called a genius.

Perhaps creativity is not on the agenda at art school because being creative is tacitly considered the unteachable core of being an artist? Asher believes that the "decisions that go into making a work are often social," but he's in a minority. Most artist-teachers believe that creativity is a very personal process that cannot be taught. As a result, students are expected to have it when they arrive, so creativity is an issue only when it comes to admissions. President Lavine says, "We hunt for students who have some spark of originality. It might seem like eccentricity or cussedness, but we want students who are in some way on edge with their world." Paradoxically, many art educators see artists as autodidacts, and high academic achievement can be a contra-indicator. As Thomas Lawson, dean of the School of Art here for over a decade, told me, "We are looking for the kind of kids who didn't quite fit in at high school."

Lawson's office is one of the few rooms on this floor that is graced with a shaft of natural light. A marked contrast to Asher, Lawson is a Scottish painter with a firm belief in the visual. He's an eloquent speaker and a prolific writer who contributes to *Artforum* and coedits a journal called *Afterall*. Lawson is a tall, self-

effacing man with thoughtful hazel eyes. When asked the reckless question, What is an artist? he said, with seasoned patience in his lilting accent, "It's not necessarily someone who sells a bunch of objects through a fancy gallery. An artist thinks about culture through visual means. Sometimes it's thinking about culture through any means possible, but it's rooted in the visual. When I was here in the late eighties as a visiting artist, there was an alarming tendency to graduate MFAs with great praise when they were doing no visible work. As they say in the movie industry, ideas are a dime a dozen. You've got to put it into some sort of form. So when I came here as dean, part of my mission was to reinvest the visual."

Nowadays at CalArts there are painters on staff but no "painting staff" per se, and the school has developed a reputation for being inhospitable to practitioners of the medium. Lawson admits, "The beef against us is that we are not an emotional painterly type of school. That's true. But we have a system that is open and intelligent, and as a group we value intelligence. So you can do anything you want, if you can defend it." However, when pressed about the fate of the taciturn painter, Lawson confessed, "I'm a painter and I know that painting is not about talking. The issues of skill and mistake are very close. You can do things that to some eyes look horrible and to others look brilliant. It's very curious—and difficult to defend." Ironically, some of CalArts' highest-profile graduates are painters: Eric Fischl, David Salle, Ross Bleckner, and, more recently, Laura Owens, Ingrid Calame, and Monique Prieto. Their success is likely to be the result of the market's rapacious appetite for the two-dimensional, easily domesticated medium.

6:20 P.M. The conversation isn't going in circles as much as spiraling amorphously. Five guys are milling about restlessly at the back. Two of them shift their weight from foot to foot with their arms crossed, while the other three actually pace back and forth with slow, silent steps. One man is seated with his back to Fiona, while another is conspicuously reading the *LA Weekly*. In most crit classes, the prohibition against passing explicit value judgments is absolute, yet people's reactions can be read from their bodies.

A good artist and a good student are by no means the same thing. Art students have a reputation for acting out. Recruited for their rebelliousness, for their portfolios that are off the wall, they can be tricky for the institution to handle.

Occasionally the relationship between teacher–role model and student-artist becomes dangerously twisted. In a UCLA crit class, a student wearing a dark suit and red tie stood up in front of the class, pulled a gun out of his pocket, loaded a silver bullet, spun the chamber, pointed the gun at his own head, cocked it, and pulled the trigger. The gun just clicked. The student fled from the room, and several gunshots were heard outside. When he returned to the classroom without the gun, his classmates were surprised to see him alive, and the crit staggered on with a tearful group discussion.

The incident was a misguided homage to—or parody of—a historic artwork by a professor in the department. Back in 1971, artist Chris Burden carried out one of the most notorious performances in L.A. art history. In a piece called *Shoot*, he had himself shot in the upper arm by a friend with a rifle in front of an invited audience at a private gallery in Orange County. The work was one of seventy-six performances that explored the

limits of physical endurance and stretched people's conception
of art.

Although Burden was not running that particular crit, the per-
verse copycat quality of the student's performance was apparent
to everyone at UCLA. When Burden heard about the incident,
he thought, "Uh-oh. This is not good." His position was simple:
"The kid should have been expelled on the spot. The student
violated about five rules in the university code of conduct. But
the dean of student affairs was confused and did nothing. She
thought that it was all theater."

"The name 'performance art' is a misnomer," Burden told me.
"It is the opposite of theater. In Europe they call it 'action art.'
When a performance artist says that he or she is doing something,
the predominant feeling is that he or she is actually going to do it."
After twenty-six years of teaching, the artist-professor resigned.
He told the dean, "I do not want to be part of this insanity. Thank
God that student didn't blow his brains out, because if he had,
you would be on the carpet big-time." Burden distrusts institu-
tions, because they lack accountability and hide behind bureau-
cratic ways of thinking. "To be a good artist in the long term, you
need to trust your own intuition and instincts," he said. "Whereas
academia is based on rational group-think. There is a magic and
an alchemy to art, but academics are always suspicious of the guy
who stirs the big black pot."

Asher looks at his watch. It's 7:01 P.M. I've sunk into Post-
Studio's parallel universe of daydreams. The crit is about "being
here" and letting your mind flow. Class numbers are ebbing.
Twenty students remain, from an earlier high of twenty-eight.
People move slowly so as not to be disruptive. The only time peo-
ple walk out quickly is when, phone vibrating, they leave the room

to take a call. When they return, they tiptoe through the debris, the scattered chairs, the sprawled legs, the sleeping dogs.

At 7:10 P.M., after a long silence, Asher stands up and waits. When no one says anything, he asks, "Do we need dinner tonight?" To which a student replies, "Are you cooking?"

We take a break so that pizzas can be ordered. The women put their refuse in the trash as they exit from the room. The men, without exception, leave theirs. I walk through the hallways of the CalArts compound, down to the creepy graffiti-lined corridors of the basement, up the extra-wide stairwell, past the closed cafeteria, up to the exhibition areas. The sounds of a jazzy Latin-experimental ensemble waft though the building. I stroll out the front door into the pitch-black night, only to find Fiona drinking tequila and orange out of a bashed-up Calistoga Springs water bottle.

What was that like for you? I ask.

"I don't know," she says with bewilderment. "You go in and out of consciousness. When so many people open up your work, they say things that you never imagined, and you start to feel baffled."

The lawn sprinklers suddenly switch on. Through the spray, we can hear the hum of huge trucks hurtling along Interstate 5, the highway that extends the full length of the West Coast from Canada to Mexico.

"To get the most out of your crit," Fiona continues, "you have to have a mysterious blend of complete commitment to your decisions and total openness to reconsider everything. There is no point in being too brazen."

Fiona and I deeply inhale the cold desert air. "I wanted to do something different," she adds. "Students make work just

because it stands up well in critiques, but outside the classroom it is often inconsequential."

We go back underground to attend the third part of the crit. Six boxes emblazoned with the words HOT DELICIOUS PIZZA have arrived, and there are only a few slices left. A guy comes over to Fiona and says, "I've never heard Michael speak so much." This is meant as both the highest praise and an act of reassurance. The comment amuses me, because Asher had uttered relatively little.

At 8:15 P.M., Asher looks toward Hobbs and asks, "Are you ready?"

Three medium-sized color photographs are pinned to the wall behind her. One depicts a horse standing by a tree. Another shows a couple of cowboy figures facing off as if they are about to duel. The third portrays a stuntman falling back onto a mat-tress in the middle of a rugged desert. Hobbs puts three issues on the agenda: photography, the western genre, and the absurd. Only her flushed face reveals evidence of nerves. She discusses the camera as a "violent tool" in the context of "visual pleasure and narrative cinema." Then she delivers the heartfelt confession, "Thomas Mann said that all women are misogynists. I can iden-tify that conflict within myself. I get pleasure from stereotypes even when I know they are wrong." Finally, she talks about the importance of humor in her work: "It's corporeal and crass—that's the language I trust most."

There are thirty-four people in the room—the highest num-ber all day. Some boyfriends and girlfriends of enrolled students have come along for an evening out. The dog population has also increased and diversified to embrace a full range of colors from deep black through splotchy chocolate and golden brown to dirty white. All six are chomping on biscuits distributed by

the patchwork-quilt knitter. The arrangement of bodies has again shifted. Several students are doing difficult balancing acts with feet up on multiple chairs. Many are sharing pillows and blankets.

Successful crits can become the basis of lifelong interpretive communities or artist subcultures. Word has it that Sarah Lucas, Gary Hume, Damien Hirst, and other artists later christened "YBAs" (Young British Artists) forged their alliances in a crit class run by Michael Craig-Martin at Goldsmiths. Arguably the equivalent of CalArts in the U.K., Goldsmiths was for many years the only British art school to amalgamate its painting, sculpture, photography, and other departments into a single fine arts school. Compared to most other British schools, it also placed substantial responsibilities in the hands of the students. A few months before this L.A. trip, I interviewed Craig-Martin, now an avuncular professor emeritus, at his studio in Islington. Craig-Martin believes that "for art students, the people who matter most are the peer group." Artists need "friendships with an in-built critique" as a context for the development of their work. "If you look at the history of art," he maintains, "all the Renaissance artists knew their contemporaries. So did the impressionists. There was a moment in their lives when they were all friends or acquaintances. The cubists were not simply individual geniuses. Their greatest works happened in conjunction. Who was van Gogh's best friend? Gauguin."

The talk in F200 has moved on to a vivid discussion of artist personas. "The art world is like a western—full of cowboys, whores, and dandies," asserts Hobbs. "Robert Smithson is the ideal hero. He even died young. Bruce Nauman buys a ranch and ostracizes himself. James Turrell walks around with a ten-gallon hat and ornate cowboy boots." New World frontiers are integral

to the mindset of many artists in L.A. When I interviewed Chris Burden, I drove through the dry hills, past the scrub oaks, to his studio in the wilds of Topanga Canyon. He bought the land from the granddaughter of the original owner. "It had only changed hands twice," explained Burden. "Coming out here, you have a feeling of space and potential. The physical situation becomes a spiritual thing. Artists need to be pioneering."

It's 9:15 on a Friday night and Asher is probably the only faculty member left in the building. "I don't have a theory of time," he explained to me in an interview. "It is a very simple, practical matter. For clear investigations, you need time. That is the only rule of thumb. If you don't have it, you run the risk of being superficial." Asher doesn't remember when or exactly how the class got so long. "People had more to say," he said. "Unfortunately, we can't go on for as long as we would like."

Many artist-teachers think that Asher's epic crits are a sign of madness, but Hirsch Perlman admires the commitment: "I love the idea. It's one thing to put in the unpaid hours, it's another to get the students to do that." Indeed, Asher personally underwrites the hours after 5 P.M., and the students line up to spend them here. CalArts takes pride in the fact that it is a twenty-four-hour campus, yet Post-Studio is an institution within an institution.

Fiona has fallen asleep on the beanbag. She is out cold, with her mouth slightly ajar. Someone's mobile phone meows. The group giggles. A student is holding forth. "This is going to end up a question eventually . . . ," he says.

At 10:05 P.M., one of the dogs groans in the midst of a dream. Another is curled up like a doughnut. Virgil, the crit's smartest dog, ever alert to the goings-on in the room, sleeps but perks up one ear whenever his master speaks. A woman is lying under a table, and it occurs to me that the couple suppressing giggles

to my left must be stoned. Asher's distinct style of pedagogy is revealing itself. This is not a class but a culture. But when is it going to end? For a fleeting moment, the crit appears to be a weird rite engineered to socialize artists into suffering. But I come to my senses, and after twelve hours of sitting, I lie down on the hard floor. Bliss.

As we move further away from the regular workday—the rational, business hour—the class takes on a life of its own. The term *bohemian* has a bad reputation because it's allied to myriad clichés, but Parisians originally adopted the term, associated with nomadic Gypsies, to describe artists and writers who stayed up all night and ignored the pressures of the industrial world.

When I was on the freeway this morning, it struck me as significant that to get to CalArts, one drives against the traffic. There is a huge pleasure in the sense of independence and the unimpeded flow, particularly when the cars going in the other direction inch mindlessly forward in a molten bumper-to-bumper mass. Los Angeles isn't a city so much as a solar system where different neighborhoods might as well be different planets. The real distance from CalArts to the Valley or Beverly Hills is not that great, but the psychological rift is huge.

Several people are sleeping. Apparently it is normal for people to drop off for forty-five minutes, then rejoin the conversation. I become aware that there is no clock in this room, then notice that above each blue door is an EXIT sign, on which someone has written IRAQ. The space is no longer a banal box but a war-torn landscape.

After an hour or two on the floor, I remember why I am here. I'm trying to gain some site-specific answers to some big questions: What do artists learn at art school? What is an artist? How do you become one? What makes a good one? Responses to

the first three questions are wide-ranging, but people's answers to the final question are all about hard work. Paul Schimmel, chief curator of the Museum of Contemporary Art, Los Angeles (MOCA), put it most eloquently: "Talent is a double-edged sword. What you are given is not really yours. What you work at, what you struggle for, what you have to take command of—that often makes for very good art."

If effort and persistence are essential to becoming a good artist, the work ethic of this marathon crit is bound to be good training. One of Asher's favorite expressions is *workable*. When asked about the importance of his class, the artist suggested modestly that it might have something to do with its "spirit of production." Exhaustiveness is necessary. Endurance is also essential. As a student told me during one of the breaks, "When there is nothing to say, that becomes the question, in which case that's a really interesting conversation."

A good art school provides a sense of being somewhere that matters with an audience that matters. "Every artist thinks they're going to be *the one*, that success is around the corner," says Hirsch Perlman. "It doesn't matter what stage they're at, either. That's what's funny about it." In L.A., many invoke the once-neglected video artist and sculptor Paul McCarthy and imagine that eventually they too will be discovered and upheld.

Footsteps echo out in the hall. It's a security guard with a burbling walkie-talkie. Time to get up. I pick a new chair. It's 12:12. Midnight is a magical hour. Asher continues to take his slow notes. The crowd is getting giddy; we're all a bit punch-drunk. A new round of food-sharing ensues—bags of Hershey's Kisses and other chocolate goodies. The conversation is often vague and people get confused, but it still feels open and earnest. The

discussion segues to a video that Hobbs made of a monkey on a bike and everyone falls apart laughing.

Five minutes to one, and no one is sleeping. No one is even lying down. The whole day has been a game of musical chairs—of alignments and confrontations, flirtations and resentments played out in space as well as words. The gaps between comments are getting longer. After a long silence, Asher says, "Is there a bar here?" The comment is absurd. It's a gesture of camaraderie. No goodbye could do justice to the end of this semester-long rite of passage. Asher takes his leave. As the students filter out, many feel bereft and one says, "It's so sad to see Michael go."

The students leave, but I stay to take one last look at the abandoned room. Huge piles of trash-filled grocery bags, orange peels, and snack wrappers litter the floor. The space no longer feels dry and institutional but complicated and inspired. Whether it's deemed art or not, the Post-Studio crit is Asher's greatest and most influential work. It's a thirty-year institutional critique that reveals the limits of the rest of the curriculum. It's also a sound piece where Asher has been at the quiet eye of a multivocal storm. It's a minimalist performance where the artist has sat, listened with care, and occasionally cleared his throat.

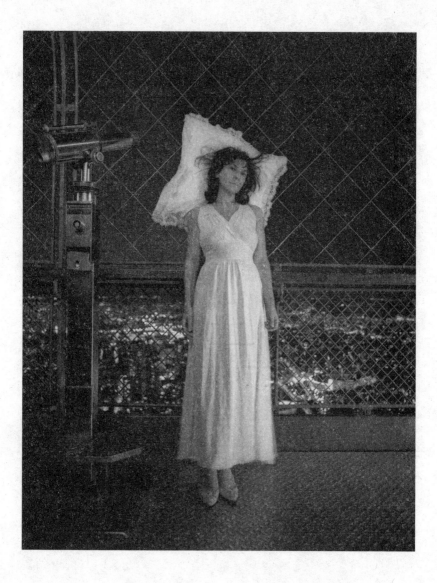

SOPHIE CALLE

Room with a View, 2003

3

The Fair

It's the second Tuesday in June, so I must be in Switzerland. Ten forty-five A.M. The world's most important contemporary art fair opens in just fifteen minutes. In the lobby of this black glass trade-show building, there isn't an artist or student in sight. Collectors—some worth billions, others just millions—stand in a tight throng, clutching their credit-card VIP passes. Many are studying their floor plans, mapping the fastest routes through the maze of gallery stands. In the old days, when art sales were slow, a few collectors would wait until the fair was closing before sauntering in to strike bargains. Nobody would think of doing that now. By noon today, there may be nothing left to buy.

The relentless boom in the art market is a topic of conversation. "When is the bubble going to burst?" wonders an older gent in a Savile Row suit and black Nikes. "We can't answer that question here," replies an acquaintance. "We have entered a macroevent that is uncharted, a scale of expansion unseen since the Renaissance!" The older collector frowns. "Nothing goes on and on," he counters. "I'm feeling bearish. I've only spent, I don't

know, two million dollars since January." For the most part, those heavily invested in art prefer to talk expansion. "A bubble misunderstands the economic realities," says an American. "Only a century ago, no one had a car. Now people have two or three. That's the way it's going with art." A hundred private jets have touched down in Basel during the past twenty-four hours. Rifling through her crocodile handbag, a woman expresses her qualms to a friend: "I feel decadent if I am on the plane all by myself, so I was relieved when a couple of curators agreed to a lift."

The crowd is held back from entering the fair by a barrier of chrome turnstiles patrolled by an officious troop of female security guards dressed in navy uniforms with matching navy berets. It feels like a border crossing. In fact, Swiss security at Basel airport was more relaxed. I hear from more than one source that even dogs are issued photo ID exhibitors' passes, but when I check this with a fair official, he dismisses it as absurd. Absolutely no dogs allowed.

The Swiss enjoy observing the rules as much as those of other nationalities like to break them. It is a cultural difference that has plagued the fair for many years, as collectors and consultants attempt to sneak in early to scour the stands for trophies and negotiate deals before anyone else has had a chance to see the work. The Parisian dealer Emmanuel Perrotin was thrown out of the fair because he gave exhibitors' passes to art consultant Philippe Ségalot and Christie's owner François Pinault. As a compensatory gesture toward Perrotin's loss of face and income, Ségalot admitted to paying him $300,000.

This year Art Basel security is extra-tight, and I've heard of only one surreptitious entrant—Ségalot. The unmistakable Frenchman with the extravagant helmet of hair transformed himself, with the help of a Hollywood makeup artist, into a bald

man and entered the fair on a shipper's pass. Or at least that is the talk. Ségalot is nowhere to be seen in the scrum, so I call his mobile. "*Allo.* Hmmm. Yes, I have heard the *rumeur*," he admits. "Some people *think* they saw me . . . I like people with a lot of *imaginayyy-tion!*"

It is a joy to snoop around an art fair before the feeding frenzy begins. Yesterday I slipped in during installation. The stands of old-time Swiss dealers were still stacked high with crates, not a staff member in sight. Other gallerists were fine-tuning the positions of their art objects and hanging lights, while those who'd had trouble gaining access to this elite club of international dealers were wiping their fingers along the tops of picture frames, checking for dust. "I'm ready for Armageddon!" said Jeff Poe, whose Los Angeles gallery, Blum & Poe, was back in the fair after a forced one-year hiatus. "They never properly explained why," Poe said with a groan. "It's water under the bridge."

Art Basel claims to host *la crème de la crème,* but the all-determining six-dealer admission committee is not without its biases and idiosyncrasies. It tends to favor Swiss galleries and those showing the kind of European contemporary art that some jokingly refer to as "dry *Kunst.*" As a member of the admission committee explained, "The fair is significant from a prestige point of view. If a gallery is not admitted, people might think that it is not as important as another gallery that is. If a gallery is refused next year, it could destroy their business."

Poe and his partner, Tim Blum, are known for discovering artists and launching their careers. Blum is high-strung and edgy, whereas Poe is laid-back, with a slow swagger. Despite their differences, many confuse their monosyllabic names; they forget

that Blum is the brown-haired middleweight while Poe is the blue-eyed, dirty-blond cruiserweight. One of their artists used to call them "Double or Nothing," referring to their symbiotic relationship and the confused setup of the gallery's early days. When I told Blum, a Catholic boy from Orange County, that a rival dealer had complained that there was "way too much dude" in their gallery, he shrugged and said, "I guess they mean we're macho, testosterone-driven, hard drinkin'. Yeah, well, we're raw. We're very West Coast. So our success freaks some people out. We've played it the way we wanted. That's why we are doing well for our artists. We believe in them and we work like motherfuckers."

During installation, in front of an exquisitely crafted three-panel painting called 727-727, Blum was speaking quick-fire Japanese with their star artist, Takashi Murakami. The two men were laughing and arguing about the price of the work. English numbers erupted out of the Japanese flow—"eight hundred thousand," "one million," "one point five," "two million." The canvas depicts DOB, Murakami's cartoon alter ego, riding on a cloud-wave in a colorful world of virtuoso painting styles. The original painting with the 727 title is in the collection of the Museum of Modern Art in New York. The new 727 is more complicated, more accomplished; it's "a culmination and a departure." Several collectors are already vying to acquire it sight unseen, but what is it worth?

"Takashi worked so hard on this painting that several staff quit," said Poe, who grew up in West Los Angeles and was the lead singer in an art rock band called Blissed Out Fatalists before starting a gallery. I mentioned that I had heard that Murakami was going to show with the omnipotent Gagosian Gallery in New York. Poe sat down, gestured me to the empty chair beside him,

and asked, "Where did you hear that?" In the art world, gossip is never idle. It is a vital form of market intelligence.

After visiting Blum and Poe, I explored the stands with Samuel Keller, the director of Art Basel since 2000. Keller is a handsome forty-year-old whose smoothness is aptly signified by his close-shaven head and shiny shoes. As he did his rounds, he praised dealers in French, cracked jokes in gesticulating Italian, and maintained an even, warm tone in German with an irate dealer who didn't like the location of her stand. I believe I even heard him say "Shalom." Keller seems to possess all the best qualities of the multilingual Swiss—modesty, neutrality, internationalism, and an instinct for quality. The impresario also has a knack for appearing not to hold the reins of power. He recruits consultants to help choose which artists get the few coveted "Art Statements" spots (where young dealers put on solo shows of young artists) and enlists curators to help select and install "Art Unlimited" (a cavernous showroom of large-scale museum pieces). Keller even has twenty-two "ambassadors," who act as channels of communication for different territories. If you took all this at face value, he would seem to run the fair like an international summit or United Nations (to use his term) rather than a profit-making enterprise. It's a strategy that has no doubt contributed to Art Basel's ascendancy over older fairs like Art Cologne, the Chicago Art Fair, and New York's Armory Show, which have slipped into being local or regional events.

Art Basel takes place in a purpose-built exhibition hall that the Germans call a *Messe*, or mass, as in "the masses" or worshippers "going to mass." Since the Middle Ages the word has also referred to markets held on holy days, and today, by extension, to any trade fair. The main building is a black glass box on the outside, with a clear-glass circular courtyard on the inside.

Three hundred gallery stands are split between two floors, each arranged in two easy-to-navigate concentric squares. The art is so demanding that the architecture needs to be nearly invisible. The ceilings are high enough to go unnoticed, and dealers praise the quality of the walls, which support even the heaviest works. Most importantly, the expensive, artificial lighting is clean and white. It blends with the natural midsummer sun filtered through the windows of the atrium.

When Art Basel first opened, in 1970, it looked like a flea market, with pictures stacked up against walls and dealers coming in with canvases rolled up under their arms. Nowadays the fair provides a respectable environment. In his light Swiss German accent, Keller explains this approach: "If you go after art and quality, the money will come later . . . We have to make the same decisions as the artists. Do they create great art or art that sells well? With the galleries, it's the same. Are they commercial or do they believe in something? We're in a similar situation."

doesn't great art = art that sells well?

10:55 A.M. Five minutes until the fair opens to the VIPs. Don and Mera Rubell, a zealous pair of Miami-based collectors, stroll into the expensive mob with their adult son, Jason. They're wearing running shoes and baggy trousers with pockets and toggles in unlikely places, like funky grandparents setting out on a long hike. They are so unostentatious, so inconspicuously wealthy, that I've heard them referred to as "the Rubbles." The three look amused by the spectacle of anxious shoppers. Having collected art since the 1960s but with particular vigor since 1989, when they inherited money from Don's brother, Studio 54 co-creator and hotel owner Steve Rubell, they are familiar with the prefair jitters. "When you first start collecting, you're intensely competi-

tive, but eventually you learn two things," explains Don. "First, if an artist is only going to make one good work, then there is no sense in fighting over it. Second, a collection is a personal vision. No one can steal your vision."

Art world insiders take a hard line on collecting for the "right" reasons. Acceptable motives include a love of art and a philanthropic desire to support artists. While it seems that everyone, including dealers, hates speculators, established collectors most loathe conspicuous social climbers. "Sometimes I'm embarrassed to identify myself as a collector. It's about being rich, privileged, and powerful," says Mera. Don listens to his wife with affection, then adds, "There is an implied incompetence. Out of everyone in the art world, collectors are the least professional. All they have to do is write a check." Both Don and Mera have down-to-earth Brooklyn accents. Their heights differ by a full foot. Married since 1964, they rally the conversation between them. "'Collector' should be an earned category," says Mera. "An artist doesn't become an artist in a day, so a collector shouldn't become a collector in a day. It's a lifetime process." *putting artists & collectors on the same plane.*

The Rubells have a twenty-seven-room museum where they rotate displays of their family collection. They also have a research library containing over 30,000 volumes. "We read, we look, we hear, we travel, we commit, we talk, we sleep art. At the end of the day, we commit virtually every penny we make—all our resources—to it," Mera declares with a half-raised fist. "But it's *not* a sacrifice. It's a real privilege."

Although their collection includes work from the 1960s, the family is particularly passionate about "emergent" art, a term that is indicative of changing times. In the 1980s, when people started to feel uncomfortable with the word *avant-garde,* they adopted the euphemism *cutting-edge.* Now, with *emergent art,* anticipation

of market potential replaces vanguard experiment. And a model in which individuals surface haphazardly overthrows a linear history in which leaders advance movements. For the Rubells, nothing gives more pleasure than being there first. They enjoy being the first collectors to visit an artist's studio, the first to buy work, and the first to exhibit it. As Mera explains earnestly, "With young artists, you find the greatest purity. When you buy from the first or second show, you're inside the confidence-building, the identity-building of an artist. It's not just about buying a piece. It's about buying into someone's life and where they are going with it. It's a mutual commitment, which is pretty intense."

When I ask the couple if I can shadow them through the fair to observe their buying, Mera looks horrified. "Absolutely not!" she exclaims. "That's like asking to come into our bedroom."

Eleven o'clock. And the collectors are off, slipping through the turnstiles and past the Swiss security as quickly as their dignity will allow. From behind me an avid collector half jokes, "You're not shoving enough!" Those interested in blue-chip art vanish around the corners at ground level, while those in pursuit of emergent swarm up the escalators. Pulled along with the flow, I find myself upstairs with a good view of the Barbara Gladstone stand. A collector once told me, "Barbara is one of my compass points. There is north, south, east, and Barbara." At Art Basel, the Gladstone booth is in the front row facing the courtyard, an aggressive location appropriate to a gallery that has been in operation since 1980 and sits on top of the ruthless ranks of the New York art world. Gladstone herself has jet-black hair and is dressed entirely in black Prada. One wouldn't imagine that this sophisticated sorceress was once upon a time a Long Island housewife who taught art history part-time at the local university—until she disarms you with her down-home charm.

Gladstone stands erect and gestures gracefully toward two photographs with high production values from Matthew Barney's *Drawing Restraint 9* series as she talks quietly to an older couple and smiles apologetically over their shoulder at a restless collector who is waiting in the wings. She has four staff members artfully posted around the stand, but they too are already trapped in intense exchanges. "The first hour is always exhilarating *and* horrendous," says Gladstone. "It is flattering when good collectors make us their first stop, but it is impossible to have a real conversation. I depend on everybody's good humor." In her gallery, Gladstone enjoys having in-depth discussions about artists' work, but here at the fair . . . "It is like being a whore in Amsterdam," she says. "You're trapped in these little rooms and there is no privacy whatsoever."

Gladstone tends to anchor her booth with a few key pieces. "I don't want it to look like a bad group show," she explains. "The trick is to find a space for everything, so each work has a chance to breathe. It means hanging less and thinking about the thematic connections and the sight lines." Some believe that a good stand should represent an attitude or taste in art; it should declare the gallery brand. "I don't know what the Gladstone brand is!" Gladstone protests, with a laugh. "My taste in art comes out of conceptualism. I know that! Even when I like paintings, they're conceptual paintings. I like artists who have an individual vision, and I want each artist to be seen on his or her own."

"Barbara Gladstone. How are you?" She introduces herself with a girlish tilt of her head and an outstretched hand to the man who has been waiting patiently for her attention. She deftly ignores all the other people trying to greet her. They walk over to a predominantly pink Richard Prince painting that bears a joke about a man walking out of a brothel. "This is the first work in

which Richard took images from 1970s girly magazines and collaged them across the canvas like he did with canceled checks," says Gladstone to the gentleman. "It's a very exciting departure for those of us who follow his work. A signature moment."

Gladstone admits that her agenda is "more complicated than it used to be, now that we take sales for granted." Placing works in collections, "which are formed for the sake of living with and enjoying art," is still paramount. But with the phenomenal growth of the art market, differentiating genuine collectors from speculators (whether they are mercenary collectors whose connoisseurship consists of a knowledge of prices or secondary-market dealers masquerading as collectors) is more difficult. "I used to know everybody," says Gladstone matter-of-factly. "If I didn't know them as clients, then I knew their names. But now there are new people constantly."

At Art Basel, one rarely witnesses a hard sell, but one increasingly overhears something I've come to recognize as a "hard buy." This takes the form of the collector describing his own "unique selling points," including notable works in his collection, the museum acquisition committees on which he sits, the way he is committed to loaning works, and that he often underwrites exhibition and catalogue costs. "Identifying people of consequence— it's an educated guess or a couple of phone calls," explains Gladstone. "The art world is still a village."

Amy Cappellazzo, the Christie's specialist who helped me understand the auction world, saunters into view. Amid the intense dealer-collector interaction, she comes across as exceedingly relaxed. "Fairs are less stressful than auctions," she explains. "There is something about standing before the object you want and the person you're going to buy it from. I can see the appeal of the real-time transaction." Cappellazzo beams, then con-

fesses, "I just bought a great piece!" She tells me how much she loves Gabriel Orozco and recounts how she and her girlfriend have several pieces by the influential Mexican artist. Then, as if remembering that art fairs are an auction house's competition, she adds, "Downstairs, it's clear that dealers are having difficulty coming up with top-quality inventory. I saw a lot of ex-lots . . ." Then the big grin returns. "But, man, I'm happy!" She does a goofy finger-jive, which is interrupted by the *bing* of her Black-Berry. "Excuse me," she says with a wink. "I've got to consult on condition for a client."

Two booths down from Barbara Gladstone is the stand of another dauntingly grand gallerist. In London, Victoria Miro Gallery enjoys 17,000 square feet of exhibition and office space. Here in Basel, the stand is a poky 800 square feet. Gallery direc-tor Glenn Scott Wright is a handsome mix of Southeast Asian and British, and he has one of those hard-to-place accents that attest to years of constant international travel. He's comfortably gay in a world where even the straight men often come across as camp.

There are no prices or red dots on the wall. Such an overt ges-ture at commerce is considered tacky. Moreover, a prospective buyer's query about cost is, according to Scott Wright, "an oppor-tunity for engagement." To a young couple, about a small Chris Ofili painting of a stately black woman with what the artist might call "Afrodisiac" hair, Scott Wright explains, "The Tate owns a group of these watercolors. They're also collected by MoMA and MOCA Los Angeles. In fact, they're incredibly popular with museums." Of course, this one is already reserved, but it could become available. He leans over and, in a hushed voice, shares the price. "I'll give you an extra twenty percent," says the hus-band. Scott Wright looks mortified. Only neophytes offer more

than the asking price. "Please excuse me," he says as he hotfoots it over to a collector who is admiring a punk-rococo vase by Grayson Perry. When gallerists are confident about demand for an artist's work, they wouldn't dream of surrendering it to the first comer or the highest bidder. They compile a list of interested parties so they can place the work in the most prestigious home. It's an essential part of managing the perception of their artists. Unlike other industries, where buyers are anonymous and interchangeable, here artists' reputations are enhanced or contaminated by the people who own their work.

Scott Wright glances up. It's the Rubells. The family roams through the stand without lingering in front of any particular work, then forms a tight huddle. Mera stands tall, with her arms behind her back. Don stoops, with his arms folded across his chest. Jason looks over his shoulder, then whispers. On another occasion Mera told me, "How do you know when you need to acquire a piece? How do you know when you are in love? If you listen to your emotions, you just know." On a more rational note, Don added, "We meet the vast majority of artists, because when you're acquiring young work, you can't judge it by the art alone. You have to judge it by the character of the person making it." And Mera elaborated: "Occasionally meeting an artist destroys the art. You almost don't trust it. You think what you're seeing in the work is an accident." Then Don wrapped it up: "What we're looking for is integrity." All three Rubells peek over their shoulders and confer one last time. Jason goes over to Scott Wright, shakes with one hand and hugs with the other. Such behavior may appear peculiar, but it is typical of those who don't want anyone to know where their acquisition interests lie for fear of attracting competition and sending up prices.

Victoria Miro herself has not yet arrived. I once heard a rival

dealer refer to her absence as an "artistic act." Miro is perceived as aloof, or even shy, which is unusual in one who puts her name over the door. She claims not to enjoy the fairs, so she often arrives late and leaves early. Like many dealers, she sees her primary role as choosing, mentoring, and curating her artists. Collectors may come and go, but a strong stable of artists with developing careers is essential to a gallery's success. In the business of museum-caliber art, supply is more delicate and dicey than demand. *status*

Scott Wright sees the Basel stand as an "interactive advertisement, which costs about the same as a year of full-page ads in *Artforum*." On the coffee table in the center of the Miro stand is a copy of the extra-thick summer issue. Knight Landesman, one of *Artforum International*'s three publishers, just dropped it there. He's five-foot-six but, dressed in a bright yellow suit and yellow-and-white check tie, he's impossible to miss. All of his suits are made by a Hong Kong tailor in red, yellow, royal blue, or plaid fabric. Everyone knows Knight. Not only has he worked at the magazine for almost thirty years, he treats advertising sales as if it were performance art. "Twenty-five years ago, most galleries were national," he tells me in sober contrast to his attire. "Nowadays there is hardly a gallerist anywhere that just shows the artists of his or her country. It would mean they were provincial and limited." I follow Landesman as he talks. "Lately the globalization of the art world has accelerated. And art fairs have been good for our business," he says. "For example, a Korean gallery took out an ad for the first time to tell everyone it's in Basel." Distracted by a pair of beautiful women, Landesman pauses for a moment of aesthetic appreciation, then concludes, "Both Art Basel and *Artforum* were prescient in defining themselves as international."

I find myself on the corner stand of another London gallery.

In contrast to Miro's colorful, painterly booth, Lisson Gallery's is minimal and sculptural. Its owner, Nicholas Logsdail, was introduced to art by his uncle, Roald Dahl, who used to take him gallery hopping in London's Cork Street in the 1950s. The first American whom Logsdail ever met was Walt Disney, who had come to their English country house to buy the rights to Dahl's *Gremlins.* The imposing dealer boarded at Bryanston, then studied art at the Slade School of Fine Art in London. He's never been a flashy dresser, and despite his wealth he lives in a studio apartment above one of his two gallery spaces. He is smoking a cigarette and studying a deep red Anish Kapoor wall sculpture with a slightly off-center hole. The stand is busy, but he ignores the mayhem. He laments the "hurry-hurry collectors who go to the hurry-hurry galleries to buy the hurry-hurry artists." He likes artists "who are on a slow burn, very good, very serious, not in the fast track, but pursuing their own artistic interests with tenacity, quirkiness, and confidence."

In business since 1967, Logsdail first took a stand in Basel in 1972, when he was twenty-six, and he has never missed a year since. "It's almost like science fiction, the déjà vu feeling of being in a time warp, returning to the same place at the beginning of June every year," he says. In the early seventies there were only two fairs with international ambitions—Cologne, which started in 1969, and Basel. In the past fifteen years, however, international art fairs have proliferated. Now Lisson Gallery shows at an average of seven fairs a year, exhibiting different kinds of work in different places—placing an accent on its Spanish and Latin American artists at ARCO in Madrid or an emphasis on younger American work in Miami (where Art Basel runs a sister fair). The footfall at the combined fairs is such that 50 percent of the gallery's turnover is done through these events.

Logsdail distinguishes between galleries and what he dispar-
ages as "dealerships." The former discover and develop artists;
the latter trade in art objects. "The art world has no rules," he
explains. "So I attribute the longevity of the gallery to the fact
that I wrote my own." Many successful gallerists see themselves
as mavericks. Some are artist-oriented dealers—they generally
go to art school and give up being an artist when they discover
they have an aptitude for organizing exhibitions. Others are
collector-focused dealers—they tend to apprentice at Sotheby's
or Christie's and often start out as collectors themselves. A third
set might be called curators' dealers—they study art history and
excel at scholarly justifications of their artists' work. In any case,
there is no set training or certification. Anyone can call himself
or herself a dealer or gallerist.

Logsdail entertains me by cataloguing the less credible col-
lecting types. "Speculators are like gambling addicts. They study
the form, they read the magazines, they listen to the word on
the street, they have hunches," he asserts. "We complain, but the
art world couldn't function without them." Then there are the
trawlers. "It's like the fishing industry," he explains as he wrinkles
his nose. "They are out there with a big net, so they don't miss a
thing and they can always say, 'I was there, I have one, I bought
that in 1986.'" By contrast, "buying in depth," or the practice of
acquiring many works by the same artist, is often cited as a very
respectable way to collect.

"A collection is more than the sum of its parts. It creates some-
thing unique," says Logsdail. The worst collections are scrambled,
disjointed, and fickle. The best have "a driving force." Logsdail
leans in mischievously and mentions the name of a collector. "He
buys with his dick," he says. "It isn't my kind of collection, but it's
a great collection. Very coherent!" he adds with a smirk.

2:00 P.M. Time to meet an Italian collector for lunch. Upstairs, in the VIP room, the horde is intent on getting its sushi *now*. After a lot of insistent finger-raising and intense eye contact, we finally order our food. Sofia Ricci (not her real name) is a full-time collector. She spends her days in galleries and museums, managing the arrival and departure of works to and from her collection, sorting out the insurance and the conservation. Still, because she and her husband own only about four hundred major works (as opposed to a couple of thousand) and because they don't usually spend more than 300,000 euros (rather than several million) on any given piece, she does not always find herself at the top of the international pecking order.

How's it going? I ask.

"*Va tutto male,*" she replies. "Everything is *so* expensive and every deal is *so* exhausting. We have bought some good art, but there is one artist—I cannot tell you who—that we really want to buy. On one stand there is an A-plus work, but it is on reserve and we don't find out whether we can have it until five o'clock. On another stand there is a B-minus work by the same artist. It represents a point in the development of the artist's oeuvre. It would complement what we already have, but it is not an iconic piece. The problem is that the B-minus dealer will hold the reserve only until four o'clock. We have got to slow down one dealer whilst we hurry up the other. *È terribile!*"

How likely are you to get the A-plus work? I ask.

"We are supposed to be second in the queue. We have known this dealer for a long time," she says woefully. "All I know about the collector ahead of us is that he has his own museum. We are going to have to set up a public foundation in order to compete for the best works." More and more collectors are opening their own

exhibition spaces. Their official reasons are philanthropic, but their covert motives have more to do with marketing. The work of living artists needs to be promoted if it is to generate consensus. Moreover, collectors of contemporary art have to be proactive about developing the aura of their collection. In our cluttered multimedia culture, a significant collection does not just arise; it is made.

Why do you collect? I continue.

"I'm an atheist, but I believe in art. I go to galleries like my mother went to church. It helps me understand the way I live." She pauses; then, as if too tired to restrain herself, she adds in a low voice, "We're so passionate about art that it has become a bigger part of our financial portfolio than we intended. Art collecting is an addiction. Some people might think I am a shopaholic who has graduated up from Gucci to Pucci to art, but we really don't look at it that way."

When Ricci lines up for free ice cream and espresso (collectors can't be expected to carry small change for such trifles), I resume my participant observation. No one is paying a blind bit of notice to the gargantuan diamond necklaces under glass in the makeshift Bulgari store. The bling will not distract the hardcore art crowd from their purpose today. The time-share jet service NetJets has its own VIP room within this VIP room. "It is an oasis; there is no art on the walls," says the company's receptionist with a beatific smile. The organizers of London's relatively new, extremely successful Frieze Art Fair stand at the edge of the room. Like me, they seem to be analyzing the scene.

3:30 P.M. I head back to the stands. The clamor of the hall has died down. People roam, less stressed. In the distance, down the

long stretch of industrial carpet, I catch sight of the wild white hair and beard of John Baldessari. He towers above the collectors, in much the same way that biblical characters are depicted in altarpieces as twice the size of their patrons. I imagine that they are asking the great artist about the meaning of art and life. Later he tells me that he was entangled in a stream of small talk.

Five galleries, each covering a different geographical territory, are representing Baldessari's photo-based dadaist work here. Nevertheless, it is often said that "an art fair is no place for an artist." One of Baldessari's oft-repeated jokes is that an artist entering an art fair is like a teenager barging into his parents' bedroom while they're having sex. "At fairs, gallerists are reduced to merchants," explains Baldessari, "a role in which they'd rather not be seen by their artists. The alarmed expressions on the parents' faces say, 'What are you doing here!'"

Artists tend to view art fairs with a mixture of horror, alienation, and amusement. They feel uneasy when all the hard work of the studio is reduced to supplying the voracious demand, and they wince at the sight of so much art accompanied by so little substantive conversation. When I ask Baldessari whether he has been at the fair since it opened this morning, he replies, "Are you kidding? I wouldn't set foot in the fair anytime before lunch. I'd be trampled. I'd be an innocent to the slaughter."

Last night Baldessari had a fair-related nightmare and subsequently very little sleep. In his dream, he was flattened. He became a portrait of himself, cut up and pasted together. "I vaguely remember being physically examined by a lot of doctors. I was under visual and physical scrutiny," he says in his gravelly voice. "Nothing was said, but they were all staring at me."

For many years Baldessari stayed free of the burden of social-

izing with collectors. "I came out of a generation where there was no connection between art and money, then all of a sudden, in the 1980s, money came into the picture," he says. "Before that, collectors were very scarce, so when they turned up, I just reacted. I didn't want to have that connection. It was like being seen with a hooker. I wanted to stay pure. I thought, 'You buy my art, not me. I don't want to be at your dinners.'" He takes a deep breath and looks around the fair. "Then slowly I realized, hmmm, that collector, he knows a lot about art, he's not so bad. One at a time, gradually, it dawned on me that you can't condemn by type." Still, Baldessari sees the art market as unwholesome and irrational. When it comes to the relationship of artistic and monetary value, "You can't use money as an index of quality. That is a fallacy. That will drive you crazy!"

This is one of the reasons Baldessari has taught in art schools for all these years. For him, teaching has been a way of maintaining independence from the market (so "I could change my art whenever I wanted") and a way of getting to know the future through the rising generation ("whether you like it or not, you might as well get to know it early," he says). Baldessari is adamant about preserving his artistic autonomy; if you do your own thing, you might be a step ahead of the market. As he tells his students when they're going through hard times, "You have to make the new work to sell the old work."

As Baldessari drifts away, I bump into an American curator. He is acting as a sounding board for his museum's trustees and keeping track of which patrons are buying what, for the works bought here today could eventually be loaned or given to the museum. He's also trying to look at the art so that, at the museum's reception tonight, he'll be able to respond to the recurring question "So what have you seen? What should I look at?" Normally deal-

ers are happy to give curators special attention, but today their focus is on collectors. As the curator explains, "Out of a sense of courtesy, I try to hang back on the first day, unless I am negotiating a discount for one of our trustees. It's a six-day fair—I'll have my conversations with dealers tomorrow or the day after."

It's almost five o'clock. By now I'm over-refrigerated by the well-conditioned air. I'm thirsty, and my handbag feels heavy. I'm attracted to a large-scale self-portrait by Sophie Calle. In the black-and-white photo, she's standing on top of the Eiffel Tower in her nightgown with a pillow propped up behind her head. Called *Room with a View*, the work refers to a night she spent atop the Parisian landmark during which twenty-eight different people read her bedtime stories. At this moment, I'm desperate to walk into its fictive space. Is it an amazing image, or am I fascinated because it acts as a balm to the fair's confusion of visual stimuli and social interaction? I'm not sure; I have fair fatigue.

I ricochet aimlessly around the stands until I find myself at the booth of Blum & Poe. The two men have scrubbed up well for the big day. Blum is wearing an assortment of rarefied made-to-measure clothes by Italian designers, no tie. Poe is wearing a pinstripe Hugo Boss suit and brown suede shoes, no tie. While Blum chats with the Hollywood agent and collector Michael Ovitz, Poe ambles over and tells me that they've sold *everything*.

Who bought the Takashi Murakami painting? I ask.

"I can't say," he replies firmly.

Then tell me how much, I cajole.

"One point two million, but officially one point four," he says, wringing his hands in mock glee. Here the discrepancy between the real price and the PR price is a respectful embellishment compared to the shameless whoppers told by other dealers. For example, Charles Saatchi has manipulated perceptions and

gleaned headlines for work by artists he owns by inflating prices by the millions. When he sold Damien Hirst's *The Physical Impossibility of Death in the Mind of Someone Living* (otherwise known as "the shark"), a "spokesman for Mr. Saatchi" said he'd received an offer of $12 million, when in fact the deal was only for $8 million. I see Saatchi out of the corner of my eye, walking with his hands behind his back, a short-sleeved linen shirt draped over his well-fed paunch, while his wife, Nigella Lawson, a celebrity chef and "domestic goddess," smiles professionally at a painting that looks as if it were made with rather too many ingredients.

"I need a beer," proclaims Poe. Just then we hear the tinkle of glasses. A waitress dressed in black with a white pinafore pushes a champagne cart around the corner. "That'll do." He beams, grabbing a bottle of Moët and four glasses. We take a seat at the desk at the front of the stand.

When I ask Poe what makes a good dealer, he leans back and thinks for a moment. "You have to have an eye—a savantish ability to recognize work that is symptomatic of an artist with real intelligence, originality, and drive." While artists tend to be critical of the notion, dealers and collectors usually revere a "good eye."* The resolutely singular expression evokes a connoisseur with a monocle or a Cyclops with infallible instincts. While its opposite, a "good ear," is disparaged for being dependent on the opinions of others, an eye enjoys the thrill of recognizing something ineffable, picking the best artists and, from within those artists' oeuvres, the best work. "Then you've got to stick with your artists," continues Poe. "Look to the horizon, point at the genius,

*For example, artist Dave Muller told me, "I prefer the expression *stink eye*, which is when someone always picks the wrong thing. I am skeptical of the tastemaker stance. It is fortune-telling, trying to recognize what will be significant before it is."

and get everyone behind you to nod in agreement." He stares into his champagne as if he could read bubbles like tea leaves, then looks up. "You also have to have a good business sense. If two plus two makes three, you're fucked." With regard to actually selling the works, Poe adds, "You have to do the chat. Create narratives and riff. The market is demented—unregulated but with loads of pretensions about how we are supposed to behave."

Poe believes that an art fair can be a tough environment for an artist. "If they are any good, they make art because they have to," he says. "They don't do it to please the market. So for some artists, hanging out here can mess with their heads. Also, let's face it, this is not the optimum place to exhibit work. The subtle notes in artworks are drowned out by the cacophony." Poe chuckles. Impressed with his own music metaphor, he gives it another spin. "It's like a free jazz concert in here, with a drunken monkey working the mixing board."

A German collector interrupts with a pressing question about an abstract painting by Mark Grotjahn. While Poe is taking care of business, I savor the problem. Dealers are middlemen. While they like to supervise direct contact between artists and collectors, they have greater anxieties about chance encounters between their most lucrative artists and rival dealers who might be looking to poach them. In this regard, fairs are dangerous. Plus there's still an ideological antithesis between art and commerce, even if the two are inextricably intertwined and even when artists make the market an overt or ironic part of their practice. In a world that has jettisoned craftsmanship as the dominant criterion by which to judge art, a higher premium is put on the character of the artist. If artists are seen to be creating art simply to cater to the market, it compromises their integrity and the market loses confidence in their work.

The stand has been filling slowly, and suddenly it's packed. Blum looks at Poe in exasperation, as if to say, "Get off your butt and give me a hand here." I'm about to leave when I see David Teiger, the collector who came to smell the aroma of the Christie's evening sale. Teiger tells me that he has finished his buying for the day, his consultant has gone off with another client, and his girlfriend, whom I know to be blond and half his age, won't arrive until tomorrow. He's in need of a companion. He admits that it was he who owned Murakami's original 727 painting and gave it to MoMA. Then we head downstairs to look around the blue-chip galleries with their more expensive art.

Teiger has been collecting on and off since 1956 and has developed a wise eye. "There are learners and there are the learned," he explains. "The former like contemporary art, living artists, the art of their time. The latter like the art of the past." As he approaches eighty, he wants more than ever to keep his mind alive, and emergent art fulfills that desire. Teiger has a certain genteel humility. "I'm just an ordinary rich person," he says. "These young billionaires with their private jets—they're in a different league. My 'new money' is now 'old money,' which nowadays means 'less money.'" He laughs. Teiger describes his collection as "life-affirming," then displays extreme modesty when he says, "I don't know if I have a collection. I have a load of stuff."

His self-effacing joke betrays a deep-seated anxiety shared by many collectors. More people than ever are buying contemporary art, and chances are that most of it is historically insignificant. It may be personally meaningful, intelligent, even edifying, but in the long term many of these collections will end up looking like the tattered silks of an age gone by or the archeological remains of an ancient garbage heap. They won't be definitive or influential. They will not have changed the way we look at art.

As Teiger and I enter each stand, dealers jump to their feet
and come over to welcome him. At a time of day when many
are exhausted and can barely raise the energy to answer other
people's questions, it is entertaining to see them so lively.
Teiger always finds something complimentary to say. Even on
a rather disappointing stand, he'll commend the dealer on the
well-made display cases. There appears to be a lot of genuine
affection between him and these dealers, even though he hasn't
bought anything from them today. The dealers all thank him for
visiting their stands. For me, the situation is less comfortable.
Teiger plays the gentleman and introduces me by first and last
name. The dealers are all exceedingly polite, but they obviously
think I'm his latest moll. At one point a senior New York dealer
whispers in Teiger's ear. I can't hear what they're saying, but from
the exchange of looks and the glance over at me, I can tell the
dealer is asking something like "Is she the latest addition to your
collection?"

Teiger's phone rings symphonically. The chief curator of a
major American museum is calling. He has a long, affectionate
chat with her. He informs her of his activities but doesn't explic-
itly seek her approval. Of the mysterious major acquisition made
today, he teases, "If you don't like it, then"—Teiger mumbles a
name—"will take it." (The person mentioned is the chief curator
of a more adventurous, rival institution with an excellent collec-
tion of postwar art.) After that call, Teiger has a long conversa-
tion with another curator from a prominent public space that has
hit hard times. He obviously loves these relationships. He enjoys
being a player in the power game of art, particularly at this level,
where patronage can have an impact on public consciousness. As
he puts away his phone, he admits with a fiendish grin, "My goal
is to acquire works that great museums letch after."

I press Teiger to show me his newly acquired masterpiece. We walk down one aisle, around a corner, and then *bang*, it's towering over us. A steel sculpture, twelve and a half feet high, with a gold mirror finish. Jeff Koons's *Elephant*. It looks like a giant number 8 with a phallic crown. We can see ourselves reflected in its lustrous finish, and as we step back the whole fair appears to be a gold bubble. A girl of seven or eight notices her reflection in the sculpture, stops in her tracks, and sticks out her tongue. She frowns. She gnashes her teeth, flares her nostrils, moves her eyebrows up and down, then skips off to catch up with her parents.

8:00 P.M. Less than an hour to go before the fair closes. Among the weary shoppers trudging in the direction of the front exit, a lone cowboy walks with a spring in his step. Sandy Heller greets me with a phone in one hand and a fair map in the other. The thirty-four-year-old art consultant is wearing a button-down shirt, with the sleeves rolled up and the tails hanging out. "It looks like we're going to come away with about forty good pieces," he says triumphantly. Heller manages the art collections of six Wall Street money managers, several of whom are billionaires. They're all aged between forty and fifty. "They're family men," says Heller. "They all know and respect each other. Some are close friends." Although Heller won't go into detail because it would violate his stringent confidentiality agreements, it is well known that one of his clients is Steve Cohen, whose $500 million art collection includes Damien Hirst's shark. According to *Business Week*, Cohen's hedge-fund firm "routinely accounts for as much as 3 percent of the New York Stock Exchange's daily trading" and its credo is to "get the information before anyone else."

I ask Heller to tell me about his day.

"My day started six weeks ago. You can't imagine the work I put into Art Basel. I have four people in the office. We're all working like mad going into the fair. We're on the phone every day, getting information, sifting it, then passing it on to our clients," he says. "So this morning, I have my checklist. I run around and say, 'Okay, we'll buy this, we're passing on this, we'll buy this, we're passing on that.' We don't buy anything without looking at it in the flesh. What's great about a work often doesn't show up in a JPEG—plus I'm a condition freak."

We find a bench. Heller sits forward with his elbows resting on his knees as if he were a baseball player in the dugout. "By afternoon you can have more complicated conversations," he continues. "Dealers whose programs I respect who don't know me, I talk to them and say, 'Look, I'm a human being and these are the clients I represent. We're not flipping things. We are not speculators.'" Hedge-fund managers are relatively new arrivals to the art world, so some worry that they might be acquiring art as if it were stock in order to turn a profit. Others argue that they're above it; hardworking billionaires have no need to make a few million on art. "What starts them collecting is a curiosity for a life fully lived," says Heller. "And nowadays, in America, it's what you do if you have money, just like it has been for decades for Europeans."

Heller's phone rings. "Hold on a sec. Don't move," he instructs. "Hey," he says warmly to his caller. "Takashi gave them a masterpiece to mark their return to Basel," I overhear him say as he walks out of earshot. He paces the floor in the distance. He meanders back as he's saying goodbye.

"You bought the Murakami!" I declare.

"No comment!" says Heller aggressively. His face clouds, then clears. "All I can say is that everyone's blown away by that new

commodifying of art. ↑

727 painting. You don't usually see primary material that good at an art fair. Everybody's talking about it. Price is a little heavy. Maybe it's worth it."

Heller tells me that he works for an annual flat fee rather than commissions. "Advisory has the potential to be a sleazy business," he says. "The mindset of the guys I work for . . . if I'm advising them to pull the trigger on a twenty-million-dollar painting, there is going to be a shred of doubt if they know that I'm getting a percentage of the purchase price. It's an inherent conflict of interest."

The trickle of people abandoning the fair has turned into a flood. We get up and start heading out too. "Wanna know the difference between a great dealer and a great adviser?" Heller asks. "A great dealer does a good job for the collector but a great job for artists. A great adviser does a good job for the artists but a great job for the collector." Heller puts his fair map in his pocket. He's a telltale combination of cocky and diffident. In the old days, consultants were employed chiefly for their art-historical knowledge. Nowadays the onus is on negotiating the difficult deal. Enabled by trust on one side and a strong network of relationships on the other, advisers in the new art world are often in a strenuous situation where speed rather than contemplation is the key. For Heller, the rewards are unique and obvious. "The money is a by-product," he asserts. "It's about being a part of the legacies that I'm helping to build."

The balmy evening air hits us as we open the front doors of the *Messe*. Heller waves goodbye while I hang back to watch the exhausted crowd. Standing still and looking lost amid the exodus is Jeremy Deller, a Turner Prize–winning British artist with a strong curatorial following. Here to install his room at "Art Unlimited," he has stayed on for the first day of the fair. He wears

shoulder-length hair, oversized sandals with bright white socks, and a deep red corduroy jacket. Apart from the remote possibility that he might be an eccentric left-wing curator who's had the misfortune to lose his luggage, Deller is coded as an artist from head to toe.

Did you have a good day? I ask.

"It's been a funny day, just floating about," Deller explains. "It's chaotic, bewildering. The amount of art in the world is a bit depressing. The worst of it looks like art, but it's not. It is stuff cynically made for a certain kind of collector. I'm not a very financially motivated person. If I were, I wouldn't be making the art I do. My art is almost unsellable." For artists who don't make easily retailed commodities—because they're ephemeral, invisible, or purely conceptual—public institutions are often the most important patrons. After a mind-numbing day at an art fair, many art aficionados crave nothing more than a well-thought-out museum show.

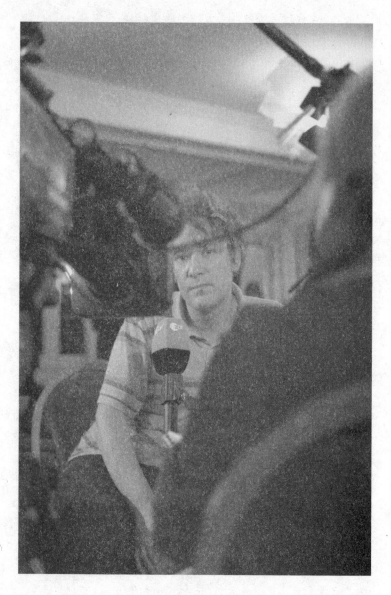

PHIL COLLINS

shady lane productions presents
the return of the real, 2006

4

The Prize

9:30 A.M. on the first Monday in December. Tate Britain, the original Tate museum, which sits upriver from its sexier younger sibling, Tate Modern, doesn't open to the public for another half-hour. Inside the museum, in a 1970s extension to the original Victorian edifice, Sir Nicholas Serota, the Tate's director, and his four-member jury are taking one last, all-determining look at the exhibitions of the four artist-finalists for the Turner Prize, the world's best-known contemporary art competition. The judges don't say much to each other. They contemplate the works and grapple with their opinions. One later admits to me that he alternately makes an effort to keep an open mind and rehearses arguments in support of his favorite. How does one compare apples, oranges, bicycles, and bottle racks?

Outside, a statue of Britannia sits on top of Tate Britain's neoclassical façade. With a helmet on her head and a trident in her fist, you wouldn't think that contemporary art was her thing. Some hundred feet below the battleaxe's gaze, on the stone steps of the museum, Phil Collins, a video artist, is smoking a Benson

& Hedges. He was at a pay phone in the subway in Brooklyn when he found out he had been nominated. "I was incredibly startled," says Collins. "The prize might be a stage for mockery— I might make a fool of myself on a grand scale. I imagined a scene out of a Brian De Palma movie. I felt like Carrie, covered in pig's blood." Collins, thirty-six, has an asymmetrical New Wave–ish haircut and wears carefully culled thrift-shop clothes. "It took me a week to accept the nomination. I had to think hard about the joys and threats of exposure." He waves his cigarette in the air. "Of course, when Carrie is covered in blood, she locks the doors of the gym and kills everybody. So . . . not everything is bad." Collins is deadpan. He waits five seconds before he arches his eyebrows and cracks a smile. He takes three quick puffs, drops his butt, grinds his foot into the ground, and says, "I've got to get to work."

At ten o'clock, as visitors pass through the museum's front entrance, the Turner Prize jury sits down in a vaulted boardroom used for trustee meetings. Today they must determine a winner. Later this evening, one artist will be presented with a check for £25,000 by a celebrity host at an awards ceremony broadcast on national television. Past presenters have included Brian Eno, Charles Saatchi, and Madonna, who distinguished herself by shouting "Motherfuckers!" on live TV. Tonight the prize will be presented by Yoko Ono. The runners-up will sit on the sidelines, trying to look upbeat, and collect consolation prizes of £5,000 each.

The Tate inaugurated the Turner Prize in 1984, and its history is in part a tale of newspaper headlines. In 1995, Damien Hirst won the prize and made news on several continents for a sculpture in which a real cow and its calf were bisected from head to tail and displayed in four tanks of formaldehyde. The

work was called *Mother and Child, Divided.* In 1999, Tracey Emin received so much media attention for her entry—an installation that included her own unmade bed, littered with bloodstained underwear, condoms, and empty liquor bottles—that many people believe that she won the prize, even though she was only a finalist. And in 2003, Grayson Perry, whose principal medium is ceramics and who likes to wear dresses befitting a Victorian six-year-old, accepted his award by saying, "It's about time a transvestite potter won the Turner Prize!"

For the past several years, the focus on current art has been such that no one waits for history to make decisions about what is great, good, or simply competent. In an ideal career narrative that starts with graduation from a respected art school and culminates with a solo retrospective in a major museum, prizes are important plot points, clarifying an artist's cultural worth, providing prestige, and pointing to the potential for long-lasting greatness.

While most art prizes are little more than a line on an artist's curriculum vitae, the Turner Prize is a national event; people take sides, argue about the contest at dinner parties, and even bet on who's going to win. The prize process is the same every year. In May, four artists are shortlisted by a jury of four judges chaired by Serota. The artists must be younger than fifty, based in Britain, and have attracted the jury's attention with an outstanding show sometime in the previous year. In October, each of the four nominees opens an exhibition in a grand room at Tate Britain. Eight weeks later, usually on the first Monday in December, the jury reconvenes and chooses a winner.

This year the nominees for the Turner Prize are diverse. In addition to Phil Collins, the video artist, there is Rebecca Warren, a sculptor; Tomma Abts, a painter; and Mark Titchner,

an artist who works in many media. One morning in October, several dozen journalists and photographers turned up for the press preview of the Turner Prize exhibition. Rebecca Warren's room contained three types of sculpture: gestural figures made of bronze, unfired clay forms, and display cases that held bits of detritus, including a cherry pit and a used cotton ball. The bronzes were like Alberto Giacomettis that had been given a good meal, a spliff, and a sex drive. The clay pieces had a look that was more preschool than art school.

A petite curator in low-rise black jeans that revealed a hint of midriff briefed the crowd about Warren's work. "These female approximations embody unleashed and exuberant creativity," she said. "They revel in distortion and degradation." She added that Warren's influences included R. Crumb, Edgar Degas, and Auguste Rodin. The press people weren't buying it. They balked at the absence of skilled craftsmanship. "Unfired clay?" one murmured. "Is that half-baked or entirely unbaked?" To a BBC Radio 4 presenter, I mentioned a memorable display of Warren's work at the Saatchi Gallery—a large room filled with headless female figures with oversized tits and asses. His quick retort: "But *these* things are all hips and elbows." Then I suggested that Warren had made an entirely new body of work for this exhibition, so perhaps we needed to give it a little time. "It's growing on me, the same way you get used to a headache," he replied.

Selling for high prices and winning prizes are two of the most newsworthy things an artist can do—hard facts in a life of relatively unquantifiable achievements. Additionally, in Britain, the press never tires of the question "Is it art?" and finds it impossible to resist sex jokes. So the photographers in the Warren room cheered up a bit when they discovered the suggestion of a few breasts and, better yet, erect nipples protruding from the

mounds of gray clay. The writers, however, were grumpy. They'd received the news that neither Warren nor the other female nominee, Tomma Abts, was willing to give interviews. I'd already had a conversation with Warren's London dealer, who'd told me that I could speak to her "as long as it is entirely off the record." Unfortunately, "Yes" turned into "We'll see," then finally "I'm sorry." When I called an acquaintance who was a close friend of Warren, hoping that he'd put in a good word, he said, "She doesn't need to talk to you. She is going to win anyway!"

The Turner Prize consecrates and desecrates artists at the same time. For many artists, the opportunity to exhibit in the hallowed rooms of Tate Britain, in a show that attracts 100,000 ticketed visitors, is too enticing to pass up. For others, the brutal scrutiny, the possibility of public loss, and/or the ideological compromises are too great, so a string of refuseniks has accumulated in the shadow of the award. This year, for instance, a twenty-nine-year-old Scottish painter named Lucy McKenzie turned down a Turner Prize nomination. McKenzie has worked as a porn model and her oeuvre is sometimes sexually explicit (one painting shows her eating a bowl of soup below a framed drawing of a woman masturbating); the tabloids would certainly have taken an interest. According to a friend, McKenzie was unwilling to "compromise the flexible and critical dialogue" around her work.

Phil Collins's work wrestles with media themes, so despite his initial anxiety about being nominated, he thought the prize could be an ideal platform. A few days after the press preview, I was following Collins through Tate Britain when he stuck his head in Room 28 of the permanent collection, where two video screens were playing his 2004 piece *they shoot horses,* a moving depiction of nine young Palestinians in a dance marathon in Ramallah. In the video, they wriggle and twist, occasionally belly-dance, and

eventually heave and drag their tired bodies to international pop tunes with lyrics like "Set me free, why don't you, babe."

Collins walked on, through the magnificent golden stone Duveen Galleries, toward the Turner Prize rooms, until he encountered a museum guard. "Hello, darlin'. Where are you today?" he asked. The sixty-something woman, dressed in a Tate-issue burgundy shirt and black skirt, replied like a longtime Londoner: "I'm in room nine'een this mornin', but I should be in twen'y-eight this af'ernoon." She is often stationed outside *they shoot horses*, and she reports viewer reactions back to Collins. The work in the darkened room seems to encourage the subversion of museum etiquette. People don't just watch the video; they dance, sing, lie down, sit and sob, even French-kiss. "There was a bunch of schoolkids in yesterday," she said. "Wanted to know why they was such bad dancers."

Collins continued through the galleries, making his way to his "office," which was installed as part of his Turner Prize exhibition. He disappeared through a hidden door and emerged on the other side of a large pane of glass, in a kind of war room of computers and telephones with a coral-red carpet and peach walls. His *shady lane productions* team was there, researching a video called *return of the real*, about people whose lives have been ruined by appearing on reality television programs. One woman was answering a hotline that Collins had set up for victims. Another was cutting an article out of a newspaper, while a third squinted at a computer screen. It was the first time in the prize's history that an artist had effectively moved his studio into the museum. Regular museum-goers may see a lot of art, but they rarely see an artist at work, and this space subverted expectations of paint-splattered workshops. Collins turned and cast an amused eye over his onlookers, then gestured me over to a

small sliding window, the kind one might find in a doctor's office waiting room. He poked his head out. "I couldn't normally afford this kind of real estate. I'm instrumentalizing the prize, using its spectacle as a way of realizing a work." He chuckled and then added, "I needed to be a victim of my own logic, so here I am—a monkey in the zoo."

A few days later I met Collins at a pub under a theater in Charing Cross Road. A century's worth of smoke mingled with an up-to-the-minute deodorizer in the basement air. It was quiet, but populated by a handful of characters for whom life was obviously a stage. We took a seat in a dimly lit crimson booth at the back of the bar. As I switched on my digital recorder, I asked Collins to say something so I could check my recording levels. "My name is Phil Collins—not *the*, just *a*," he said. "That's what I have to say all the time. If you call for a taxi or a pizza and you say your name is Tina Turner, they're just like, 'Yeah, right, fuck off.' It is like a curse." Collins lit a cigarette and leaned back. He had just come from a "home visit" where he had done a preliminary interview with a reality TV subject—a woman who, after appearing on the show *Wife Swap*, found that her son was being beaten up in the schoolyard.

Collins is fascinated by survival and what he calls the "specific beauty of people living in situations of horror." Although he officially lives in Glasgow with his boyfriend and their Dalmatian, he spends most of his time traveling to war-torn cities—Belfast, Belgrade, Bogotá, Baghdad—and making elaborate videos with the locals. In *baghdad screentests,* for example, local Iraqi men and women sit in front of his camera, fidgeting, flirting, and staring. The piece was filmed before the 2003 invasion, and it's impossible to watch it now without wondering what has become of the participants.

Collins ordered a round of drinks, then realized he had no cash. He doesn't have a credit card or a mobile phone. He has never driven a car, and until last year he didn't own a washing machine. Although his art relies on his extreme sociability, Collins doesn't know many artists and rarely goes to "private views" (the rather closed British term for openings). "I found art school to be liberating, but the commercial art world . . . is there anywhere you could possibly feel smaller? It's the only place where you can give away free booze and no one turns up." Collins slid his chin so far into his hands that his face scrunched up. "I can't bear it when someone says, 'I have to make art or else,'" he said. "That is a very privileged thing to say." Collins said he didn't feel much rivalry about the prize. "I have no interest in pushing to the front of the queue. I would rather somebody else got off the train first." He stared into a well-used cut-glass ashtray, then looked up. "Anyway, I'd rather not recognize the terms of the game. Award-winning art? The category doesn't apply. You might find a great work of art in someone falling over in a supermarket. That might be the most extraordinary visual encounter of your day."

Housed next to Tate Britain in a red brick building called the Lodge, Nick Serota's office is Edwardian on the outside and modernist on the inside. Resting in the center of his corner office is a black Alvar Aalto table, which serves as a desk, overlaid with a tidy grid of thin documents. Paper is evidently forbidden to accumulate into a stack. On the right-hand wall are shelves of brightly colored art books, and on the left, windows through which one can see the front steps of the museum and, towering above them, the haughty profile of our lady Britannia.

Serota was running late for his appointment with me; he was

on a catamaran whizzing up the Thames from Tate Modern. His assistant stepped into the outer office and offered me tea. She told me how delightful it was to work for Nicholas Serota. One doesn't call him "Mr." because he was knighted in 1999; the tabloids call him "Sir Nick." Art world people like to talk as if they were on a familiar, first-name basis with all the power players, whether they know them personally or not, so one hears about Damien (Hirst), Larry (Gagosian), and Jay (Jopling, owner of the prominent White Cube gallery). In London, Serota owns the name Nick, while other noteworthy Nicholases tend to be referred to by their surname (for instance, Nicholas Logsdail, the owner of the important Lisson Gallery, is known as Logsdail).

The son of a Labour minister, Serota studied economics and art history at Cambridge, then wrote his master's thesis on the painter J.M.W. Turner (the prize's eponym) at the Courtauld Institute of Art. He joined the Tate in 1988, when it was little more than a fine outpost of national heritage, and he now presides over an empire of four museums—Tate Modern, Tate Britain, Tate Liverpool, and Tate St. Ives. With more than 4 million visitors a year, Tate Modern is the most popular tourist attraction in London and the most visited modern art museum in the world. Tate Britain's almost 2 million visitors ensure that it also takes a respectable position in worldwide ranks. (In 2005–6, for example, New York's MoMA had 2.67 million visitors, Paris's Centre Pompidou had 2.5 million, and the Guggenheim Museums in New York and Bilbao received 900,000 each.)

Serota glided in twelve minutes late. "Very sorry," he said in a crisp accent. "I was giving a tour to American collectors. They arrived late and in turn delayed me." Serota sets his twenty-year-old, official Swiss Railways wristwatch ten minutes fast. He is tall and thin. His mouth evokes the expression *tight-lipped*. He always

wears a dark suit and a white shirt. On this occasion he wore a muddy asparagus-green tie. He disappeared for a moment and returned without his jacket. He took his seat and methodically rolled up his sleeves. We skipped the small talk.

At the top of my long list was a question about the Tate's power to legitimize artists. With regard to the Turner Prize, the strong list of previous winners acts as an endorsement to the current nominees, but Serota was still circumspect. "There is nothing sacrosanct about the status of any prize," he said. "It will only carry authority while it continues to be awarded to artists who are held in high regard or who are seen, in a relatively short time, to have merits that perhaps people didn't recognize at that moment. It's only as good as its last outing."

Competition between artists is almost taboo in the art world, and Serota admitted that contests like the Turner Prize are "iniquitous in drawing distinctions between artists of very different kinds." Artists are meant to find their own path, make their own rules, and compete with themselves. If they develop a habit of looking over their shoulders, they risk being derivative. But if they are completely ignorant of the hierarchical world in which they operate, then they're in danger of being outsider artists, caught in the bog of their own consciousness, too preciously idiosyncratic to be taken seriously.* "Few artists enjoy direct competition," said Serota. "Artists struggle to express themselves, and for that they need an inordinate amount of self-belief. In some circumstances that self-belief will shift into competitiveness, but it is rarely comfortable." Serota took off his rimless glasses and

*"Outsider art," also called "naive art," usually refers to the art made by inmates of insane asylums, mentally disabled people, or self-taught artists who have had little or no contact with art institutions.

pinched the bridge of his nose. "I shared that discomfort when I started at the Tate, but I came to recognize that the format of the prize—the early announcement of the shortlist and the public display of four artists' work—spurs people to reflect about art." The prize's promotional materials incite each viewer to "judge for yourself." "It creates a frame," he added emphatically, "which allows people to participate in a rather more active way than they would as viewers of a thematic exhibition organized from the point of view of a single curator."

Serota resisted commenting on the many awards that have been set up in the wake of the Turner Prize, but he admitted to being "exceedingly pleased" that the British artist Tacita Dean had just won the Guggenheim's Hugo Boss Prize. "Tacita was nominated for the Turner at a moment [in 1998] when she was known to relatively few people. It would have been surprising had she won that year. At that stage, being on the shortlist was a help to her."

Only two women artists have won the Turner Prize in its twenty-two-year history—Rachel Whiteread, in 1993, and Gillian Wearing, in 1997. On this topic, Serota spoke like a politician. "No women won the prize for the first ten years, so it is two women in the last thirteen. There is a difference." He frowned and sighed. "I don't think you can persuade a jury to discriminate positively. A jury has a volition of its own. If there were any sense that someone was going to win because of his or her gender or ethnicity, then the prize would lose all credibility." He lifted his finger and placed it precisely on the table as if he were making a fingerprint. "But if you asked me, do I think the right proportion of male and female artists have won the prize in terms of the contribution of the different genders to the discourse of contemporary art over the last ten years, the answer would be no."

Serota has chaired the Turner Prize jury every year since 1988. Although the judges are selected for their individuality and asked to be "utterly subjective," few remember who the judges were in any given year, and the Turner Prize is often said to represent the times. "Generally speaking, people are ambivalent about becoming a judge," explained Serota. "They are very conscious of the fragility of new art and the vulnerability of the artists. They know their decisions will be keenly felt." At their first meeting, he advises the judges to shortlist only artists whom they regard as capable of winning. "There shouldn't be someone brought in as a makeweight, because it can be an ordeal to be a nominee," he said. "I take a lot of stick from the press, but I've got used to it. I know that today's story will be tomorrow's fish-and-chip paper. For artists and judges, it is more difficult. They find it hurtful to be trivialized and caricatured." According to Serota, the media have found it hard to get hold of something that they regard as sensational this year. "Maybe the prize has grown up?" he wondered. "Maybe we have moved on to another generation of artists, whose work commands a different type of attention?"

Tomma Abts's studio is a modest room, lit by skylight, in an artist-run maze of thirty-two ground-floor studios called Cubitt, which is located in a North London mews. Even with recently installed radiators, the air was uncomfortably cool. A trestle table with a white laminate top and two junk-shop chairs sat on the clean concrete floor. Abts's studio was remarkably devoid of visual references—no postcards, no clippings, no art books other than her own catalogues. She employs no assistants and paints her small canvases flat on a table or in the crook of her arm. She doesn't like having people watch her work. "Nothing

happens that you can't imagine anyway. I am just sitting there painting," she explained.

Abts is a well-liked member of the Cubitt co-op. She's a regular volunteer for unpopular jobs like rent collector and a level-headed participant in committee meetings. Her studio-mates mused affectionately about her eccentricities. Apparently when someone has occasion to knock on her door, Abts opens it only a crack or emits a hushed holler to say that she'll be out in fifteen minutes. Awfully private, she is also admirably discreet. She is the last person to fuel the emotional battles that can erupt when a group of creative people work day in, day out in the same building. So effective is she in this environment that rumor has it she was raised on a commune. When I inquired whether this was true, Abts responded irritably, "Do I have to answer that? Does it matter?"

Abts, who is thirty-nine, was born in Germany and has lived in England for twelve years. When I visited, she wore no discernible makeup except mascara. With bright blue eyes and shiny shoulder-length hair, she is, like her paintings, controlled and beautiful in an inconspicuous way. "When I start a painting, I have no idea what it will look like," she said in a quiet voice as she gestured at the four canvases in diverse states of completion that she had hung at eye level for my visit. Abts's pictures are all the same size—nineteen by fifteen inches—and she produces fewer than eight paintings a year. "I wouldn't mind if I was quicker," she said. "Sometimes they take five years, sometimes two. Recently I completed one that I started ten years ago. I work on them in phases, with lots of breaks in between."

Abts begins her work with a translucent acrylic wash, then applies oil paint in precise layers to create geometric abstractions that tease the viewer with hints of figuration. "My work hovers

between illusion and object, and it reminds you of things," she explained. "For example, I create a daylight effect or a feeling of movement. Some shapes even have shadows." In Abts's paintings, the bright lines that pop tend to be left over from the original wash, while the somber backgrounds that recede are among the last strokes applied to the canvas. "I always work inside out," she continued. "I know it's finished when the work feels independent of me."

Abts gives all her paintings titles that she selects from a dictionary of German first names. We lingered before one called *Meko*, a red, white, and green painting with an op-art feel. Critics describe her paintings as "living things" that incite "intersubjective confrontation." Abts frets about which paintings are exhibited together and exactly how they are hung, as if she were arranging the seating plan for a dinner party and it would be a disaster if *Teete* sat too close to *Folme*. When I mentioned casually that I'd be curious to see her dictionary of first names, Abts looked alarmed, moved toward the table, tossed a sweater over the mysterious volume, and said, "It is better if it is unknown."

Abts doesn't relish speaking about her work, but she has developed a professional patter. "Why, as an artist, would you want to explain yourself?" she said as she tugged on the small gold horseshoe on a fragile chain around her neck. "Painting is so visual that it is very difficult to say things that don't compromise it." Abts refused to name any influences or any artists with whom she feels an affinity. She likes to keep things abstract. On the topic of what makes a good artist, she was willing to point to perfectionism: "For me, you care one hundred percent about what you do. You can't say, 'It's okay like this but it could have been a different way.' You have a total vision of how things have to be—it has to be just right."

One subject that Abts was keen to avoid was Chris Ofili, the last painter to win the Turner Prize, in 1998. As his girlfriend at the time, she had an intimate view of the prize's peculiar public process. "I have been part of the London art world for eleven years," she said as she looked out the window. "There are four artists nominated every year. You always know at least one. It doesn't matter who they are." It took Abts three days to decide to accept her nomination. "I want to participate in things that are about art, not artists' personalities. I wanted to stay an artist and not suddenly become something else . . ." She took a long, conflicted pause and then smiled. "Like a media person."

Whatever the outcome of the prize, the New Museum in New York has decided to honor Abts with the first solo show to be held in its new building, in April 2008. New Museum senior curator Laura Hoptman, a loquacious intellectual and a longtime Abts fan, believes that "if Tomma had not arrived at this moment, we would have found a way to create her. It seems odd to talk about abstract painting in these terms, but I think of her work as a kind of activist art. We're living in a hell of a time right now, and I see profundity in these small objects. These dour geometries are not just formal exercises. There is a lot of work in them, but they're not simply about the labor. Tomma falls into the tradition of mystic painters like Barnett Newman, Piet Mondrian, or Wassily Kandinsky. She has cracked a nut that artists have been working on for eons—how to paint the inchoate. Her paintings have this 'thing,' this feeling, this notion of the vastness of the universe and the internal . . . soul."

It is hard to imagine two artists more dissimilar than Phil Collins and Tomma Abts. She creates slow-cooked fictions—lonely, restrained pieces that turn their back on the specificities of the everyday. He gathers raw documentary experiences, which are

contingent on the participation of others and delve into their messy lives. While few artists capture the global moment as well as Collins, few artists resist our times as defiantly as Abts. Yet similarities in their histories reveal just how small this art world is. Both have shown at the infamous Wrong Gallery in New York, been feted at the Istanbul Biennial, and received the Paul Hamlyn Award, a bursary-style accolade given to artists who need "thinking space." Finally, in this race, Collins and Abts are favored by two of Britain's most influential art critics, the *Guardian*'s Adrian Searle and the *Daily Telegraph*'s Richard Dorment.

Rebecca Warren, however, is the bookies' favorite. The betting shop William Hill is the market leader in special betting on cultural events such as the Oscars, the Man Booker Prize, and the potential plot lines in forthcoming bestsellers. According to the firm's spokesman, Rupert Adams, the results of the Turner Prize are "so random" that odds compilers do not require art world expertise. "We Google the artists, and whoever is the best known often comes up high. It suggests pedigree," he said. "As with a horse, it is one of six or seven variants. This year we felt it was time for a painter—that's art to the layman—so our odds at the time of the nomination, back in May, had Abts as the six-to-four favorite. But Warren has since pulled into the lead because of where people are putting their money." With a total stake of about £40,000, the Turner is a small market that is often swayed by "friends and family betting."

The artist Keith Tyson admits that he had a gambling problem when he was a nominee in 2002. "I had an intellectual interest in chance as well as a fantasy of beating the laws of mathematics," he said. "The Turner Prize was my first opportunity to bet when I could have an effect. My odds were seven to two. In a four-horse race, that is an insult. I had absolutely no choice. I'm sure it's

solely because of the bets I put on myself that I went from being the underdog to the favorite. I won't say how much I took home, but I won more from betting than I did from winning what was then a twenty-thousand-pound prize."

One day in early November, Mark Titchner, who was then ranked third in the bookie's standings (odds: three to one), was speaking to fifty or so visitors in his room at Tate Britain. A bashful hippie type with rock-star sheen, Titchner had already acquired a handful of groupies—hip young women with nose rings and cleavages on proud display. At thirty-three, Titchner is the youngest of this year's nominees and positioned as the taste of a younger generation; his work has the avid backing of art college students, and the Acoustiguide that accompanied his exhibition features commentary from the lead singer of a grind-core band called Napalm Death. Titchner's room was purposely overloaded: a kinetic black-and-white sculpture spun to psyche-delic effect; television monitors flashed Rorschach ink blots; a giant red-and-black billboard poster read, "Tiny Masters of the World Come Out"; and three large wooden sculptures (respec-tively evoking a pulpit, a tree, and a table covered in car batter-ies) were attached to each other by wires and said to amplify the psychic mood. The room hummed with activity.

Slouching with his hands in the pockets of his black jeans, Titchner explained the spinning sculpture, which is called *Ergo Ergot:* "Ergo refers to René Descartes's famous statement, 'Cogito ergo sum.' Ergot is a fungus with hallucinogenic properties that was synthesized to make LSD." Titchner has no problem with words, but, self-conscious about being perceived as pretentious, he hedged his way to a conclusion: "I guess it is kind of like the case that reality is not what it seems to be. We build our belief systems with fragments of faith." He swept his hair out of his

eyes, then asked, as if thinking aloud, "What does it mean for a work of art to succeed in this context? People like it? It's bought for a lot of money? Critics like it?" He stopped short of mentioning the judges.

After the crowd dispersed, Titchner lingered in his exhibition. He told me that coming back to the exhibition was a little bit like returning to the scene of the crime. It was difficult because "you start questioning some of the decisions you've made." Like the other nominees, he found that the prize process made him uneasy. "It's cool to have qualified," he said. "But I think you could get obsessed and spend all day Googling yourself." Titchner couldn't bear to read the press. "Right now, I'm not interested," he said, wrinkling his nose as if he'd just caught wind of a revolting smell. "I've read stuff in the past and got angry when I felt that the work had been done a disservice. It's nothing to do with me, really." He looked at his feet and then slowly swept the oak floor with his gaze. "For an artist, the most important thing is to entertain yourself on a daily basis. And you want to be able to sustain a level for a long period and actually get better."

I told Titchner that I was under the impression that most artists, whatever their odds, think they're going to win. First, friends, dealers, and other believers surround the artists with support; any nay-saying tends to be done behind their back. Second, the minute the artists agree to participate in the prize, they enter a strange zone where they need huge amounts of self-belief in order to weather the public scrutiny. "Thinking you're going to win is a good way of torturing yourself," Titchner admitted with a pained expression. "My contemporaries have been very supportive, but a few have said, 'Oh yeah, well done. The show looks great, but you won't win.'"

After reading a feature on Rebecca Warren in the British fash-

ion magazine *Harpers & Queen*, in which the sculptor likened herself to a "pervy middle-aged provincial art teacher," I pestered the Tate press office yet again for an interview. With five days left until the final judgment, I was offered a last minute, nonnegotiable, one-hour slot. When we sat down in a meeting room at Tate Britain, Warren wore jeans, a black blazer, and green leather boots that had the air of being just one pair in a considerable collection of trophy footwear. Her dark hair was pulled back in a disheveled ponytail. "I've tried not to think about the prize in a competitive way, because it would involve second-guessing the best way to work, and it might affect the art," she told me. "I wanted to be as true as I could to the lineage of what I've been doing. Eventually things crystallize. Your work takes on a form that's recognizable, or otherwise you'll never be known. It has to become apparent that 'Oh, Rebecca Warren makes that kind of thing.'"

Although Warren is clearly determined about her career, she was curiously ambivalent about her work. "I don't necessarily love the things that I'm making," she said. "It's about allowing yourself to accept what you do." When I asked the tough question What makes a great work of art? she ventured a tentative answer. "A great work," she said, "allows you to look at it without it nagging you. It's not that it's open to *any* interpretation, but it's not got a limited fixed meaning." Warren was nevertheless amused by the tabloids' reductive antics. Back when the shortlist was announced, the *Daily Star* ran a story headlined "Booby Prize for Art." It depicted one of her figures with gargantuan buttocks next to a speech bubble that said, "Does my bum look big in this?" Warren's reaction was unequivocal: "Once you've got in the *Daily Star*, you just think, this is brilliant."

Warren's work bears witness to the legacy of Young British

Artists, or YBAs, an acronym coined by Charles Saatchi. The YBAs were part aesthetic tendency, part brand identity, part social group. Their diverse, generally figurative artistic output shared an ability to trigger media "scandals." Damien Hirst was for many years considered the ringleader of this at once amorphous and cliquey part of the London art world. It was initially affiliated with the art school at Goldsmiths but has since tended to move in the hinterland of the White Cube gallery. When I asked Warren about her attitude to the term, she admitted, "I'm PYBA—post–Young British Artist. I'm the same age, but I've come along later. I'm attached, but not quite attached. I know most of those people, but I also know the younger generation."

Rumors have circulated over the years that Nick Serota manipulates the final verdicts of the Turner Prize judges. When I mentioned this, he initially replied obliquely: "I work in a society that doesn't value art as much as I think it should, and therefore I've always thought that taking a hard line about one kind of art would be destructive." Then he added with a little irritation, "My tastes are broader than my reputation." Serota closed his eyes to think for a rather long time before he admitted, "In the lull before the event—I won't say storm—I begin to consider how I can orchestrate a good result, how I might put a bit of emphasis here or there to get a good conversation going to ensure that everyone who wants to say something has a chance to do so. Sometimes, when there is a deadlock, I have had to lean, because in those circumstances I don't think we should settle on everyone's third choice."

This year, the judges, whose combined personal preferences will create an objective winner, include a journalist and three

curators. Lynn Barber, a columnist with the *Observer,* is the only art world outsider. In October, two days before the exhibition opened, she published an account of her experiences as a judge in an article titled "How I Suffered for Art's Sake." "I hate to say it," she wrote, "but my year as a Turner juror has seriously dampened, though I hope not extinguished, my enthusiasm for contemporary art." Barber complained that her qualifications to be a judge were negligible, the prize's rules were "weird," and her judgment went "haywire." At the same time, she asserted that while all four artists were producing "interesting work," one of them was so "outstanding" that she "would have thought the winner was blindingly obvious." In fact, the problem started earlier, during the process of shortlisting; Barber complained that her artist picks were so "brutally rejected" that she wondered whether she had been chosen merely as a "fig leaf" to cover the machinations of the art world.

The Tate's officials were privately furious. "Lynn's article will make it more difficult for the jury to work together," admitted Serota. "In the past, people have been able to speak their mind feeling pretty confident that what they say will not be written down and used in evidence against them." One of Barber's accusations was that the jury didn't seriously consider nominations from the public. Serota disagreed. "The jury do take those nominations seriously." He raised his eyebrows and chortled silently. "But *not* to the point of doing *deep* investigations into an artist who has shown *once* in Scunthorpe!"

The other judges were dismayed as well. One of them, Andrew Renton, who runs the curating program at Goldsmiths and also manages a private contemporary art collection, told me, "I fear that she has shot her load. She has sidelined herself as a judge by going public before we've finished the process." Renton also

said that Barber's inexperience had led her to put forth nominations that the others felt were "beyond premature." The Turner Prize, like any award that aims to stand for something coherent, needs to be conferred at the right time. As Renton explained, "To give the Turner nomination to someone who is straight out of art school is utterly irresponsible. By the same token, it shouldn't become a midlife-crisis prize." The Turner Prize honors artists on the cusp between what the art world would call "late emergent" and "early midcareer." Lifetime achievement awards present little drama, as they can't go seriously wrong, whereas prizes that recognize promise in very young artists offer less excitement because the stakes are so small.

Renton hadn't made up his mind who should win. "The greatest critical work in my mind is the Talmud," he said. "It's one argument superseding another—an ongoing, open-ended dialogue that allows multiple points of view. For me, that is what art is about." Conflicts of perspective may enlighten, but conflicts of interest can confuse. In overseeing a private art collection, Renton buys art on a weekly basis. "We were probably the first real supporters of Rebecca's sculpture. We also own several videos by Phil Collins, and we've just bought a Titchner piece. The only artist we don't own is Tomma Abts." Renton continued, "The more qualified a person is to be a judge, the more conflict there is going to be . . . Still, I have to be more kosher than kosher. In the jury room, my agenda is transparent. I'm disempowered."

Margot Heller, another judge, is the director of the South London Gallery, a public space with a strong track record for showing young artists who go on to receive Turner Prize nominations. Like many who devote themselves to the discreet, elite world of art, Heller is mediaphobic, but she tried hard to open

up, as if using the occasion of my visit as a free trial of aversion therapy. "I have heard many people asserting, with absolute conviction, that so-and-so will win," she managed. "But I'm a judge and I honestly don't know who the winner will be." When I met her in her white office, Heller was dressed in a white shirt buttoned up to the collar. "I don't think there is such a thing as the four most outstanding artists," she said with an anxious glance at my digital recorder. "It is a group decision. I am genuinely happy with the four we chose, but it's not the same as if you asked me alone to come up with a shortlist."

The fourth judge is Matthew Higgs, the director of White Columns, the oldest artist-led exhibition space in New York. I met Higgs in his closetlike office surrounded by piles of bubble-wrapped artworks by disabled artists. Higgs trained as an artist and still makes his own art, such as found and framed book pages that bear titles like *Not Worth Reading* and *Art Isn't Easy*. I'd heard that he had the ability to sway a jury and could be "ruthless in his dismissal and superbly articulate in his advocacy." When I mentioned this, Higgs peered at me through his Buddy Holly glasses and said, "I wouldn't damn anything. I support things that I believe in, and I believe in a lot of things." Although he said he admired the prize's role in democratizing art, he thought it was a shame that "quiet, sensitive work often gets drowned out, while flashy, photogenic work becomes mythic noise around the show." Was this a hint? Higgs gave a further indication of whom he might support in the jury room when he explained what makes a great work of art: "It's not about innovation for innovation's sake or the ambition to be novel or unique. All good art gives us an opportunity for a different relationship with time." To this, Higgs added in a barely audible mumble, "It's usually about an indi-

vidual's radically idiosyncratic interpretation of the world. We're inherently fascinated by work like that because we're inherently fascinated by other people."

With a week to go before the awards ceremony, Phil Collins hosted a press conference at a shabby gilt-and-mirrors hall in Piccadilly. As part of his piece *return of the real,* he invited a panel of nine people who had appeared on reality television programs to tell their stories to an audience of journalists, including Lynn Barber. One young man spoke about how humiliated he had been when he went to Ibiza as part of a reality TV competition to see who could date Miriam, only to learn that Miriam was a pre-op transsexual. Barber heckled from the audience: "What did you *think* you were doing?" Collins, undaunted by her power over his fate, told her to shut up.

After the panelists had spoken, the conference opened up to questions. Collins walked around the room with a cordless microphone in hand, acting the breezy part of a professional talk-show host but intermittently indulging in startlingly "unprofessional" habits. He slumped, looked at his feet, chewed his lip, and scratched his cheek with the mike.

"Nicholas!" he barked, nodding at Nicholas Glass, the arts correspondent for Channel 4 News. Glass asked the group how they felt about being part of an artwork.

"I like to make an exhibition of myself," answered a woman who had suffered through medical complications on *Brand New You,* a cosmetic surgery show.

"Art is like having a conversation. This work is very interactive," said a man who had been blamed for his autistic son's bad behavior on *The Teen Tamer.*

"It's what the Turner Prize is all about," said the man who had tried to date Miriam.

A TV reporter from Germany had a question for Collins. "Is this project really art?" she asked.

Collins stared into her camera and said, "If this work isn't art, then I have to ask you, is this news?"

The cameraman swung his head out from behind his equipment. "We can't use that!" he exclaimed.

Indeed, Collins's work doesn't look like art. After the media left, I asked him why. First, he wants his work to "sit close to the thing it is critiquing, so sometimes the aesthetic dimension is willfully pared down." Second, he asserted that the best works are the ones that least confirm your expectations: "It is amazing when you can't believe what you are seeing. I hold out for those moments. The unsettling nature of art is, for me, its deepest attraction."

Three days later, on the Saturday night before the awards ceremony, Channel 4 broadcast *The Turner Prize Challenge*, a half-hour reality TV program produced by the Tate, in which four contestants—two students, one accountant, and an art teacher—competed against one another to explain the work of the four nominated artists to the general public. The contestants had been winnowed from several hundred "screen tests" —videotaped comments that visitors had made in the Turner Prize Video Booth at the museum. (The Tate sees itself as a "content-rich organization." It has a comprehensive media facility, with in-house editing suites and camera crews who are "out shooting all the time.") In this program, one of the contestants explained that in the course of her art appreciation "journey," she had learned that art should not "just please the eye" but "rip open your mindset." The winner, Miriam Lloyd-Evans, was a full-lipped twenty-one-year-

old art history student. She clinched her victory by calling Collins's reality TV victim hotline to ask if he wanted to hear about her experiences in making *The Turner Prize Challenge*.

Serota and his jury have been sitting in the vaulted boardroom, trying to determine a winner, for three hours. Four white tables are arranged to form a large square, evenly surrounded by sixteen chairs. Serota has a side to himself. His back faces the only window in the room, which looks out over the muddy Thames. When they first sat down, the art world judges—Renton, Heller, and Higgs—sat in a row across from him, while Lynn Barber sat in isolation on the left. But Serota and Renton made eye contact, and then Renton stood up and moved to the chair next to Barber's. Barber took this gesture as an opportunity to apologize for her indiscretion and promised not to write about the final deliberations. The jury watched the three-minute interviews with the artists filmed by Tate Media, and the conversation began.

The judges were initially divided, but early in the meeting, three out of four came out in favor of the same two artists. No one made an issue of either artistic medium or gender. Pros and cons accumulated. They talked a lot about relevance and timing. Every statement seemed to change the lay of the land. If Serota had a favorite, no one knew who it was. Just after 1 P.M. they thought that they had agreed on a winner, and they adjourned to reflect on their decision over salad in the room next door. Then they went back in the boardroom, confirmed their verdict, and discussed what should go in the press release. By two o'clock their job was done.

As he is pulling away from Tate Britain, Andrew Renton calls me from his "espresso black" Saab convertible. "It was very hard work, very intense, but we have a decision!" he says with a slightly hysterical laugh. "There were no fisticuffs—just a fantastic articulation of the merits of all four. It was astonishingly grown-up." Renton pauses. His indicator clicks loudly as he makes a difficult turn. "All I can say is, the exhibition does make a difference. It is the last hurdle." Honking and what must be the low roar of a double-decker bus ensue. Renton mutters "Crikey," then directs his voice back to the phone. "There was an internal logic to the decision," he says. "It had to be, in the end."

The Turner Prize has a reputation for being a reliable indicator of an artist's ability to sustain a vibrant art practice over the long term, but perhaps it is a self-fulfilling prophecy. The personal confidence gained from being nominated can galvanize an artist's ambitions, while the museum's public endorsement leads to further exhibition opportunities. Nevertheless, the jury can't pick just anyone; if they can't choose the best artist, then they at least need to plump for the right artist. In the course of researching the prize, I've experienced a similar chicken-and-egg confusion about the prize's ability to *reflect* or *create* a defining sense of the moment. It finally hits me that it's vital for the prize to do both.

At 5:30 P.M., a little over an hour before the award party is due to begin, Tate Britain's blockbuster Old Master show "Holbein in England" (a reminder of just how long London has been attracting international artists) is still heaving with visitors. Upstairs, the Duveen Galleries have been transformed into what looks like a swanky nightclub with purple lights and black leather couches. In a side gallery that's zoned off for the caterers, the cooks are putting the finishing touches on the canapés. In another alcove, a

DJ is setting up his decks. At the far end, set between four giant golden stone columns, is a chrome podium where the Channel 4 News crew is doing a sound check.

Nicholas Glass looks into a camera and says in a deep, smooth voice, "We are all waiting with bated breath for four people to be put out of their misery. They've been waiting. We've been waiting. And the waiting is just about to be over. Yoko Ono is in the wings. Nick Serota is mounting the podium. Here he comes. Over to Nick." Glass smiles and lowers the microphone. "Of course, I won't say that exactly," he says. "We've got six minutes live at the end of the news. After the speeches, we'll show a clip about the winner's work, then I'll ask the winner three questions and hope that he or she will say something, anything, before a voice in my ear says, 'Okay, wind it up.'"

Glass talks in discrete sound bites. "Serota is absolutely professional. He'll get on and off the stage quickly." He stops, smiles. "It's the interview with the shell-shocked artist that makes me slightly anxious. Depending on who wins, it could be a *very awkward* television moment. But people love that. If the winner has nothing to say, they will enjoy my discomfort." He pauses, smiles again. "I will probably have had a drink or two by that time, as, I hope, will they. It's easy to fuck up, but I am old enough not to care." The seven o'clock Channel 4 news is one of few hour-long news programs on British television, and even though Glass has the luxury of six minutes rather than other newscasters' two and a half, he admits, "There is no time to be profound. It is like a football event, where you can share people's anxiety about who is going to win, then take pleasure in someone's euphoria at the end of the game."

Over Glass's shoulder, Yoko Ono is slowly mounting the steps of the podium. She wears trousers, a top hat, and Lennon sun-

glasses. She adjusts the microphone down to her height and says, "In 1966, I was in New York, I received an invite from London, and made a journey across the water. It . . . changed my life for-ever." Her voice betrays her Japanese roots. "In those days New York was the center of the art world. Now it's London." She reads the words ardently, as if she were reciting a poem. "Artists' power *can* affect the world . . ." Her voice rings through the cavernous gallery. "I am happy to open the gate of acceptance by the insti-tution of art to another young artist . . . And the 2006 Turner Prize goes to . . ." She stops. Her envelope is empty. It is just a rehearsal.

I make a beeline to the spot where her entourage has set up camp. "The spirit of art is to express the truth," she tells me ten-derly. "Politicians are too involved in red tape to be human. Art-ists are freer to express themselves, but if we self-censor ourselves to accommodate the monetary world, we destroy the purity of art." I wonder how she feels about the competitive aspect of the Turner. "I feel bad in having to announce one winner, but I think that just being a candidate has made a big difference to the lives of all four. Sectors of the peace industry are always criticizing each other, but the war industry is so united. We need to respect each other's position. It is great that art is flourishing."

At 6:45 P.M. the doors open and the crowd flows past security, into the hall where waiters stand with trays of cocktails provided by Gordon's Gin, the prize's sponsor. Among the throng are a number of past winners: Rachel Whiteread (1993), Wolfgang Tillmans (2000), Martin Creed (2001), Keith Tyson (2002), Grayson Perry in a prim black rubber dress (2003), and Jeremy Deller (2004).

Since his win, Grayson Perry has become one of Britain's most famous artists, and in addition to his art practice, he has written

a weekly column for the *Times*. "Rather than carrying on being the subject of the media, I elected to become a member of it," he explains with a swing of his handbag and a glance at his wife. "In the art world there is a snobbery which suggests that the artist is meant to be a shadowy figure in the background behind the work. That kind of high-integrity marketing strategy is very common. Whether people call it a marketing strategy or integrity is another matter." Perry stops to be adored by a trio of female fans, then continues. "The monk-artist is an attractive archetype in a world where there are only so many—the belligerent drunk, the batty dame, the flaming tortured soul. It's a big part of the attraction of art—the work as a relic of the artist/saint/holy fool. People want to touch the cloth or whatever. It's part of the religion."

Charlotte Higgins, the arts correspondent of the *Guardian*, has already submitted her copy. "For the first edition, you can submit as late as eight o'clock," she says, "but it's heavily frowned upon—an emergency measure, reserved for death and disaster. My editor is usually on my tail by six." Higgins writes four thousand words and files around five stories in an average week. "Every year I put in a call to the one press officer who knows who has won at around four o'clock, whip up six hundred and fifty words by six, then throw on a clean frock and rush down here." She glances at the time on her BlackBerry. "After the press conference, I'll call in a few tidbits and a decent quote for the third edition. Now I long for something jolly to happen—a nice bit of chaos or contention." Higgins scans the crowd and giggles. "It all looks slightly comedic when you already know the result."

Conceptual artist Martin Creed is feeling nostalgic. His winning installation from 2001, *Work No. 227: The lights going on and off*, is currently on display at the Museum of Modern Art in New York. "I remember being scared of losing and not liking

the fact that I cared about it so much," he says. "I felt a terrible
conflict between wanting to win and thinking it was stupid. I
learned a lot about myself during the prize. I realized that I was
so competitive—so scared of losing—that I had entered a field in
which whatever I did, I could pretend I'd won." He looks suspi-
ciously into his tall glass of some sloe gin concoction before he
takes a gulp. For Creed, no one is ever best in show. "If the artists
create artworks, then the judges create a winner. Whoever they
chose is a reflection of themselves."

In a side gallery—a gray room hung with William Blake paint-
ings acting as a green room—this year's nominated artists are
trying to enjoy a glass of champagne. Dressed for the cameras,
they politely admire each other's clothes and avoid all mention of
the prize. Serota makes the rounds, complimenting the artists on
their shows, saying, "I know how difficult this is. I hope it's been
a good experience notwithstanding all the pressures." Although
the judges were invited, when Matthew Higgs drops by, he feels
like an intruder, so he flees back to the party in the Duveens.

With the DJ and the lighting, the event feels a bit like a prom,
although more cosmopolitan than the one in De Palma's *Carrie*.
Indeed, it is a graduation, or at least an important rite of passage
for many British artists. One by one, this year's nominees emerge
and are corralled into an alcove to the left of the podium, like
finalists for homecoming queen. Phil Collins has scrubbed up
well and is a model of nonchalance. Rebecca Warren alternates
between looking giddy and looking grave in a black short-sleeved
dress and gray high heels. Mark Titchner is poker-faced in a navy
blazer. His girlfriend looks up at him—an emotional buttress.
Sitting farther away from the stage on a bench is Tomma Abts.
She sports a natty gray-and-beige inside-out dress, but she looks
thoroughly morose. She is hunched over, head in hands, elbows

on knees. The artists are watched over by their dealers, who wear firm professional smiles. Serota slips in and out of conversational clusters as he makes his way to the stage. He looks handsome, if a tad funereal, in a dark suit, white shirt, and silver tie. A PR woman whispers in my ear, "It's time," and the museum director skips up to the podium, delivers a sixty-second speech about "questioning contemporary values," and introduces Yoko Ono as an "artist of international repute."

Most people here care about who is going to win. Some long for victory for a friend. Others believe that certain triumphs are more just than others. After an excruciating silence as Ono fumbles with the envelope, she finally declares that the winner is . . . "Tomma Abts."

Abts ascends the stage, kisses Ono, and delivers her short, unprepared thanks. She is swept downstage right, where the Channel 4 News crew is set up for her live interview. Serota moves swiftly to the left to kiss the cheeks and shake the hands of the artists who will forever remain nominees. Abts, meanwhile, is ushered into her room of paintings. Cameras flash and paparazzi holler, "Tomma, over here!" "This way, darlin'!" and "Could we have happier?" Facing the press pack, Abts deflects their questions so expertly that the *Daily Telegraph*'s arts correspondent remarks, "She should get a job in the Foreign Office."

An hour later, back in the Duveen Galleries, the crowd has thinned and gossip is flying. Someone tells me that all the sculptures in Rebecca Warren's room have sold to a dozen different collectors for a total of half a million dollars, or maybe it's pounds. (A Turner Prize nomination is often said to increase an artist's prices by a third, whereas a win doubles them.) Phil Collins will soon be on a plane to Indonesia to research a video. Both he and Warren have slipped off to their separate after-parties; Collins's

is at the Three Kings pub in Clerkenwell Green, while Warren's "very private" affair is hosted by an Italian "art world figure."

Mark Titchner is still around, leaning against the bar, surrounded by friends. He's scheduled to exhibit in a group show at the Venice Biennale. As he knocks back a bottle of beer, he tells me that he's had better evenings elsewhere. "It was like being dumped by your girlfriend in public, then asked to be 'just friends,'" he said. "Just because you know it's coming doesn't make it any less weird."

CHRISTOPHER WILLIAMS

Kodak Three Point Reflection Guide . . . , 2005, as reproduced
on double cover of *Artforum,* April 2006

5

The Magazine

8:30 A.M. on an icy Valentine's Day, I'm walking along Seventh Avenue toward the offices of *Artforum International*. A street hawker chants, "Get your free *A.M. New York*" in a beautiful baritone as commuters spill out of the subway. The art world may be decentered and global, but Manhattan is still the print media capital that supports more art critics than any other city. I nod at the doorman as I enter the unassuming 1920s Beaux-Arts building, which houses the magazine's editorial and advertising staff. *Artforum* is to art what *Vogue* is to fashion and *Rolling Stone* was to rock and roll. It's a trade magazine with crossover cachet and an institution with controversial clout. In an episode of *Sex and the City*, the relationship between the characters played by Sarah Jessica Parker and Mikhail Baryshnikov is starting to falter. How do we know? He's reading a copy of *Artforum* in bed. Likewise, when Bart Simpson becomes an artist and opens a gallery in his treehouse, how can we be sure of the enfant terrible's success? He's featured on the cover of *Bartforum*.

The elevator's old-fashioned *ding* announces the nineteenth

floor and I step onto a grubby landing facing a glass double door that says ARTFORUM on one side, BOOKFORUM on the other. An orange Post-it note hails: "Pizza Delivery, Enter & Yell." Beyond the unlocked doors, a park bench sits across from the reception desk and a Manhattan zip code map. A few more paces into the mostly open-plan office yield a view of white laminated desks adorned with wilted white daisies and white Apple Macs. "Hello?" I call out. Silence. All sounds come from outside: sirens, honking, the grinding and crashing of a construction site.

A stack of February issues sits on a counter in front of the entrance. The magazine has a distinctive square shape, and this month's cover features a detail of *The Plumbing*, a retro-modernist oil painting by Amy Sillman. On page 3, the illustrated table of contents starts with obituaries of a Swedish museum director and the Hollywood film director Robert Altman, then moves to a review of the latest volume by the eminent Marxist art historian T. J. Clark. Columns on architecture and design are followed by a young artist's "Top Ten" of favorite exhibitions and other cultural experiences. Longer, more theoretical features come next: most of them are monographs exploring the work of a single living artist. After these pieces are four extended and forty short reviews of exhibitions from around the world. I try to flick to a "1000 Words" written by the performance artist Miranda July, but I have trouble finding the article for all the advertisements.

My cell phone rings. "Sarah! It's Knight!" Knight Landesman is the *Artforum* publisher who's always clad in primary colors and treats advertising sales as if they were performance art.

"I'm in your office," I say.

"Are you still up for attending that opening this evening?" he asks.

"Absolutely." I want to experience the poles between which *Artforum* thrives, hence an afternoon among art historians at the College Art Association conference followed by an evening in a gallery in Chelsea. "Will you be wearing a red suit?" I ask.

"Of course," he replies. "You don't think I'd wear yellow today, do you?"

As I hang up, Charles Guarino emerges from behind a bookshelf in jeans and one of his many black zippered cardigans. "Darling," he says satirically, with outstretched arms. A droll insomniac with a hardworking slouch, Guarino likes to lord it over the empty office. The *Artforum* organization is desynchronized in the manner of a family home with teenagers. The publishers, accountants, and advertising people arrive and leave early, while editorial takes over the asylum at night. As we walk toward his office, Guarino says, "*Artforum* is mincemeat. What are you going to make of us, meatloaf or meatballs?"

Guarino, Landesman, and Tony Korner, the three publishers of *Artforum*, have been working together for almost thirty years. Korner bought the magazine in October 1979, when it consisted of two typewriters, four telephone extensions, and a subscription list. Landesman and Guarino joined soon thereafter. By that time *Artforum* already had a distinguished history. Founded in 1962 in San Francisco, the magazine soon moved to Los Angeles, where it established its critical edge as a specialists' magazine, and then relocated in 1967 to New York, where it consolidated its position as the forum for debate about minimal and conceptual art. In November 1974 the editors had a famous falling-out when several staff members objected to an advertisement in which the svelte feminist artist Lynda Benglis posed naked with a giant dildo in response to an image published in the previous issue—a

self-portrait by Robert Morris, bare-chested in a Nazi helmet and chains. Those editors left in protest to set up an academic journal (without illustrations) with the revolutionary moniker *October*.

Shortly after Korner acquired the magazine, Ingrid Sischy was made editor. Her *Artforum* explored the relationship between high and popular culture, deepened the magazine's reporting of the local East Village and SoHo art scenes, and broadened its coverage of European art, particularly German postmodern painting. During this period *Artforum* adopted a perfect-bound spine rather than a fold. Sischy resigned in 1988 to take over the editorship of *Interview*. Her successor, Ida Panicelli, expanded the international coverage further, but as English was not her mother tongue, *Artforum* suffered from what one insider called "the wrong kind of unreadability." In September 1992, Jack Bankowsky was appointed. He simultaneously reintroduced serious academics to the magazine's roster of writers and expanded its popular appeal with a wide range of formats that improved its navigability. Tim Griffin, the current editor in chief, took over the helm of the magazine in September 2003.

"A publisher has to worry about everything," says Guarino as he settles into the high-backed swivel chair behind his messy desk. "My job is to mind everybody else's business and try not to act like it. Knight has a perverse ability to sell advertising. I'm more of a devious Machiavellian manipulator." He looks for a reaction, then adds, "My whole identity is tied up with being invisible."

Guarino's office evokes an ivory tower. It has windows on three sides: some offer glorious glimpses of the East River, others present unobstructed views of the Hudson. He shares the space with Korner (who is in Europe today), and between their desks is "the conference room," a round table surrounded by five brown

leather chairs. Guarino draws his rimless glasses up onto his fore-head and peers at a chart depicting the copy flowing into the current issue. "*Artforum* is running like a clock at the moment," he says as he tosses it aside and turns to a stack of white envelopes. "A fabulous invitation to a palazzo in Torino," he announces. "I'll have to live vicariously." After wading through half his mail, he turns to his computer. "My in-box is choking and dying," he says. "Here's something wildly internal—Tim copying me on a letter. But I will not get between editors and their writers. That is the stairway to hell.

"One of my missions is to make the writers feel loved," says Guarino. "I love them for their effort, then I love the staff for turning their work into something that will eventually appear here." Between the magazine and the website, *Artforum* hosts a wide range of voices. Contributors don't necessarily like each other's style; some are divas who resist being edited. "I have rela-tionships with a lot of writers," says Guarino wearily. "At a cer-tain point, one suffers that beleaguered feeling of agents dealing with stars."

Artforum has an editorial department of sixteen people, most of whom graduated from Ivy League universities or their Brit-ish equivalents. "We are blessed to work with staff that can't be bossed," explains Guarino. "It's like trying to shepherd a pack of wolves." Most studied English literature or creative writing rather than art history. "We are also blessed with being a destina-tion," he adds. "They arrive and we try to corral them."

Guarino worked with a group of performance artists before he joined the magazine, and he loves the art world for its char-acters. As for contemporary art, "ninety-five percent of it cannot be taken seriously," he declares. Guarino is more cynical about art than one might expect of someone who participates in the

production of a monthly art world tome. "I'm like the atheist
priest who understands the salutary effect of religion," he tells
me. "You can't be the leader of scientology if you believe in aliens
and all that shit."

Somewhat like a Turner Prize victory or nomination, an *Art-
forum* front cover, feature, or sometimes even a review can have
a tremendous impact on an artist's career. And just as the prize
relies on the authority of the museum and the trustworthiness
of the jury, so the magazine's influence is directly related to its
perceived integrity. "There is an abiding belief, based on the
facts, that you cannot buy your coverage in *Artforum*," declares
Guarino. "A new dealer's first response is to be a little upset and
frustrated, but in the end they respect us for it. Our reputation is
dependent on an entire history of doing our best to be objective
in a world of subjectivity. Of course, an objective opinion is an
oxymoron, but that's never stopped us."

Guarino takes the cap off a Quill ultrafine black permanent
marker and signs a new *Artforum* press card, and as he hands it
to me he says, "Take this, sister. Use it honorably. Use it well."
In the process of negotiating access to *Artforum*, I ended up writ-
ing freelance reports for the magazine's website. Participation
seemed to be the only way to enable observation. Editors and
publishers who are accustomed to the power of representing are
not always entirely comfortable with the prospect of being repre-
sented, but it was implied that they'd let me in if I wrote for them.
As it happens, the online and print magazines are run as separate
entities with different content, so I never had direct involvement
with the main object of research—the glossy monthly.

Still, I couldn't help thinking of Adrian Searle's maxim "No
conflict, no interest." Searle, who is one of Britain's most influ-
ential critics in part because he has a reputation for maintaining

independent opinions, told me, "You often end up knowing too much. Some people think that they can be pure and aloof, but I don't know if that is even advisable. Everything I've learned has come from talking to artists, but you can gather too much personal information, so I make it a policy to be very forgetful." As it happened, Searle also gave a compellingly straightforward definition of criticism. "Art critics are just spectators who say what they think," he said. "If I were an artist, wouldn't it be truly dreadful if nothing were said about what I did? Don't things live not just by direct experience of them but by rumor, discussion, argument, and fantasy?"

Artforum's integrity is no doubt attributable to the principles of its noninterventionist main owner, Tony Korner. The second son of a British banker, he attended Harrow, then read law and economics at Cambridge. Korner is a gentleman. He stands six foot two, wears navy blazers, and uses polite words like *backside*. Unlike most art magazine owners, Korner has never collected contemporary art. When I interviewed him one evening in his London flat, an exotic environment full of objects dating from the Middle Ages to the nineteenth century, he explained: "It felt cleaner to avoid the conflicts. First, I didn't want favors from dealers. I didn't want to slip into the muddy waters of backroom bartering or the fast lane between what might be on my walls and what might be on the cover of the magazine." As he poured me a glass of champagne and offered almonds, he continued, "Second, I grew up in a society that hardly acknowledged that the twentieth century existed. When I started at *Artforum*, I was a beginner and probably would have bought all the wrong work. It was good for me and the magazine that I looked at everything with fresh eyes and that I wasn't—and still am not—vested in any specific art movement or trend."

When I asked Korner what makes a good art magazine, he was adamant: "The one essential thing—it cannot follow the market. Nor should it try actively to influence the market. It has to have its own point of view. It has to be honest. After that, clarity of writing, purity of design." Korner gazed thoughtfully at the two fifteenth-century Flemish donor portraits that hang on either side of his mantel. "We regard ourselves as the contemporary art magazine of record. We spend an incredible amount of time fact-checking, making sure we have the accurate dimensions and materials of each work, et cetera." When I mentioned that newspaper critics complain that art magazines, which are dependent on gallery advertising, rarely publish negative reviews, Korner was unruffled. "We can have credibility without negativity," he declared. "What we *don't* publish is sometimes very telling." Moreover, *Artforum* is renowned for publishing scathing reviews of major museum shows and biennales. Korner can be proud of the magazine, but he is not self-satisfied. As I was leaving his flat, he told me the old joke "If you're resting on your laurels, you're wearing them in the wrong place."

10:00 A.M. The editorial department is located on the west side of the nineteenth floor, while the advertising department sits on the east side. Production acts as a buffer in between. The managing editor, Jeff Gibson, is quadruple-checking a feature to make sure it is "squeaky-clean." The soothing hum of low-volume dub music and the smoky scent of Lapsang souchong tea pervade his small, orderly office. Gibson likens his job to that of a traffic cop, maintaining relationships and filtering copy from eighty to a hundred writers. Before joining *Artforum*, he coedited a magazine called *Art & Text* and wrote a dictionary of

delusional conditions common to artists and critics, titled *Dupe*. In the latter he defined *schizophrenic appraisal* as "wild swings in evaluative criteria brought on by competitive envy" and *sideline omniscience* as "a heightened sense of enlightenment based on inexperience."

A few doors down, senior editor Elizabeth Schambelan is waking up to another round of editing an article "written by a foreigner in a rush." She's already had a "painful back-and-forth" with the author, so she's resigned to spending the morning on more revisions. Schambelan worked as an assistant editor at the book publishers Serpent's Tail and Grove Atlantic before coming to *Artforum*. "I kept making proposals to publish books that nobody wanted to publish," she says. "I had *unbelievably* uncommercial ideas." Schambelan thinks there is some credence to the adage that writing is fifty years behind painting. "I was so sick of reading Hemingwayesque novels full of muscular lyricism," she explains. "Contemporary art seemed to be taking more interesting risks than contemporary fiction." She fingers a printout as if she were eagerly dreading her work. What about the writing that *Artforum* publishes, I ask—what are its conventions? "I honestly don't think we have a dominant discourse," she replies. The etymology of the word *magazine* suggests a place where diverse goods are stored. "We're committed to being a portmanteau for different things," she explains. "Some of our writers are very academic, very theory-driven. Others come from literary or journalistic backgrounds."

Between the managing and senior editors' offices lies the larger corner lair of thirty-six-year-old editor in chief Tim Griffin. An avalanche of books, magazines, and packages slides over his leather couch, armchair, and desk. On the floor, a television sits on top of a DVD player next to more landslides, while on the desk

the clearing between the keyboard and the screen is demarcated by a can of Dr Pepper and a navy New York Shakespeare Festival mug. With an MFA in poetry from Bard College, Griffin follows in a venerable tradition of poets (from Charles Baudelaire to Frank O'Hara) who have turned to writing art criticism. "You sit wherever you want," he tells me as I enter. "I'll move a few things out of the way so we can actually see each other's faces."

Dressed entirely in black, with a hairless head and a solemn manner, Griffin comes across as an embattled, half-hip, half-geeky cleric. He sits still, his hands in his lap. Since his first issue as editor in October 2003, the magazine is generally perceived to have become more serious. He tells me, "Art is an intellectual, philosophical, and spiritual endeavor." Before leaving home this morning, Griffin made a couple of calls to Europe, and while traveling down on the subway from Harlem, he read some "galleys" (that is, page proofs). When he arrived at the office, he checked in on the cover, made sure a key article had arrived, and confirmed that "there were no holes or emergencies." Griffin is busy trying to close an issue, a monthly ordeal that involves long hours of relentless word-crunching, so I jump straight into the interview: What makes a good editor?

"You have to be willing to exchange ideas," says Griffin. "You have to have your ear to the ground. You have to be open to all factions . . . while exercising judgment." He quotes the lyrics of a Kenny Rogers song about knowing when to hold your cards and when to fold 'em, then adds, "Ideally, *Artforum* ends up telling the story of art in its day." The editorial pages convey the critical tale. The ad pages deliver the market narrative. "If you can't have intellectual dialogue in an art magazine," he asserts, "then where in the world are you going to have it?"

How would you describe the influence of *Artforum*? I ask.

"I'm still trying to wrap my head around that one," says Griffin earnestly. "There's an argument out there that once upon a time the critic led the dealer led the collector, whereas now, supposedly, the collector leads the dealer leads the critic. You'd be a fool to argue that the landscape hasn't changed, but we still try to drive the discourse, or at the very least give a perspective." *Artforum*'s content focuses on exhibiting artists, so galleries would seem to sift and sort first. But then, artists often pick up dealers in other cities after they've received an endorsement from a convincing critic. Rather than being a linear chain of influence, each player has sway, and consensus tends to swirl.

How would you describe your relationship with dealers?

Griffin shrugs. "You might think that dealers have a taxpayer sensibility—'I'm paying your salary so I'd better see all my interests reflected'—but to date, people have been generous," he says. "I think everyone recognizes that we could lose the whole game if we don't have a meaningful dialogue happening somewhere." Griffin takes a sip of his coffee, then returns his hands to his knees. "I don't want my editorship to be associated with the rise of a handful of artists," he continues, "but rather with a shift in the language used—a substantive change in the discourse around art and the kind of attention that this community brings to it." Griffin loathes anything that he sees as trivializing art, which is one of the reasons he scorns artforum.com's online diary, *Scene & Herd*. "It risks simply mirroring the 'celebrification' of the art world and its creation of veiled coteries," he declares with distaste, as if my writing for that far too well-read part of the *Artforum* organization were tantamount to whoring myself in a brothel.

A fire alarm abruptly pounds through the building. Griffin glances out the door but stays still. Apparently the alarm has been going off several times a day. On Griffin's desk is an old

Christmas gift from the Norton Family Foundation: a music box by the artist Christian Marclay, which says SILENT on top and opens to reveal the anagram LISTEN. As ignoring the siren is obviously the thing to do, I ask: When was the last time you were caught between conflicted interests?

"It must be more recently than I think," he says. "But if you start supporting artists who don't deserve it or in a manner that seems like overkill, you will drive your readers away and undermine your own credibility." When Griffin believes in an artist, he is devout, but when he doesn't, well . . . "There's some art that we just don't touch," he says. "I have no idea why it sells or why people care." The alarm stops and he looks relieved.

Griffin's eyes drift to his computer screen. Do you have time for another question? I ask.

"Okay, lay it on me. Then I might have to tune out," he says.

There are many metaphors for the function of art critics, like "Art criticism is to artists what ornithology is to birds" or "Criticism is the tail that wags the dog." What's your analogy for the role of the critic?

Griffin glances at the Venetian blinds that block his spectacular westward view, then at the cover of the Collier Schorr catalogue sitting atop one of the mounds on his desk. "A critic is a detective," he says finally. "You look at all this, and you just try to make it mean something."

Hmm . . . So a critic is a *private eye*? I ask. Does that mean that artists are murder victims and their work is evidence? I would hate to think that you were investigating something as dreary as insurance fraud.

"It's an existential thing," replies Griffin. "Nothing is ever *evidence* in and of itself. You have to decide what might constitute a clue. Perhaps, as was the case in John Huston's *noir* classic *The*

Maltese Falcon, there isn't even a crime that can be solved. It's a matter of trying to create meaning in these things in the world around you and giving art a place where it can resonate." Griffin takes another sip of coffee and adds, "My favorite detective is actually Marlowe in Robert Altman's *The Long Goodbye*." In the surprising final scene of this film, Marlowe kills a friend who faked his own death in order to escape conviction for the murder of his wife.

As I get up to leave, Griffin, who is acutely aware of *Artforum*'s intellectual legacy and not altogether comfortable with its commercial status, says, "Just don't make me out to be the toothpaste salesman for a counterculture."

Not so long ago I had coffee with a very different kind of poet-critic, Peter Schjeldahl, the chief art critic for *The New Yorker*. In his East Village flat, surrounded by artworks presented by friends during his freelance days, Schjeldahl told me that he dropped out of college. "I was an impatient, undisciplined, drug-using narcissist," he said. "It was the early sixties. It seemed like the thing to do." At that time the poetry world bled into the art world. "All the poets wrote criticism for *ArtNews*," he said. "Little by little, I discovered that there was nothing else I did well that they paid you for."

For Schjeldahl, the purpose of art criticism is "to give people something to read." He sees it as a "minor art, like stand-up comedy," rather than a metaphysical endeavor. "A great art critic is the last thing any civilization gets," he explained. "You start with a house, then you get a streetlight, a gas station, a supermarket, a performing arts center, a museum. The very last thing you get is an art critic." Moreover, "You're not going to get a good art critic in St. Louis. To be a good critic, you have to be able to make a new enemy every week and never run out of people to be

your friend. In this country, that's L.A. and New York. Otherwise you're going to be moving a lot."

Whereas Griffin has edited "feature packages" on European cultural theorists and has no fear of jargon, Schjeldahl is a populist who complains about professional intellectuals who "think they are scientists and aspire to some kind of objective knowledge." He takes solace in the fact that "bad writing is a self-punishing offense. It doesn't get read, except by people who have to read it." Nonetheless, he's willing to be amused by jargon's function as shoptalk. "You hear two auto mechanics and you have no idea what they are talking about," he explained. "There is a kind of poetry in their impenetrable phrases. Why shouldn't art criticism have that?"

Schjeldahl often feels like he has "seen it before," so he looks at contemporary art for pleasure less than he used to. "Art is generational, and *Artforum* is a magazine that identifies with youth," he explains. "It's *the* art magazine, whose role is to hold up a two-way mirror to the rising generation, so they can see themselves and we can see them from the other side." Many *Artforum* writers are either young people or academics trying to earn a reputation rather than a living. "Those who write for the little they are paid by *Artforum* are writing for glory," said Schjeldahl. "But there is a point when your glory meter smiles and you notice that you are starving to death."

Critics' poor pay means that their personal interests and social relationships can easily overshadow their professional obligations. "It is a conflict," affirmed Schjeldahl. "I really like artists, but I find that I'm hardly friends with them anymore. I had to stop accepting work." Back in the 1980s, a dealer who still has a gallery in Chelsea tried to hire Schjeldahl. "She offered me tons of money. I said to her, what you don't realize is that

all the value that you want would be gone the moment I took your check. Later she called and said, 'I know you wouldn't take money. I wouldn't dream of offering you money. But I tell you what I'm gonna do—I'm going to pay for your daughter's education.'" Schjeldahl laughed and added, "Another time she said, 'Tell me again about your ethics.'" At *The New Yorker*, which the critic described as "so high up the food chain that I'm drifting on a cloud," Schjeldahl is vigilant about his agendas. "One of my principles," he explained, "is that my reader has to know or intuit my interest in the situation. If there is anything bearing on my opinion that I don't declare in the course of the piece, then I am picking their pocket."

Outside Griffin's office, the *clickety-click* of keyboards and the white noise of giant printers override the low buzz of the fluorescent lights. I walk along a row of cubicles where everyone is worrying over texts under Anglepoise lamps. Griffin's assistant, a smart twenty-five-year-old with a copy of *Vanity Fair* under his desk, sits next to the fact-checker, an art history graduate who wears vintage furs. Next to them are two associate editors, one with a degree from Harvard, whose work uniform includes high heels and earplugs, the other with a degree from Oxford, one of the few here who hangs his coat on a hanger.

Perpendicular to "pod row" is a corridor, which acts as "the library" (a floor-to-ceiling wall of books) on one side and "the kitchen" (a grungy sink, half fridge, and microwave) on the other. Two women from advertising and the reviews editor stand by the water cooler, waiting for the kettle to boil. I pass a well-fingered map of Europe and a sequence of red-pen-on-yellow-Post-it notes written in Landesman's distinctive handwriting (imploring late-

leaving staff to lock up and clean up), then skirt a corner and find myself back by the entrance. The reception desk is now manned not by a chirpy girl but by a gangly male artist who answers the phone in a morose monotone.

I wander through the congenial all-female space that deals with advertising, circulation, and accounts. *Artforum* has a circulation of 60,000 copies; roughly half are mailed to subscribers and half hit the newsstands. Sixty-five percent of the issues stay in North America, while the other 35 percent fly to foreign, mainly European countries. Although both *ArtNews* and *Art in America* have higher circulations, they do not have the professional readership that makes *Artforum* the art world leader. "We are not going to admit that *anyone* is our competitor. We're *Artforum* and they're not," says Guarino with a grin. "We keep an eye on [the British art magazine] *Frieze*. They do a good job, but we like to think that we do better," says Landesman.*

Beyond the accountants' corner sits the enclosed office of *Bookforum* editor Eric Banks. On his door, a postcard declares, NO MORE ART. His desk is a cityscape of neatly stacked new releases, but the office itself is empty. I feel a cold draft and step over the threshold to investigate. "I'm on the ledge," Banks announces in his deep southern drawl. He has climbed out the window onto a balcony to chain-smoke a few Marlboros. "Don't you love my Warholian view?" he adds, pointing toward the Empire State Building. Banks worked at *Artforum* for eight years before taking over the helm of its bimonthly offspring, *Bookforum*, a literary review for "intellectually curious, not quite eggheads, I would

**Frieze* is an international art magazine that began publication in 1991 and comes out eight times a year. Since 2003, its owners, Amanda Sharp and Matthew Slotover, have also run the Frieze Art Fair.

never use the word *hip*, but certainly younger, smarter" readers. I sit down on the peeling radiator and Banks begins to enthrall me with insights into the psychological dynamics of *Artforum*. "The family structure is beneficial and not so," he says. "Some days it feels like the Brady Bunch, other times it's more like the Manson family. I love the Mansons. They've always been my favorite killers."

My cell phone rings. "Sarah! Where are you?"

Standing some ten feet from Banks's office at one of his many workstations is Knight Landesman. Bright-eyed, compact, clad in a vermilion suit, Landesman evokes not one but a host of fantastic fictional characters. Imagine Jiminy Cricket, ever ready with quiet advice for Pinocchio, or the pagan sprite Puck in a new Shakespeare-inspired office comedy from the makers of *Bruce Almighty*. While Landesman is visually demanding, he is verbally self-effacing. "I subsumed my identity into the institution long ago," he tells me. "I think that is true for everyone who works at *Artforum*. It's not a place where you are going to get your name in lights, but working here gives you an added dignity." Along with advertising director Danielle McConnell and her staff, Landesman brings in the bulk of the revenue. For the past two years, as the art market has boomed, the magazine has been as thick as a phonebook, earning it the nickname *Adforum*. "I see my job as the ground crew," he says. "Fueling the plane, getting everything ready so that, in an ideal world, the editors and writers can fly wherever they want.

"Come with me," commands Landesman, who doesn't like to stay still for long. I follow him to Guarino's office. In the center of the round table is the dummy, a mock-up of the magazine, which specifies the location of all the advertisements this month. Guarino, who is leaning over it, looks up as we enter and says,

"Knight, we're confused. Why is this weird trashy thing opening up the museum section instead of something glorious, beautiful, and strong?"

"Change it," replies Landesman. "I didn't want to start with the Schaulager because I wanted to keep them near MoMA." Guarino turns to me and explains, "MoMA is always the last ad before editorial. It says to everyone, 'Hey, you're ahead of MoMA, so shut up, don't complain.'" When dealers open up a new issue of *Artforum*, the first thing they do is check to see where their ad falls in its hierarchy of pages. Galleries pay a premium to be placed in the first 30 percent of the magazine. "Just because you can afford to pay doesn't mean you can get in," continues *scarcity* Guarino. "For it to maintain its value, you have to make sure that only certain people can live there." Some ad positions are consistent: Marian Goodman is across from the table of contents; Larry Gagosian is adjacent to the contributors' page; and Bruno Bischofberger, whose distinctive ads consist exclusively of photographs of Switzerland, has had the back cover of every issue since the 1980s. But many other spots vary from month to month.

"It's like a Rubik's cube," explains Landesman. "Every ad involves a story. The Basel Art Fair ad cannot go next to an ad for a gallery that is not in Basel. Bigger galleries can pay to control what's on the page opposite by buying spreads, but it's up to us to make it look good all the way through."

"Even at the very end of the dummy you're looking at some beautiful ads," says Guarino. "But if I were an art dealer advertising in *Artforum*, I would deliver the quietest, most elegant, most subtle ad that I could, because I know I would get good placement. They would reward me for my restraint."

A few years ago, *Artforum* had an identity crisis about whether to accept fashion ads. In the end, the staff decided to admit them

but to give them left-hand-page positions only. At that time, they didn't think jewelry was "the right signifier," but they eventually admitted Bulgari when the company became a key sponsor of the website.

The intercom makes a loud beep. "Knight?"

"Yes," says Landesman.

"Stefan from Gallery B on line one."

"Okay, I'll take it here," says Landesman. "Huh . . . Okay . . . Let me mention it to Mike Wilson, our reviews editor, and see if he can pop in and see it himself . . . Hmm, yes, it was definitely a unique show. How long is it up till? I'll make sure he gets up. You'll see his name in the book. He's the reviews editor. He makes the decisions. Okay. Great."

Landesman hangs up. "I always get calls from people wanting to make sure that their shows get seen," he explains. "We stay out of the editorial process. If you ask any of our reviewers, why did you review this show in London, Berlin, or New York? they will say it's because they wanted to. You can tell that when you read the reviews—they've been written by someone with an intellectual or emotional stake in the work."

The only editorial ground on which the publishers officially tread happens to be the site that offers the most powerful affirmation of an artist's work—the front cover. Each month (or rather ten times a year) the design director creates three or four different possible covers for the editors and publishers to consider. Landesman likes a commercial cover, "something that will sell well on the newsstands. Pictures of girls and ascending airplanes are good. You can't put a pile of dirt on the cover . . . although we have." Griffin, by contrast, says, "I don't worry about the newsstand. The cover is a portal to the issue. It's iconic and metonymic. Ideally, all aspects of what's happening in an issue are

somehow compressed into this one image. We try to do that without betraying the artist. Something can be emblematic of the issue but not of the artist's work, so our philosophy requires a little give-and-take."

Artforum's design director, Joseph Logan, worked at French *Vogue* before he came to the art magazine. His minimal office, which sits next to Griffin's, displays a selection of thin, relatively ad-free *Artforums* from the 1960s that were designed by Ed Ruscha. For Logan, a key question in deciding what art to put on the cover is, does it work as a square? "The square format is great because it doesn't privilege horizontal or vertical images," he says. "But it can be a nightmare. I'm not supposed to crop, out of respect for the art, and each reproduction is supposed to emulate the way the work is hung." Since joining the magazine in 2004, Logan has made the *Artforum* logo smaller, so it is "a little stamp" that interferes less with image. "The art we put on the cover is not our voice, but by putting it on the cover, we make it our voice," he explains. "Whenever you put the *Artforum* logo on a work of art, it is not just their work anymore." The validating impact of the cover depends on when it occurs in an artist's career. "Every now and then," says Logan, "we like to take risks with the cover by giving it to a younger artist." Logan and the editors don't sit around talking about the longevity of an artist's career, but they wouldn't give the top spot to someone who they didn't think had a certain amount of staying power.

One of *Artforum's* most talked-about covers in recent years reproduced a diptych by the fifty-year-old "artists' artist" Christopher Williams. The magazine published two covers for the issue: a photo of a beautiful brunette with a closed-mouth smile and a yellow towel on her head ran on the cover of half of the print

run, and an image of the same woman with a toothy laugh ran on the other half. The double cover is one of Logan's favorites. "It played with the language of advertising and studio photography," he says. "It evoked a fashion magazine even though she wasn't dressed or retouched. At *Vogue*, we would have obliterated all the wrinkles and veins."

Christopher Williams found it strange to see his work on the newsstand in Texas, in the bathrooms of galleries in Paris, on billboards in Vienna. When I met up with him in a beer garden outside Art Basel, he told me, "All artists experience cycles. Before the *Artforum* cover, I felt that something was happening, but when it came out, it definitely changed things. Suddenly there was recognition from noncolleagues like collectors and museum people." Williams particularly appreciated the way the magazine published two covers. "A lot of my work is about doubling and about small changes, like her smile," he said. "Those guys recognized this. My work wasn't just 'represented,' but an aspect of it came out conceptually through the magazine."

After discussing his cover, I asked Williams about how he generally looked at the magazine. "Even if I get home at ten o'clock at night and the TV is on, I'll still open it up and go through the ads," he told me. "It's like an illustrated bulletin. I'll often adjust my travel plans to catch a show." The next morning, "I might skim all the reviews, because it's a way to catch up on what I've missed and it's a reflection of how things are being received. If a friend gets a bad review, I call them up and say, 'That critic is an asshole. I don't know why they didn't get it.' If they got a good review, you call and say, 'That's fantastic!'" When it comes to the columns and features, "I'm more selective. I always read the 'Openings' pieces about young artists and the 'Top Tens,' particu-

larly for suggestions about music. I like reading the more difficult stuff too. I'll read an article about an artist I don't care about if it's a writer I like."

The power of *Artforum* as a promotional vehicle is not something with which all its contributors are 100 percent comfortable. A few months ago I met the well-known freelancer Rhonda Lieberman, who has been writing for the magazine since 1989 and on the masthead as a contributing editor since 2003. Given the heavily *hämisch* quality of her written voice, Lieberman was unexpectedly slim and stylish in person. "In the art world, a critic is an exalted salesperson," she told me. "When you are writing a feature, no matter what you write, you are contributing to a super-glossy brochure, and when you whip up a review, you're little more than a glorified press agent. If I were into that, why in the world wouldn't I be a dealer?" Lieberman contended that honest criticism must contextualize. "I can't *not* notice the market. A lot of artists notice it and play with it. Writers shouldn't bury their heads in the sand," she said, wagging her finger. "Within *Artforum*'s sleek upmarket exterior is this endless blowing of windbags who lift and separate art from the marketplace through a strategic use of theory." Lieberman suggested that the loftier the writing is, the more effectively it legitimates. "We are supposed to commune with their self-contained emporium of fine ideas," she concluded. "And transcend the fact that certain things are supervaluable to shopping fetishists. It's repression by omission, and it's mind-boggling!"

Artforum is often under attack from a number of sectors. As Guarino explains, "People feel ambivalent about the magazine. We're resented by the artists who never got what they deserved, the dealers who owe us too much money, and the critics who were never asked to write for the magazine. And while a lot of

collectors subscribe, many complain that they just can't read it."
Korner regrets that the editor in chief is always under intense
scrutiny. "*Artforum* is establishment in a funny sense," he said.
"And therefore people want to pull it down. They're always try-
ing to catch us out." When I asked him which segment of the art
world was most vociferous, he responded, "Academics, without
a doubt."

2:00 P.M. I leave *Artforum*'s offices and head to the Hilton
Hotel in midtown, where six thousand art historians and other
art-oriented scholars are converging for the annual conference
of the College Art Association (CAA). I've made back-to-back
appointments with two art historians in order to flesh out my
understanding of the magazine. The generic hotel is outstand-
ingly bland except for the shock of the garish wall-to-wall car-
peting. Art historians wearing Banana Republic and designer
diffusion-line suits swarm the building seeking to improve their
positions, recruit colleagues, and win publishing contracts. Some
network on their own; others parade the corridors with entou-
rages of grad students nipping at their heels.

The CAA bears comparison to an art fair. It's a market,
albeit one in which art historians are selling themselves within
an economy of modest scale. For the cost of a work by a mid-
ranking German photographer (one in an edition of six), a col-
lector could obtain a unique art historian for an entire year. Like
the fairs, the conference is also increasingly focused on new art.
Doctoral theses used to be written about work that was at least
thirty years old. Now, artists unheard of six months ago are being
"historicized" at CAA.

I take the elevator up to the top floor of the hotel, where I've

arranged to meet art historian and *Artforum* contributing editor Thomas Crow, who has just moved between two pinnacles of his profession. Head of the Getty Research Institute for seven years, he now holds the Rosalie Solow Chair in Modern Art History at New York University's Institute of Fine Arts. A compact man with a high forehead, black hair, and a gray beard, Crow has published much-admired books on eighteenth-century, modern, and contemporary art. According to Crow, *Artforum*'s strength is that it embraces history: "They have a major historical piece in virtually every issue." Moreover, when Crow writes for *Artforum*, he doesn't approach it any differently than he would a scholarly journal. "It's simply how compressed you have to be," he explains as he sips his filter coffee. "The articles are shorter, so you don't have the luxury of building up and you need more dramatic hooks, but I don't try to write anything less ambitious. I have never been asked to make my argument more accessible or dumb it down in any way."

Artforum's strategic ties to the art-historical world may contribute to the way it "maintains its dominance with impressive acuity" over competing art titles, according to Crow. "*Artforum* is like the dominant athletic team who always finds a way to win," he says. "It's like the New York Yankees or Manchester United. It's always there, and you have this sense that it always will be." Although all contemporary art magazines attempt to make something more permanent of the ephemeral, *Artforum* makes it an overt policy. As Griffin told me, "I want to go to art history and make it look contemporary *and* go to contemporary work and make it look historical." The result may be a publication that provides a context for what Crow calls "art at its highest level"—in other words, the art destined for art history.

Crow doesn't see himself as a critic and is resistant to adopt-

ing self-conscious, high-style writing. "I just try to keep myself out of the text," he tells me. "Half the battle is in the description. If your material is vivid enough, you don't need to adopt an ego-driven voice where you're always reflecting on your own forma-tive experiences or your own complexity of mind." Crow taps his conference schedule of events. "I don't like cults of personality, even minor cults," he adds. "It gets in the way of observation and learning. Your material should be out in front, carrying the weight." Crow rises to refill his mug at the self-service bar. The two women to my left are having a cheerful conversation about the use of lapis lazuli in early Italian Renaissance altarpieces, while the grave man to my right is quietly relating what is evi-dently an enthralling tale of hirings, firings, and "alleged sexual harassment" to an attentive friend.

When Crow returns, I ask him to expand on the issue of self-restraint. "Many of the artists who are ruling the roost at the moment—Jeff Koons, Maurizio Cattelan, Damien Hirst, Tracey Emin—exploit constructed personae," he says. "Cults of person-ality are realities, people are attracted to that, but there has to be a space between you and the people that you're writing about, so you're not just echoing the situation that you're trying to ana-lyze." Although art historians are always making judgments about what is worth their time, Crow believes that "severe attitudes and extreme judgments are a bit out of place." For weekly columnists who are read for their consistent taste, "their readers enter into a regular relationship with them. They want to know whether they thought it was phony or great." However, "If you're an art his-torian, you can't just decide that you like this little bit of history because it appeals to your self-regard. A real historian doesn't do that." On this count, Crow laments aspects of the textbook *Art Since 1900* by the powerhouse academic quartet Hal Foster,

Rosalind Krauss, Yve-Alain Bois, and Benjamin Buchloh. "If you read the little chapter on Californian assemblage, for example, Ed Kienholz is written off as a bad artist. It creates confusion that is counterproductive. I would hate to see students reading that chapter and not looking at Kienholz again."

I thank Crow for his time, squeeze into a crowded elevator, and descend to a café off the lobby to interview a younger art historian, Tom McDonough, who teaches at Binghamton University and writes for *Art in America*. As we line up for tea, the tall, pale author of a book on the "language of contestation" in postwar France defends *Artforum*'s linguistic convolutions. "You need to have a complex language to analyze complex ideas," he says with genuine enthusiasm. "So there is a justification for all that footnoted, highfalutin claptrap. Obviously, we—I have to include myself here—are also performing a set of competencies. We are assigning ourselves a peer group by using a certain language. It's code. It signals an in group."

McDonough believes there was a time when people were convinced that the role of criticism was to advance culture. "Now, instead of moving culture ahead, it's about finding a group of people you can promote," he explains. "They promote that work not because they think it is the most important work being made or because it is a do-or-die issue, but because it's a little corner that they can own." McDonough pauses and adds, "Not that I haven't found my own niche as well and mined it for all it's fucking worth. I'm not excluding myself from this tenure-seeking game."

Still, McDonough is disappointed that *Artforum* has "settled into predictable formulae," and he condemns its "rapid turnover" of Top Ten lists and its "cycles of obsolescent previews." (Three times a year, but not in February, the magazine runs blurbs about

upcoming shows.) But the worst thing about *Artforum*, according to McDonough, is that it offers "no controversy, no real debate. It's a comfortable world in which people basically all agree with one another. That concept of a *forum*—a public sphere in which ideas could be discussed—has disappeared." Although *Artforum* makes a point of including contrary opinions, it does rely on a small cadre of historians and critics. McDonough is not alone in seeing its debates as narrow and elitist.

At 5:30 P.M., I leave McDonough and, as I'm crossing the academic-infested lobby of the Hilton, I bump into Jerry Saltz, who is on his way to the ballroom where the CAA is holding its awards ceremony. The event is supposed to be "as close as art historians get to the Oscars," and Saltz's column in the *Village Voice* is being honored with the Frank Jewett Mather Award for Art Criticism. Twice a finalist for the Pulitzer Prize, Saltz tells me that the Mather is nothing to sneeze at either. "Greenberg, Rosenberg, and Roberta—the big guns—along with some other idiots have won it," he says, referring to the dogmatic formalist Clement Greenberg, his ideological archrival Harold Rosenberg, and Saltz's wife, *New York Times* critic Roberta Smith.

One of the eye-opening facts about the small world of contemporary art is that two of the most influential critics in America, Jerry and Roberta, as everyone calls them, are married to each other. The previous Saturday, I had met Smith for lunch at an old-style New York deli. We sat across from each other in a brown vinyl booth and ordered chicken soup with rice and grilled cheese on whole wheat. Smith is a fresh-faced fifty-nine-year-old with thick red hair and multicolored eyeglass frames. She did a master's in art history and then became "obsessed" with *Artforum*. "That was where everybody wanted to be," said Smith, who went on to write reviews for the magazine between

1973 and 1976. "When I set out, my goal was to do criticism as a primary activity and not get a hardening of the arteries. Most critics have a great deal of difficulty developing beyond the art that was their first love." These days, Smith always looks at *Artforum*, but she rarely reads it. "The ads are great. Everyone has to look at it to see what's there. It's really snobby, like Anna Wintour." Smith can't imagine going back to a specialist art monthly. "Writing for an art magazine is like recording in the studio, whereas writing for a daily is like doing nothing but perform onstage. Which do you think is more fun?"

Many believe that no one critic wields quite as much power as Smith. "You draw attention to artists and give people ways of thinking about them," she explained with a graceful wave of her hand. "Power is something that you have because you've earned it. It ebbs and flows with every piece." Integrity is fundamental. "That's why you don't buy art and don't write about your best friends," she continued. "That's why you keep your eye on the main subject, which is art. You need to handle whatever power you have in a responsible way if you want people to listen to you."

Smith believes that it is essential, but not always easy, to be honest about your experience. "You have to be prepared to let your taste betray you," she explained in a sisterly way. "When you are writing, you have a lot of white noise. Doubt is a central part of intelligence, and doubt is hard to control. What I do is I write first and question myself later. After my deadline, I have a little whimper session: I feel bad about something; it could have been better; certain people are going to hate me the next day."

When I wondered aloud about the relationship between art criticism and art history, Smith offered a range of lucid answers. "Art criticism is done without the benefit of hindsight," she said.

"It's done in the moment. It doesn't involve research. It is out in front, giving some reactions." As art objects move through time and space, people "throw ideas, language, all kinds of interpretations at them. Some of it sticks and some of it doesn't." Smith always hopes that her ideas will be "useful and accurate enough to get used." She took a bite of her sandwich and tilted her head. "Art accumulates meaning through an extended collaborative act," she said. "You put into words something that everyone has seen. That click from language back into the memory bank of experience is so exquisite. It is like having your vision sparked."

As we were draining our soup bowls, Saltz arrived and took a seat next to his wife. Jerry and Roberta are about the same height. They don't look alike—she has brown eyes, he has blue—but they match perfectly. Despite the years of mirroring, however, they have markedly different voices. Saltz is a critic-boxer; he writes about the art world as well as art and often picks fights on matters of principle. Smith, by contrast, is more of a figure skater. She glides in and out of arguments before her readers notice she's had them. When I asked the pair how it felt to be the king and queen of criticism, Saltz declared, "We're just a couple," while Smith confessed, "We have an amazing time. We're able to do as much as we do because writing doesn't mean we have to be alone. We're just totally in it."

Do your deadlines coincide? I asked.

"He has Monday and Tuesday. I have Tuesday and Wednesday," replied Smith.

"But we don't talk about a show if we are both writing about it," said Saltz. "That is an absolute rule."

How often do you write about the same thing?

"Not so often," said Smith. "Our method of keeping out of each other's way has evolved over the years. We almost never

overlap anymore where galleries are concerned, unless it is an artist whose blue-chip status is beyond dispute. In certain cases, each of us will warn the other off a show that holds a special interest, on a kind of first-come, first-serve basis. It is somewhat different where museums, especially big museum shows, are concerned."

"I feel that artists deserve exposure in the *New York Times*," affirmed Saltz. "Sometimes I'd like to review the show, but I think it is unfair, especially to a living artist, to take the *Times* away from them."

How do your tastes differ? I asked.

"Taste is a hard one," replied Smith. "We both tend to see it as inherently polymorphous and fluid, but I think our approaches to art differ, and this probably affects the kind of art we're drawn to. Mainly, I'm more of a formalist. I'm more concerned with materials and how they're used. I'm probably more interested in abstract painting. Jerry has a much keener sense of psychological import—deep content and narrative—than I do."

"I'm interested in all those formal things," said Saltz, "but I came to art through a different door. In Chicago, where I grew up—a world away from the New York discourse about abstraction—I remember being in the Art Institute with my mother and seeing two paintings of Saint John the Baptist by Giovanni di Paolo. I was ten years old. I kept looking back and forth. On the left, Saint John was standing in a jail cell. On the right, his body was still in the cell, but a swordsman had just cut off his head. Blood was spurting everywhere and the head was in midair. Suddenly I understood that paintings could tell a very complete story." Saltz scratched his head. "As I've gotten older, the telling part has gotten more layered. I'm looking for what the artist is trying to say and what he or she is accidentally saying,

what the work reveals about society and the timeless conditions of being alive. I love abstraction, but I even look at that kind of work for narrative content."

Saltz looked affectionately at Roberta to see if she wanted to add anything. She returned his gaze with a smile.

7:00 P.M. I'm stuck in slow traffic on my way to Chelsea, the gallery district that Saltz refers to as "the trenches." Not long ago I had a conversation with Jack Bankowsky, the editor of *Artforum* between 1992 and 2003, now an editor at large. Dressed like a dandy in a jacket, vest, and tie of remarkably well coordinated plaids, he has a style that contrasts markedly with Griffin's. Bankowsky became editor of *Artforum* shortly after the art market collapsed in 1990. "It was close to the bone when I took over," he explained. "The health of the magazine was in question. We all worked on the assumption that no money was being made and that we were benefiting from the largesse of Tony" (Tony Korner, the principal owner). By the time Bankowsky stepped down, *Artforum* was no longer operating in the red, but a "hard times" mentality nevertheless pervaded the corporate culture of the magazine. "It has always been grueling to produce *Artforum*," said Bankowsky. "People work extremely long hours and they're always on the edge. I had this fear when I was the editor that it was my fault, but now that I'm gone, producing the magazine is just as much like passing a stone as it ever was." In fact, Bankowsky may have inherited the magazine's extreme work ethic from his predecessor Ingrid Sischy, who was notorious for conducting all-night editing sessions.

In describing his editorial approach, Bankowsky spoke about the importance of being a connoisseur of art criticism. "It's typical

for people who are interested in theorists like Rosalind Krauss to abhor writers like Peter Schjeldahl, but I like the best work from the warring camps and attempted to court them both," he explained. Even though the supplementary status of criticism makes it a "fraught enterprise," Bankowsky believes that criticism influences the way people think about art. "Trickle-down criticism plays a big role in the market and the way art moves through the world," he said. "Someone like Benjamin Buchloh—counterintuitively, given his leftist disposition—has an enormous amount of influence on the way art is validated in the marketplace."

The power of *Artforum*, according to Bankowsky, lies in its seriousness. "You have to understand the pieties," he told me. "Seriousness at *Artforum* and in the art world in general is a commodity. Certain kinds of gallerists may want the magazine to be serious even if they have no real coordinates for distinguishing a serious article from the empty signifier of seriousness abused." Bankowsky implied that mainstream New York intellectuals' disdain for "art world yahoo faux scholars" was often well founded. "I was always trying to combat art world quackery, but I found that it was next to impossible," he said. "There are structural things about the magazine that make sustaining basic professional standards tough. Its internationalism necessitates reviews in translation; they're often delirious and/or wacky and present editorial difficulties that you just don't get in a mainstream magazine. And *Artforum*'s relationship to academe means that some contributors are trafficking in academic lingo but don't know what they're talking about, while others have an important point to make but they're accustomed to contributing to specialized journals that don't put a premium on graceful essay-writing." Either way, art criticism's "weird lingua franca" was at its worst when played back in gallery press releases.

As we were concluding our conversation, I mentioned an artist friend without a dealer who hated *Artforum* because it was "exclusive, incestuous, self-important, and self-congratulatory." Bankowsky laughed and said, "All those things are true. That's its brand identity, but it could be self-satisfied about worse things."

My cab pulls up at Paula Cooper Gallery, which sits on both the north and south sides of West Twenty-first Street—and on page 33 of the February issue of *Artforum*. Founded in 1968 and having represented many important minimalists, not to mention having paid for the notorious 1974 Lynda Benglis ad, the gallery has a long history with the magazine. Nowadays most of Paula Cooper's ads contain no image. Every month the gallery issues a straightforward announcement in a no-frills font of the artists' exhibitions, their opening dates, and the addresses of the gallery's two spaces. The color of the lettering and background changes, but the format remains the same. An aide told me that Cooper doesn't like to run text over an image and she wants the work to have a lot of space around it. She has always sought a purist experience of art, so she struggles with illustrations.

A glance in the guest book and the sight of a red signature confirms that *Artforum*'s front man is here. Landesman likes to be out seeing and understanding the art. "If you're tuned into the galleries' programs," he told me earlier, "you have a sense of when it is an important moment for them, when they are ready to step up the size of their ads or take out another one for a museum show. In general, you never push for an ad, but sometimes you know when it is smart for them and when they'll be happy they did it." I eventually spot the elfin publisher chatting up a long-legged gallery assistant and recall that he loves the art world because "it's a neutral ground where people meet and interact in a way that's different from their class ghettos." I try to get a view of the Walid

Raad exhibition, but the large rectangular room is so crowded with students from Cooper Union (where Raad teaches), CAA art historians (where the Lebanese conceptualist is fashionable), fellow artists (like his stablemates Hans Haacke and Christian Marclay), and assorted others that I can't do so without backing into people and stepping on toes.

9:00 P.M. takes me back to *Artforum*'s offices. The building feels entirely empty except for the group of editors who sit around the production table eating Thai noodles out of cardboard take-out boxes. "Come, join us around the campfire," says Griffin as I enter. "We were just having a bona fide editorial exchange, but you missed it," he adds as he takes a swig of beer.

"We can recreate it!" offers Schambelan, to whom I had been voicing my frustration that their office didn't offer enough dynamic interaction.

"Yes, Elizabeth, please lead us in prayer," says Griffin.

There is silence while the editors eat. Fresh red gerbera daisies now dignify all the desks.

"We were talking rather aimlessly about the next few installments of '1000 Words,'" offers Griffin. "1000 Words" is a regular *Artforum* column in which artists discuss a recent or upcoming project in their own (by necessity often highly edited) words.

"1000 Words for the summer issue . . . ," says Scott Rothkopf, a senior editor who has gone part-time to finish his PhD. "I did recently hear from our dear friend Francesco Vezzoli about his project for the Italian Pavilion at the Venice Biennale. It sounds like a made-to-measure '1000 Words.'"

"Francesco's been working you like a flower in a window box," teases Griffin with a typically outfield simile.

"He's going to stage a series of mock election campaign commercials, vaguely Republican versus Democrat, starring Sharon Stone and Bernard-Henri Lévy," says Rothkopf, undeterred. "People will read the issue, then four days later get on a plane and see it in Venice."

"Then they'll reach for a drink." Griffin chuckles. "That sounds fine. Let's go ahead, but carefully, because I'm sure there'll be plenty of press. Could you tell him that it would be a huge turnoff if he gave the same statement to *Flash Art*?"

One by one, the editors return to their desks to resume sweeping and clarifying their texts. "I'm groggy because I just crossed one finish line and we've all got a few more to run," explains Griffin with a groan. "We have finally come to a point where we are closing the issues in a reasonable fashion, and at this point in the season we're all fried." Indeed, the art world has expanded and picked up speed. With all the money flowing in and the extra editorial pages to fill, I imagine, it is difficult to keep up the pace. As an editor in boom times, Griffin has the luxury of ignoring commercial pressures and pursuing a rarefied exchange about art. "The mission of the magazine is to privilege the art." He sighs. "It's the only way to bring meaning to all of this. Otherwise, we're just killing trees."

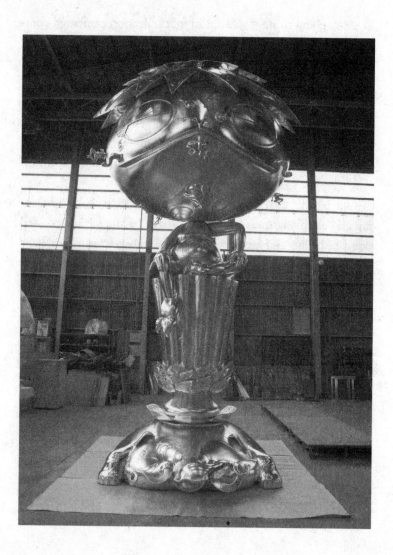

TAKASHI MURAKAMI

Oval Buddha, 2007

6

The Studio Visit

9:04 A.M. The glossy red marble lobby of the Westin Tokyo, like most hotels in the city, is dotted with stewards who bow their heads as guests walk by. Tim Blum and Jeff Poe, whom I last saw in Basel, stand by the front doors with their arms folded, their feet planted firmly apart. They glare at me through their Ray-Bans when I arrive a few minutes late, then we set off on our day trip to see an important new work. For seven years the Los Angeles dealers have been observing the artistic evolution of Takashi Murakami's *Oval Buddha*. It still needs to be covered in platinum leaf, but the sculpture, with the budget of a small independent Hollywood film, is otherwise finished. The eighteen-foot-tall self-portrait is sitting in a foundry in Toyama, an industrial town on the northwest coast of Japan, awaiting an audience.

"Haneda Airport, please," says Blum in fluent Japanese. The taxi is polished black on the outside with the conventional white lace seat covers on the inside. The driver is wearing white gloves and a surgical face mask. He looks like an extra in a bioterrorism B movie, but here it's the sartorial norm for those with colds and

bad allergies. On the back of his seat, a sign informs us that our driver's hobbies are (1) baseball, (2) fishing, and (3) driving.

Poe is sitting in the front seat. He has jet lag and a hangover. Blum and I have taken the back. Blum lived in Japan for four years. "I really enjoy speaking the language," he tells me. "It's theater to me. I would have loved to have been an actor." He is tanned and has a week's worth of stubble. He wears a skull ring that sometimes brings him good luck. "Schimmel says that I look like a deranged movie star," he adds, flashing his white teeth self-mockingly. While Blum may be a generic leading man, Poe resembles the Dude as played by Jeff Bridges in *The Big Lebowski*.

Paul Schimmel, the chief curator of the Museum of Contemporary Art in Los Angeles, will also be flying to Toyama today. His solo retrospective of Murakami's work, entitled "© MURAKAMI," opens in four months and is supposed to culminate with *Oval*. Blum leans toward the front seat. "Schimmel has been quadruple-dipping!" he complains with a half-laugh. "First we donate a hundred thousand dollars toward the exhibition. Second, Larry, Perrotin, and we pay for the advertising." He is referring to Murakami's New York and Parisian dealers, Larry Gagosian and Emmanuel Perrotin. "Third, we have to airfreight *Oval* so it arrives on time. And fourth, we're expected to buy a few twenty-five-thousand-dollar tables for the gala." Blum turns to me. "Ask Poe about money. That's a trauma. He hates to spend."

Poe slowly shakes his head without lifting it from the headrest. "Schimmel has made history repeatedly," he says in a monotone. "He's done some scholarly shit and some spectacular shows. It's money well spent—peanuts compared to what we've poured into fabricating *Oval*." Poe swigs his spring water, then hugs the

two-liter bottle. "*Oval* has enormous significance to us, and not just because it's the gallery's biggest-budget production to date." When Blum & Poe opened in 1994, the partners sold Cuban cigars out the back of the gallery to help make ends meet. Even in 1999, when they showed Murakami's work in an "Art Statements" booth at Art Basel, they had to ask people from other stands to help them lift the work because they couldn't afford installers. "Seeing this piece," continues Poe, "will be emotional."

A living artist's first major retrospective is a time of reckoning, not just for critics, curators, and collectors but for the artist himself and his dealers. According to Blum, it is not surprising that the forty-five-year-old Murakami should be "validated" in a foreign land. "Japan is a homogeneous culture. They don't like it when someone sticks out too much. They want to pound 'em back in." Blum looks out the window as we drive through an intersection with dizzying electronic signage. "The status of creativity is much lower here," he continues. "The art market is weak, and there isn't a well-established museum network for contemporary art. Dissemination is difficult."

In order to maximize his impact and pursue all his interests, Murakami runs a company called Kaikai Kiki Co., Ltd., which has ninety employees in and around Tokyo and New York. The company is involved in what his dealers call an "insane" range of activities. It makes art. It designs merchandise. It acts as a manager, agent, and producer for seven other Japanese artists. It runs an art-fair-*cum*-festival called Geisai, and it does multimillion-dollar freelance work for fashion, TV, and music companies. (When said in reverse, Kaikai Kiki forms a Japanese adjective, *kikikaikai,* which is used to refer to uneasy, strange, or disturbing phenomena.)

"Takashi is an incredibly complicated man, but he's not pre-

cious, and there's no horseshit," says Blum. "His father was a taxi driver, but Takashi has a PhD . . . and he has curated a truly epic trilogy of exhibitions exploring Japanese visual culture." The third exhibition, entitled "Little Boy: The Arts of Japan's Exploding Subculture," which was installed at the Japan Society in New York in 2005, won several awards.

One of Murakami's most visible commissions has been for the accessories giant Louis Vuitton. In 2000 the company's artistic director, Marc Jacobs, asked Murakami to reenvision "monogram canvas," the company's century-old signature pattern in which the beige and brown initials *LV* float in a field of four-petal flower and diamond shapes. Three Murakami designs were put into production, and one of them, "multicolor," which used thirty-three candy colors on white and black backgrounds, was so successful that it became a standard line. Murakami then turned the tables on the big brand by pulling it into his own oeuvre with a series of paintings that consist of nothing but the multicolor *LV* pattern. "The Vuitton paintings are going to be important later on," declares Poe. "People just don't realize it yet. They look at them as branding and that's boring, but they're as *superflat* as anything he's done," he says, using Murakami jargon to refer to the way the artist's works flatten the distinctions between art and luxury goods, high and popular culture, East and West.

As we drive by a canal and catch a glimpse of the red-and-white Eiffel-like structure called the Tokyo Tower, I ask, What is a dealer's role in the studio?

"When people think of artists' studios, they imagine Jackson Pollock dancing around a canvas," says Poe grumpily from under his beige baseball cap. "Dealers are editors and conspirators. We help determine what gets shown and how it gets shown, and we help put art in production." Poe turns around and looks

at Blum, then at me. "At the end of the day, our business is to sell symptoms articulated as objects," he declares. "I like to think that I have a more honest relationship with our artists than some other dealers, but I don't want to be anyone's shrink."

Two days ago I visited Murakami's three Japanese studios. My interpreter and I took a train to the prefecture of Saitama, then a taxi past vibrant green rice paddies and residential streets to the main painting studio, a barn-shaped space with beige aluminum siding. Half a dozen bicycles with baskets and a taxi with its engine running were parked outside. Murakami was on his way out, having just finished his daily inspection. He looked glum. He wore what would turn out to be his uniform of the week: a white T-shirt, baggy army-green shorts, and white Vans without socks. His long black hair was tied up in a samurai bun. I confirmed our interview scheduled for later that day at Motoazabu, his central Tokyo design headquarters. He nodded solemnly and left.

The painting assistants looked like they'd just been chastised. This morning, as always, the staff had arrived by 8:50 (no one is ever late in Japan) and started their day by swinging their arms to recorded piano music for ten minutes of *rajio taiso*, or calisthenics. It's a national ritual in which they've partaken since primary school. When Murakami is there, he joins in. By 9:30, when I arrived, twelve employees were dotted around a white room the size of a long tennis court. Three of them were working on a triptych of circular paintings whose grimacing flower characters also appear in the Murakami-designed opening credits of a popular Japanese TV drama. It needed to be completed for a press conference in three days. Some of the black lines were

muddy and wobbly—"not crisp enough." Some colors were dim and streaky—"not dense enough." The platinum leaf was flaking off in parts. Plus the triptych needed to be finished "NOW!" One of the painters told me that she has a recurring dream in which Murakami is yelling at her. "He is always angry," she explained with a shrug. "The atmosphere is usually intense."

One man took a photo of the first canvas with a small digital camera. Murakami is a stickler for documenting every layer of a painting, so he can follow the process even when he is out of town and look back on the layers to reproduce similar effects in future works. Two women had laid the second and third paintings flat on a long trestle table. One sat cross-legged on the floor with her eyes two inches away from the picture's edge. She had a thin round bamboo brush in her left hand and a Q-tip tucked into her hair. The other, an artist named Rei Sato, knelt on the floor, reapplying platinum particles. They were all wearing standard-issue brown plastic sandals and white cotton gloves with the thumbs and forefingers cut out. No one had more than a speck or two of paint on his or her clothes. They worked in silence or in their own iPod worlds. When I asked Sato if there was any room for creativity in the work, she replied, "None at all." However, she is one of the seven artists represented by Kaikai Kiki and would be showing her own art in a group show in Spain. "My work is completely different. It's deliberately rough!" she added with glee.

I walked around the room, snooping in corners, and discovered a plastic crate full of ten-inch-square mushroom paintings. Murakami has created four hundred different mushroom designs, so the exam given to new staff to test whether they are ready to wield a brush in his name is to paint a mushroom. Deeper in the room, I came upon a phalanx of small, round, blank canvases that had received twenty thin layers of gesso primer so they

would be as flat as glass. On the ground, leaning against the wall, was another battalion of works-in-waiting. A total of eighty-five canvases were on the way to becoming what Murakami casually calls "big-face flowers" but are officially titled *Flowers of Joy*. Gagosian Gallery sold the fifty on display in its May 2007 show for $90,000 apiece. (The official price was $100,000, but everyone who's anyone gets a 10 percent discount.)

At the very back of the space was a notorious unfinished work—sixteen large panels shamefully stacked with their faces to the wall, half hidden under translucent plastic sheets. In fact, this entire studio was set up only six months ago to accommodate this very piece. Commissioned by François Pinault, the influential collector who owns Christie's auction house, the painting was to be the fourth work with 727 in its title (the first is in the collection of New York's Museum of Modern Art, while the second belongs to hedge-fund manager Steve Cohen). Like the other 727 paintings, it was supposed to feature Mr. DOB, Murakami's postnuclear Mickey Mouse character, as a god riding on a cloud, which can also be interpreted as a shark surfing on a wave, inspired by Hokusai's famous nineteenth-century woodblock print *The Great Wave of Kanagawa*. Murakami's sixteen-panel magnum opus was meant to line the atrium of Pinault's Palazzo Grassi museum during the opening days of the Venice Biennale, but a few skilled staff walked out on Murakami at a crucial time and the project had to be put aside.

"Takashi's being late on a painting for Pinault is like Michelangelo's being late for the pope!" was the oft-repeated quip, originally made by Charles Desmarais, the deputy director for art at the Brooklyn Museum, where the Murakami retrospective would travel to in April 2008. (After that the show would open at the Museum für Moderne Kunst in Frankfurt and the Guggenheim

Bilbao in Spain.) Later that day, in his finely sliced, sashimi-style English, Murakami described his predicament in another way: "I was in big tension. They was too much tired. Every day upset. They thought, 'Fuck you, Takashi.' I thought, 'Oh my god, I cannot make the work.' But I cannot say anything to Monsieur Pinault. It was a very tough time."

Murakami has a painting studio in New York that mirrors this one in many respects. Linked by e-mail, iChat, and regular conference calls, it too is tidy, white-walled, and silent except for the whir of the ventilation and the occasional blow-dryer being used to dry paint. I visited twice—once in April, when everyone was working around the clock in preparation for Murakami's Gagosian show, and once in mid-May, when people had more time to talk. On the second visit, I watched Ivanny A. Pagan, a Puerto Rican–American painter who'd recently graduated from art school. On a stool beside him were three little plastic pots. "Green three twenty-six, yellow sixty-nine, and orange twelve. It's paint by numbers with a twist," he told me. "I don't want to discriminate on the basis of color, but the yellows are sticky! They're mean because they show the brushstrokes." He paused to sweep his brush through a tight spot on an op-art-inspired "midsized flower ball," then added, "You would think that synthetic paint would be uniform, but all the colors are different." Murakami is insistent that no trace of his or any other painter's hand should be seen in the work. "We're out of Q-tips today and I have a dust problem," Pagan said with a heavy sigh. "It is frowned upon to touch the painting," he added as he readjusted his gloves. "About ten days before the Gagosian show, Takashi came into the studio. Most of us were new recruits, so we had never met him. It was pretty stressful. We had to redo all fifty small flower faces." Pagan dipped his bamboo brush in water and dried it on his jeans.

"Thankfully, the painting director here, Sugimoto-san, has been working with Takashi for ten years. She's so technically precise, it's spectacular. She can refine paintings in a flash." For Pagan, going to the opening of the Gagosian show was "like seeing the work for the first time." He couldn't believe it. "I worked on one of those flower balls for over a month, but with the varnish on it, under the lights, it was a completely different experience. We'd applied layer upon layer of paint, but for the general public I'm sure it looked like it had just arrived on the canvas."

Murakami is unusual among artists in acknowledging the collective labor inscribed in his work. For example, with *Tan Tan Bo* (2001), a three-panel painting of the ever-mutating DOB character, which MOCA is using for its magazine advertisements (in this work, DOB looks like a saucer-eyed intergalactic spaceship), the names of the twenty-five people who worked on the piece are written on the back of the canvas. Other paintings credit upwards of thirty-five names. Similarly, Murakami's desire to help his assistants launch their own careers is unusual. Many artists loathe losing good help and, more important, the *appearance* of creative isolation is central to their credibility.

After a few hours at the Saitama painting studio, two PR women, my interpreter, and I piled into a seven-seater Toyota chauffeured by one of the nonpainting assistants, a cool dude in a fedora and vintage fifties glasses, to go to the site of Murakami's original studio, which he set up with three assistants in 1995. Initially called the Hiropon Factory, in homage to Warhol's Factory and his manufacturing model of art production, it was renamed Kaikai Kiki in 2002, when Murakami reconceptualized his entire operation along the lines of a marketing and communications

company. While the Sega Corporation has Sonic the Hedgehog and Nintendo has Super Mario, Kaikai Kiki was named after the mascots that appear on its letterhead and cultural goods. Kaikai is an anodyne white bunny, while Kiki is a wild three-eyed pink mouse with fangs. Both characters have four ears each, a "human" pair and an "animal" pair, suggesting that the company is all ears.

Our fifteen-minute journey, which passed modest but respectable homes with bushes pruned like bonsais, ended on a gravel driveway surrounded by a handful of dismal prefabricated buildings, self-seeded trees, and weeds. In addition to providing two workspaces, the location plays host to Murakami's archive, two greenhouses containing his cactus collection, and a grand platform of pink lotuses in waist-high ceramic planters. The lotuses were so out of keeping with their humble environment that they looked as if they'd just landed there.

In the first airless building, three studio assistants listened to a Japanese pop-rock radio station, JWAVE, as they prepared to paint a smaller-than-life-sized fiberglass sculpture entitled the *Second Mission Project Ko* (often called *SMPKo²*), a three-part work in which Miss Ko, a manga fantasy of a girl with big eyes and breasts, a tiny pointed nose, and a flat, aerodynamic belly, metamorphoses into a flying jet. The work is in an edition of three with two artist's proofs (called APs). The first three editions had already been sold; this first AP needed to be finished in time for the MOCA show. Miss Ko's head, hair, torso, legs, and labia were laid out separately on what looked like two operating tables. At one table, two women were cutting tape into precise shapes to cover her for spray-painting. In another part of the small room, a man was testing different shades of white for a Bride of Frankenstein–style lightning streak in her hair. Against

her Barbie-pink skin, he examined swatches of creamy white, gray-white, blinding fluorescent white, and a fourth white that lay in between. He chose the two he thought worked best and said, "Murakami-san makes the final decision." When I asked what he thought of Miss Ko's looks, he said, "She is a master-piece of media-world beauty, but she's not what I want personally in a woman."

Murakami's editions are differentiated not only by number but by color. The first sculpture of an edition might contain three hundred colors, while the third might feature as many as nine hundred. Murakami complicates, tweaks, and perfects the works as he goes along, playing with pigment not just as an aesthetic category but as a racial one. Some sculptures and paintings come in albino, Caucasian peach, olive brown, and jet-black versions. Later, Murakami would tell me that he thinks of Japanese skin color as "plum."

In the next building we politely removed our shoes, only to barge in on seven women eating rice dishes out of Tupperware containers. The Kaikai Kiki merchandise staff members were having their daily communal lunch. I was told they'd set up a temporary merchandise showroom elsewhere, so we walked across the gravel to another cardboard box of a building, where I found Mika Yoshitake, Paul Schimmel's assistant for the MOCA show, shuffling in slippers through a sea of T-shirts, posters, post-cards, pillows, plastic figurines, stickers, stuffed monsters, mugs, mouse pads, key chains, catalogues, cell-phone covers, badges, tote bags, handkerchiefs, decorative tins, notepads, and pencils. To one side, next to its original white pyramid packaging, was a notable gem—a ten-inch-high plastic sculpture called *Mister Wink, Cosmos Ball*. Perhaps owing to his computer-universe sen-sibilities, Peter Norton (of Norton Utilities) was an early adopter

of Murakami's work, and back in 2000, he and his then wife, Eileen, commissioned an edition of five thousand *Mister Winks* to send to friends and business acquaintances as Christmas presents. This clowny egghead character sitting in a sloppy lotus position with upturned palms was the first incarnation of *Oval*.

"We're going to have a room in the exhibition devoted to merchandise," said Yoshitake with a mildly pained expression. "Paul wants nothing to do with the details. I'm choosing which three hundred items get shipped to L.A." Yoshitake grew up in California and has Japanese parents. She was working on a PhD on Japanese conceptual and process art at the University of California at Los Angeles when she was poached by the museum. (Later Schimmel would tell me, "Among the art historians at UCLA, I'm like the Antichrist. I lure their best students to the dark side!") With her art-historical knowledge and language skills, Yoshitake became an essential link between MOCA and Kaikai Kiki. "Initially, I didn't much like Takashi's work," she told me. "I'm interested in ephemerality and entropy in art. I'm not a big 'object person.' But Takashi's art has grown on me." Yoshitake held a clipboard in one hand and played with her bead necklace with the other. "I've come to love the DOB character," she continued. "Especially when he is on a self-destructive rampage of consumption and excess." Yoshitake had revised her opinion about pop artists. "I used to assume that they didn't have anything substantial to offer and that their main goal was to surround themselves with fame and fortune," she said. "But Takashi's got bigger ambitions. His works are not just superficial icons. His use of parody and nonsense give a critical edge to all that spectacle and branding."

After a noodle lunch, we headed to Murakami's slick headquarters in a three-story office block in Motoazabu. It was at least

an hour's drive, past more rice paddies and light industrial facili-
ties, over a major river and along an elevated highway engulfed
in soundproof fencing to the plush neighborhood, not far from
the designer stores of Roppongi Hills. Once there, we ascended
to the studio in an elevator. When the doors drew apart, we faced
a stainless steel and glass door for which a fingerprint scan and a
four-digit PIN number were required. Once we were across the
threshold, the swath of bare white walls and well-sanded wood
floors initially evoked a gallery back room, but on closer inspec-
tion it was clearly a high-security digital design lab. The second
floor housed two boardrooms and two open-plan office areas.
The third floor was architecturally much like the second, except
that's where the real creative work was being done. While on my
quick tour, I caught a tantalizing glimpse of a 3-D computer ren-
dering of *Oval Buddha* rotating on a pedestal, but before I could
get a good look I was whisked away by the PR woman.

Murakami roamed the third floor barefoot, evidently happier
than he'd been that morning, swiftly answering questions from
his staff. His workstation, a sixteen-foot-long table, was situated
in the center of a large room, surrounded by his team of four
designers and five animators, all of whom sat with their backs
to him, their gazes purposefully directed at their white-rimmed
twenty-inch screens. At the hub of his table was a Mac laptop
around which were scattered stacks of blank CDs, art magazines
and auction catalogues, empty takeout coffee cups, and a box of
mini-KitKats. On a counter at the end of the room, a triptych of
face clocks told the time in Tokyo, New York, and L.A. Above
them were three full-sized color printouts of the flower triptych
I'd seen in progress at the painting studio.

Had Murakami been sitting in his swivel chair, Chiho
Aoshima would have been sitting within reach of his right hand.

Although her location would suggest that she was working on one of Murakami's projects, Aoshima was actually putting the final touches on a picture for an upcoming show of her own work in Paris. Aoshima used to run Murakami's design department, but the thirty-three-year-old artist quit to devote herself full-time to her own art. Unlike Warhol's Factory, where, in the words of the art historian Caroline A. Jones, women were "expected to work hard for no pay, suffer beautifully, and tell all," six of the seven artists whose independent careers are promoted by Kaikai Kiki are female.

At the appointed time, Murakami settled into his swivel chair in a half-lotus position, one leg up, the other dangling, ready for a conversation. He offered me green tea and apologized for his English, admitting that even in Japanese, he had "no power to communicate in words. That is why I twist to the painting." Nevertheless, he believes in the influence of media coverage and acknowledges that the studio visit is an important art world ritual for promoting art. Murakami told me that he was working on thirty or forty different projects that day. "My weak point—I cannot focus on just one thing. I have to set up many things. If just looking at one project, then immediately get the feeling it boring." At the end of last year, Murakami was so exhausted that he spent ten days in the hospital. "That was very stressful. I bring my computer. Many assistants come to my room. Finally doctor said too much crowd, waste of money, you must go home."

What kind of a boss are you? I asked.

"I am a very bad president," Murakami responded without hesitation. "I have low technique for driving the company. I don't really want to work in a company, but I have big desire for making many pieces. Operating the people and working on art are completely different. Every morning, I upset people," admitted

the unrelenting aesthetic micromanager. "I used to think that my staff were motivated by money, but the most important thing for creative people is the sense that they are learning. It's like video game. They have frustration with my high expectations, so when they get my 'yes' for their work, they feel like they've won a level." He stroked his goatee. "I'm thinking a lot about how to connect with people who are under thirty in Japan. I have to communicate with a video game feeling."

Murakami had pulled the elastic band out of his hair and put it around his wrist while he was talking; his hippie mane now hung down his chest. "At the design stage, I think they do input their ideas," he said. Murakami's work starts as a paintbrush drawing on paper, which his assistants then scan into the computer using the live-trace tool of Adobe Illustrator CS2, then they fine-tune the curves and zigzags with different techniques. "I don't know how to operate Illustrator, but I will say 'yes, yes, yes, no, no, no' when I check the work," he said. Vector art software like Illustrator, which allows the user to stretch, contort, and scale up images without any degradation, has transformed the design industry, but relatively few fine artists use it. Photoshop, which is used by artists such as Jeff Wall and Andreas Gursky, has revolutionized contemporary photography, but the bulk of painting and sculpture production remains doggedly low-tech. At Kaikai Kiki, the artwork's design goes back and forth between Murakami and his computer-literate assistants until he is satisfied with the picture. By the time the design is sent to the painting studio for execution, there is little room for interpretation, except perhaps in the process of turning digital colors into real-world paint mixes.

The situation is not quite as straightforward with sculpture, where the transition to an object with actual length, width, and depth requires substantially more intermediate analysis and clari-

fication. For *Oval*, Murakami's first metal sculpture, the artist used his regular fiberglass fabricating company, Lucky Wide, to make variously scaled models, then a foundry called Kurotani Bijutsu (*bijutsu* means "art") to cast and assemble the piece. Murakami told me that the production of *Oval* was initially so strained that many sculptors quit, and one even had a stroke. "This piece have the grudge of those sculptors," he explained. "*Oval* is haunted with a very dark energy. It is part of its success. Probably you can experience that feeling when you see it.

"An artist is a necromancer," said Murakami. Even with the translation support of almost all the bilingual people in the room, the statement was cryptic. A dark wizard? A high priest? Someone who can talk to the dead? Murakami's work bears witness to his many years as an *otaku* science-fiction geek and obsessive manga fan. In Japan, these geeks have a reputation for being socially dysfunctional, sexually frustrated young men who live in a fantasy world. As Murakami explained, "We define *subculture* as a cool culture from abroad, but *otaku* is an uncool indigenous culture. My mentality came from those animation geeks. I idled my time, imagining that Japan was a Philip K. Dick world." Murakami absentmindedly put his hair back up in a slightly cockeyed bun. "An artist is someone who understands the border between this world and that one," he continued. "Or someone who makes an effort to know it." Certainly Murakami's work sits between many universes—art and cartoon, yin and yang, Jekyll and Hyde—but nowadays the artist is by no means an aimless dreamer. "I change my direction or continue in same direction by seeing people's reaction," he admitted. "My concentration is how to survive long-term and how to join with the contemporary feeling. To focus on nothing besides profit is, by my values, evil. But I work by trial and error to be popular."

I asked Murakami, an avowed Warhol fan, what he did not like about the American pop artist. Murakami frowned and groaned. "I like everything," he finally offered, a Warholian answer if ever there was one. "Warhol's genius was his discovery of easy painting," he continued. "I am jealous of Warhol. I'm always asking my design team, 'Warhol was able to create such an easy painting life, why our work so complicated?' But the history knows! My weak point is my oriental background. Eastern flavor is too much presentation. I think it is unfair for me in the contemporary art battlefield, but I have no choice because I am Japanese."

When I quoted Warhol's famous line "Being good in business is the most fascinating kind of art . . . Making money is art and working is art and good business is the best art," Murakami laughed and said, "That is a fantasy!"

In his very early years, Murakami resisted using Warhol's signature silkscreens in favor of entirely handpainted work, but he relented as a means of broadening his repertoire of styles, playing with repetition and improving his productivity. Now the two artists' silkscreen techniques diverge greatly. Where a Warhol four-foot flower painting (from 1964) would typically use one screen, Murakami's meter-in-diameter flower-ball works use nineteen. Moreover, whereas accidents, fades, and spills were accepted, even sought after, by Warhol, the level of meticulous craftsmanship in Murakami's work is, as one critic put it, "absurdly high." Murakami closed his eyes. "Absurd? Yes, I think so." He nodded slowly, with a grimace. "And painful!"

A studio is supposed to be a site of intense contemplation. Murakami does not have a preferred thinking space or somewhere that he feels is the heart of his studio. "Anywhere, anytime," he said frankly. "I take a deep breath, send oxygen to my brain, meditate for a few seconds, and get to work. After

this meeting, I have to redo my drawing for Kanye West's new album jacket. No time to worry about where I am." Murakami was referring to *Graduation*, the hip-hop artist's third album, for which he also designed the singles covers and an animated music video. Murakami explained how the collaboration evolved in simple terms: "Kanye was big fan of my big breast sculpture. He learned my work and asked me to make designs." The "big breast sculpture" is *Hiropon*, a painted fiberglass work completed in 1997 of a blue-haired girl with gargantuan breasts from which milk gushes in such abundance that the flow encircles her body like a skipping rope. "These past few weeks was really happy me," continued Murakami, "because I found a good communication style with professional animation people." Murakami had out-sourced the execution of the work. "Deadline is coming soon and production cost is fixed. Kanye's company people is very serious. A little stressful but I am enjoying."

When it comes to sleeping, Murakami is equally indiscriminate about place. The artist has no home per se, just a bedroom only a few yards from his desk here. He also has a sparse bedroom in his New York studio and mattresses in corners at his two Saitama locations. He works long hours seven days a week but naps two or three times a day. Murakami is a nonconformist in many ways, but he is utterly conventional when it comes to his Japanese work ethic, for Kaikai Kiki is typical of the nation's notoriously demanding corporate culture.

Murakami's bedroom didn't look much like a bedroom at all. At first glance it was hard to find the bed, a navy couch with a foam pillow at one end and some crumpled-up fabric that could have been a pair of boxer shorts at the other. One wall was glass, and although the room couldn't be seen directly from the communal spaces, it offered little in the way of privacy. On white

shelves, a large vintage Hello Kitty, a green blob monster covered in eyes, a soft-porn maid figure, and plastic versions of characters from the paintings of Hieronymus Bosch fought for attention. The DVDs of Hayao Miyazaki—the director of *Spirited Away* and other critically acclaimed animated features is one of Murakami's heroes—sat in an orderly row, while a wide range of art books (about colorists like Henri Matisse and masters of deformation like Francis Bacon) was mixed in below. As we parted that day, Murakami told me, "I threw out my general life, so that I can make a concentration for my job. You maybe expecting more romantic story?"

Of all the studios and live-work spaces I've visited, the one that came to mind was that of another ascetic bachelor without a lounge to relax in. When I was doing background research in Los Angeles for the second chapter of this book, I visited Michael Asher at his bungalow apartment on the outskirts of Santa Monica. When he ushered me into what would have been the living room, I found myself in a sea of waist-high black filing cabinets. The walls were white and, with the exception of a few lists and Post-it notes, completely unadorned. The only places to sit were some tattered office chairs that had lost most of their stuffing.

Although Murakami's complex, transnational, multistudio setup couldn't be further away from the Post-Studio, periphery-embracing, anticraft ethos of CalArts, the Japanese artist and the Californian conceptualist share a keen sense of discipline. And even if some aspects of Murakami's practice hark back to the painting atelier of Peter Paul Rubens while other facets embrace a digitally designed future, his art has an intellectual drive that engages with contemporary conceptual art.

That night I had supper at a superb hole-in-the-wall sushi restaurant where no one spoke English except the four museum people I was meeting there. Paul Schimmel, Mika Yoshitake, Jeremy Strick (the director of MOCA), and Charles Desmarais (from the Brooklyn Museum) all sat in a row and drank Murakami's favorite tipple, shochu (Japanese gin) on ice. I sat next to Schimmel and across from our sushi chef, who had two gruesome scars where he'd sliced the knuckles off his left hand. Schimmel is originally from New York, but the jovial fifty-two-year-old has lived in Los Angeles for twenty-six years and had the top curatorial job at MOCA for seventeen. Known for his rigorous and speculative exhibitions, Schimmel supports Murakami with missionary fervor. "Takashi's masterpieces are unimaginably challenging," he told me. "He has put gazillions of hours and beyond reasonable intelligence into his works. His intent is to make something for all ages, and you can see it."

Schimmel likes to think that curators don't so much "validate" artists as "illuminate" them. "The mere announcement of a solo exhibition can have an impact on an artist's market, but sometimes that doesn't sustain itself until the show is up," he explained. "The authority of the institution is no guarantee of success. Big institutions can have a negative impact on artists' careers. Sometimes you see all the work together—boom, boom, boom—and it doesn't make things better." Schimmel devoured a portion of golden sea urchin, then knocked back the seaweed broth in which it had been floating. "To really illuminate, you have to put aside institutional prerogatives. You have to bend the will of the museum to accommodate the artist's vision. MOCA does that. There is no *one* MOCA way."

Schimmel likes to mutate his curatorial style with each exhibition. "The truth is, I hate the word *branding*," he told me. "I'm a

late-seventies counterculture guy and an old-fashioned art histo-
rian, but my eighteen-year-old son is into branding. I understand
that it's deeply meaningful to the younger generation and it's
integral to Takashi's work . . . You can't ignore the elephant in
the room." A plate of something covered in green slime arrived;
Schimmel eyed it with open curiosity. "To experience Takashi,
you have to experience the commercial elements in his work,"
he said, talking with his mouth full. "Collectibles, whether they
are luxury goods or merchandise, represent a fulfillment. It com-
pletes the intimate circle. Takashi understands that art has to be
remembered and memory is tied to what you can take home."

Art bloggers will no doubt be appalled by the inclusion of
a fully functioning Louis Vuitton boutique within the MOCA
show, but it's Murakami's version of "institutional critique," and
Schimmel defended it. "It was difficult for a museum to relin-
quish this sacred ground, but it was absolutely the right thing
to do in this instance," he said. "They'll be selling a limited line
of goods especially produced for the show." The restaurant was
stuffy, and Schimmel wiped the sweat from his brow with his
napkin, then looked at me earnestly. "I've never found choosing
a controversial artist to be anything but the right choice. If there
is already absolute consensus, if there is nothing you can do in
terms of illumination, why do it?"

A studio isn't just a place where artists make art but a plat-
form for negotiation and a stage for performance. The following
day I was back at the Motoazabu studio to sit in on meetings
between Murakami and the museum folk. In the larger of the
two white-walled boardrooms, Murakami sat directly across
from Schimmel at a long wooden table lined with twenty black

leather chairs. Flanking the artist were two beautiful, bilingual thirty-year-old women: Yuko Sakata, the executive director of his New York operations, and Yoshitake, MOCA's project coordinator. Sitting on either side of Schimmel were Desmarais and I.

The first item on the agenda was the exhibition catalogue. Murakami, in his T-shirt and shorts, hair up, started leafing through the glossy page proofs. The first page of the catalogue showed a work from 1991 that appropriated the marketing campaign of Japanese toy manufacturer Tamiya. It read: *TAKASHI: FIRST IN QUALITY AROUND THE WORLD.* The piece's form was alien to what would become Murakami's visual language, but the content was spookily spot on. "It shows chutzpah. That is the trajectory," said Schimmel as he hovered over the proofs.

"What you want to look for is everything. Color. Cropping. Tell us," said Schimmel to Murakami respectfully. "Some reproductions were so bad that we moved them from being a full page to a quarter page. And we've still only got fifty percent of the loan forms back." The curator groaned, then addressed the group. "Takashi has difficult collectors. I met one in Venice who was so pissed off with him that the collector didn't want to lend his painting to our show." While artists usually waive payment for reproductions in small catalogues devoted to private collections, Murakami had insisted that this collector pay him a fee to photograph a work that hung on the collector's living room wall. Schimmel garnered sympathy and eventually convinced the collector to make the loan by saying, "Let me show you our nightmare contracts!"

Murakami is dedicated to ensuring his rights as an artist and controlling the dissemination of his oeuvre, so MOCA's "© MURAKAMI" activities are kept in check by four documents, including a copublishing agreement for the catalogue, an image-

licensing agreement for the publicity, and a data treatment memorandum related to the use of super-high-resolution files to make things like merchandise. Unusually, the museum also issued a seven-page letter of agreement outlining a breakdown of responsibilities and stipulating that Murakami had, as Schimmel put it, "final right of approval on all aspects of everything."

Murakami turned to the next double-page spread: *Time Bokan* (1993), a manga-inspired mural of a white mushroom-cloud-*cum*-skull on a crimson background. Here the artist had clearly found his stylistic stride and personal repertoire of images. Murakami argues in essays and exhibitions that it's popular cultural forms rather than art which have rehearsed the most traumatic experiences of the Japanese nation and cites as evidence the blinding flashes, B-29-like spaceships, unnaturally fast-growing plant life, and "monsterization" through radiation exposure that pervade Japanese comics and animated films. Earlier Schimmel had told me, "The bomb that landed on Nagasaki was originally destined for the town where Takashi's mother lived. He grew up being told, 'If Kokura had not been cloudy that day, you would not be here.'"

Eighty pages went by in which Murakami circled specks of dust and other tiny flaws with a red ballpoint pen. He wrote vertical lines of Japanese script down the side of the page that said things like "more pink" and "enhance the silver in the gray." The meeting trundled along until we came to a double-page spread affording four views of a sculpture called *Flower Mantango*. "This work is a tour de force," said Schimmel, pressing both hands flat on the table. "It's an amazing accomplishment—to take lines like that into three dimensions. It's so complex, and the colors are equal to the armature." Murakami got up abruptly and walked out of the room. We all looked at each other, perplexed. "Boredom?"

joked Schimmel nervously. After a minute Murakami returned with a video camera trained to his eye and asked Schimmel if he could please repeat his praise for the camera. "Ah. Um. What did I say?" said Schimmel. I read back his words from my notes, and he recited his lines for the Kaikai Kiki archive.

Some twenty pages later, Schimmel pointed to the only photo in the entire catalogue that offered a view of the production process—a shot of a twenty-three-foot Mr. Pointy at the fabricator's—and asked, "Do you like seeing it in the studio setting or do you think we should silhouette it? It might look better on a white background." Murakami's own catalogues tend to explore social contexts, artistic tangents, and historical precedents, whereas Schimmel's concentrate on the object itself. Murakami took off his glasses to look at it closely and then said unequivocally, "I like to see the artist's reality."

The catalogue meeting concluded smoothly. Murakami said, "It is much good," and Schimmel responded with a relieved "Arigato." Deluxe bento boxes had been placed on the table, and Murakami passed them around. Jeremy Strick had come into the meeting just before we adjourned. Over lunch, he told me that in his job as museum director, "studio visits are more a pleasure than an obligation" and that "it's a privilege to see incomplete work."

When we'd finished eating, we slid down the long table to the location of a dollhouse-sized model of the Geffen Contemporary building, 35,000 square feet of flexible warehouse exhibition space that Schimmel called "the heart and soul of the museum." In it were miniature versions of ninety artworks as Schimmel planned to show them. "It will have a wonderfest temple quality," explained the curator. Murakami smiled as he peered into the model. In among the art, you could see the merchandise

room and the Louis Vuitton boutique. Schimmel had created a few "completely immersive environments" with the use of Murakami's flower and jellyfish-eye wallpaper. He'd also recreated Blum & Poe's 1999 Art Basel booth, which was entirely devoted to Murakami's work. "We're remaking historical installations," said Schimmel. "And gesturing to a commercial art fair from within the museum."

The pair had already worked out most of the kinks, so this last inspection by the artist was meant to be little more than a rubber stamp. Murakami put his hand on his cheek, laughed, pointed at a room, and laughed again, but as he studied the installation, a storm slowly brewed in his face. Yoshitake and Sakata looked at each other, then back at Murakami, as they waited for a reaction. Schimmel was uncharacteristically silent. Murakami tugged at his goatee, then reached into the model, picked up the six-inch-high Styrofoam version of *Oval,* and dropped it into the middle of the largest room in the show. Schimmel took a deep breath. "The exhibition crew sent me with one mission—don't let him move *Oval,*" he said. "That's an expensive move. It probably requires a second crane and headaches all round for the crew."

"I say 'concern,' but it is your show," said Murakami.

"To be honest," said Schimmel, "I think it's the right decision. The scale is right. The themes work."

"Paul, you are the chef," said Murakami with a nod. "I lend my ideas and my pieces, but you cook the exhibition."

"I'm going to see what I can do," replied Schimmel.

Murakami put his hands together as if in prayer and made a quick but emphatic bow from his seat.

On the way out of the boardroom, Schimmel told me, "An artist's confidence in a curator is essential to making a great solo show. Takashi brings a lot of baggage. He runs an organization

that is not dissimilar in size and scope to MOCA. There is no infantilizing the artist, no 'we know best for you.'" Schimmel chuckled. "When it became clear to Takashi that I had joined his staff, the empowerment was unlimited!" Murakami's generosity in allowing others their creative say would seem to be in inverse proportion to his legal rights. "I've actually been surprised that he hasn't been more particular about the selection of individual works," added Schimmel. The outer office was quietly busy; the admin staff glanced up as we walked past. "Timing is crucial for monographic exhibitions," Schimmel continued. "With retrospectives of an artist's most highly regarded works, as opposed to project-oriented solo shows, you get the sense that there is a moment when suddenly a single artist's oeuvre can be immensely satisfying."

A good retrospective combines familiarity and the unknown. "So a curator needs good access to all the material, and he has to join the artist in taking risks," explained Schimmel. "Takashi's ambition bowls me over. He takes everything he's got and says, 'Let's double up.' That's what he's done with *Oval*." Schimmel hadn't yet seen the work. Based on photos, he thought it could be the artist's most important sculpture to date. "To see an artist's single greatest achievement at the end of the retrospective—now that is how you want to end it." We arrived at the elevator, and Schimmel ran a hand through his salt-and-pepper hair. "The best solo shows come when an artist and curator are connected and highly invested," he admitted. "When their reputations depend on it . . . when they're both putting their careers at stake."

Our taxi finally draws up outside Haneda Airport, a bright and breezy example of modernist architecture. Although it han-

dles only domestic flights, it is one of the five busiest airports in the world. As we line up to check in, I notice that Blum's and Poe's passports are smothered with stamps that testify to the constant travel required to keep up with the globalization of their business. The predatory eagle on their navy covers contrasts dramatically with the symbol of national identity that adorns the Japanese passport—the chrysanthemum. Murakami's flower paintings are often considered the least edgy part of his oeuvre. Apparently Schimmel once called the small flower faces "bon-bons," to which Pinault's consultant, Philippe Ségalot, replied, "But they are *dee-licious*, just like chocolate croissants. You can't help but have one." However, when one considers that Murakami has taken a national icon and endowed it with a gaping orifice in a culture where a wide-open mouth is considered rude, the image comes across as a little more challenging.

We get our boarding passes, and as we head to the gate we discuss Murakami's workspaces. "When I go into a studio, I look at absolutely everything," says Poe in his lazy California drawl. "Supplemental information is incredibly important. If there is a truth there, it's not just in the work but in how they work, how they act, who they are. It's tough with Takashi now because that information is spread out over so many locations, and half of it is on his hard drive." Once in the departure lounge, the dealers take seats. "The Motoazabu studio sends a message. It says, 'We're not some messy workshop. We're a clean, pristine, professional business.'" Poe pauses, then adds, "Of course, the organization is totally dysfunctional, but that's not the signifier."

Murakami and his entourage of Kaikai Kiki staff arrive. Not far behind them march the four American museum people. The hellos are warm. Blum and Murakami hug, then natter in Japanese. The artist tells me, "It is good to come back to the friend-

ship with Tim." For the third day running, he's wearing the green shorts, but he's upgraded the T-shirt to a short-sleeved shirt and a beige Yamamoto-style linen jacket. Poe gets into a conversation with Schimmel. Yoshitake has a list of things to cover with Sakata. Strick and Desmarais, having gone native, flash their digital cameras with Japanese abandon, while a young man with greasy shoulder-length hair records all the encounters on video for the Kaikai Kiki archives. The flight to Toyama is called; we join a disciplined queue of Japanese salary-men to board the Boeing 777. The All Nippon Airways flight attendants have giant purple bows tied around their necks and mauve makeup. The service has a hyperreal quality, as if they were scripted stewardess-characters in a computer game.

The seating assignment offers a near-perfect representation of the hierarchies of the art world. Murakami sits by himself in 1A, a window seat in business class. He reads the newspaper, then watches what he calls a "really maniac, totally geek animation" on his Mac. Blum and Poe sit in 2C and 2D. The MOCA people are in economy, row18. Desmarais is nearby, in 19. The six Kaikai Kiki staff members are aligned in row 43. Apparently Murakami, sensitive to the symbolism of the situation, asked Yoshitake to tell him who was the highest-ranking person from MOCA. When told that it was the director of the museum, he asked her whether Jeremy Strick would like his seat. Yoshitake assured the artist that Strick would be fine in economy.

Out the window, a plane with Pokemon on its tail descends as we ascend over Tokyo's hazy sprawl, soaring past miles of docks lined with shipping containers, then inland above the clouds on a northwest course, two hundred miles to Toyama. Murakami's characters often look like they are flying or floating; even his sculptures seem to defy gravity.

When I was in the offices of *Artforum* a few months ago, senior editor Scott Rothkopf was working on his essay for the "© MURAKAMI" catalogue. It wasn't the first time he'd written about Murakami's work. Four years earlier, during the 2003 Venice Biennale, he'd been struck by the artist's omnipresence. "Everywhere I looked, there was Murakami," Rothkopf told me. "Not only did he have two magnetic works in the 'Painting from Rauschenberg to Murakami' exhibition at the Museo Correr, but you could see the Murakami handbags through the window of the Louis Vuitton store, and African immigrants were selling copies in the street. Collectors were carrying real ones; tourists carried fake ones. Murakami had taken over the Biennale, almost like a virus. He couldn't have planned it, but you could see his work flowing through the global art and fashion marketplace. It was as if he'd injected dye into the system." Rothkopf's review of the Biennale resulted in an *Artforum* front cover for Murakami, or at least for the handbags that sported his pirated designs.

"Takashi's practice makes Warhol's look like a lemonade stand or a school play," declared the young art historian. "Warhol dabbled in businesses more like a bohemian than a tycoon and hatched a brood of 'superstars,' but none of them could sustain their status outside his Factory." Unlike Warhol's other artistic heirs, who pull the popular into the realm of art, Murakami flips it and reenters popular culture. "I was taught that one of the defining premises of modern art was its antagonism to mass culture," said Rothkopf. "If I wanted to be accepted more readily by the academic establishment, I could argue that Takashi is working within the system only to subvert it. But this idea of subversive complicity is growing stale, and more importantly, I just don't believe it's a viable strategy." Rothkopf concluded, "What makes Takashi's art great—and also potentially scary—

is his honest and completely canny relationship to commercial culture industries."

I'd heard that Murakami referred to his Louis Vuitton work as "my urinal," so I thought I'd ask his boss on the project for a reaction. Marc Jacobs was in his office at the Paris headquarters of Louis Vuitton when I caught him on the phone. In our preliminary chat, he was careful to describe Murakami as an artist, not a designer. "It's not like he sent me a sketch of a handbag or anything," he explained. "Takashi created the art that we applied to these products. The documents we received were in the format of a canvas. In fact, they looked a lot like the *LV* paintings that he went on to make." When I confronted Jacobs with the urinal line, he took an audible puff on his cigarette. Jacobs understands the art world—he collects, he attends the auctions, he visits the Venice Biennale—but the same might not be said for his LV customers. "I'm a big fan of Marcel Duchamp and his ready-mades," he said coolly. "Changing the context of an object is, in and of itself, art. It sounds like a put-down, but it's not." Given that Duchamp's "urinal" (officially titled *Fountain*, from 1917) is one of the most influential works of the twentieth century, one might argue that Murakami is in fact glorifying his LV affiliations. Certainly Jacobs was looking forward to seeing the LV boutique installed in MOCA and happy to have Murakami describe it as a ready-made. "It's not a gift shop—it's more like performance art," he told me. "Witnessing what goes on in the boutique in the context of an art exhibition is as much an artwork as the art that went into the bags."

Toyama Airport is little more than an airstrip with a handful of gates where all flights come from Tokyo. It's a short walk through the building to the line of black Crown Super Saloon cars that will take us to the foundry. Standing beside each car is a driver in a blue suit, pilot cap, and white gloves, anxious to open the door lest we leave fingerprints on the polished paintwork. Blum, Poe, and I get in the second car of a convoy so formal that onlookers might assume we are part of an official diplomatic delegation.

"*Oval* has been gestating for so long, I can't quite believe it's finished," says Blum with a deep sigh of relief. "It's been an intense trip." As we weave through the outskirts of Toyama, a blue-collar town where discount stores have oversized street signs and telephone wires swing from poles, I ask how they go about underwriting fabrication. "We have no contract," explains Poe. "Everything is an oral agreement. Kaikai Kiki will say, 'The budget will be *x*,' and if you are a dumbshit, then you presell based on that figure. When the budget gets to be *x* times two or three, you cannot go back to Takashi and try to renegotiate because . . . well let's just say you would *not* want to be in the room for that discussion. So we do not price the piece until it is finished and installed, wherever that may be. We know from experience: never, *ever* presell the work."

The fleet cruises along a flat plain of farmhouses and factories and comes to a halt at the turquoise gate in the chain-link fence that surrounds the foundry. As we get out of the cars, we are hit by the smell of burning. At this moment, as Old World industry meets New World art, no one is quite sure what the protocol should be. The managers of the foundry and the fabricators, Lucky Wide, are on their feet, wondering whom to welcome first. A project director from Kaikai Kiki New York and an exhibition

technician from MOCA, who arrived earlier in the week to watch
the eight parts of the sculpture being craned into place, don't
so much greet us as wander over to join the party. Ten foundry
employees stand in a line with hands behind their backs, not sure
where to look, while a reporter from the Toyama newspaper and
his photographer stand by, waiting for their story to unfold.

While Blum and Poe hang back, waiting for Murakami, I notice
that Schimmel has wasted no time. I follow the curator into the
building and look up at *Oval Buddha*. The Humpty Dumpty–
ish character sits on a tall pedestal in a half-lotus position, one
leg up, the other dangling, with a spiral inscribed on his belly.
He's crowned with a supernova explosion of hair, and he's liter-
ally two-faced. In front, he has a goatee much like Murakami's
own and an undulating, half-frowning, half-smiling mouth. In the
back of his head is a furious mouth with a double row of sharklike
teeth. His back sports a protruding plated backbone. It has to
be one of the largest self-portraits ever made, but somehow the
gesture doesn't suggest self-aggrandizement but rather a feeling
of absurd enlightenment.

"Unfuckingbelievable!" says Schimmel, his face wiped clean
with surprise. "Fantastic," he mutters as he notices that the
entire structure sits on a squashed elephant. "I think that once
Takashi accepted that it was a self-portrait, he was able to take
it further. He's been concealing his identity until now." Schim-
mel walks right up to the base of the sculpture and stands under
its huge overhanging head. "The improbability," he says looking
up. "So precarious, so emblematic. It could fall over from the
weight of ambition. It's either a disaster waiting to happen or
it's . . . brilliant." By now everyone else is walking slowly around
the work. "In terms of showstoppers, I got lucky. They'll be pray-
ing to this thing in five hundred years!" he announces. The cura-

tor walks over to Murakami, who stands with his hands on his hips, soberly inspecting the changes that have been made since he last saw the work, two weeks ago. "Takashi," he says, "you've taken on the twelfth century. This is breathtaking. We're going to do our very best to accomplish the best location for it." The Kaikai Kiki cameraman rushes over, but it is unclear whether he manages to capture the moment.

I stroll over to Strick, who is looking pensive, and ask him what he is thinking. "What's the members' opening going to be like? And the gala? What will be the conversation among artists? How will this change what people think about Murakami?" replies the museum director. "Every sector of the audience is in communication. Reactions are reinforced. At a certain point a consensus is formed. Sometimes it takes a while, but a work like this, which is so powerful and unexpected—it will make an impression very quickly. People will be surprised and talk about it."

Yoshitake looks baffled. "I don't know. Is it sacrilegious?" she wonders aloud. Certainly this bipolar character couldn't be further away from Zen. "The Buddha is a transcendent being whose serenity is meant to reassure us that everything will be okay in our next lives, but this creature is disturbing." The PhD student stares at the work, grappling with its connotations. "I think it's the only truly post-atomic Buddha I've seen," she adds. "Takashi is not an overtly political artist . . . but it's interesting that he is making work like this for an American audience at this time."

Poe looks satisfied. "We're gonna make an edition of ten on a domestic scale. That's the next project. Love that!" he says. "People should be able to live with *Oval*. The references and meanings are still there." Blum walks over. The partners stand, feet planted on the ground, arms across their chests, as if they are staking out territory in a tough schoolyard. "It's as entertaining as fuck. So

entertaining that it may get backlash," says Poe. "I just hope it
fits on the plane when it's crated. At the moment we've only got
two inches of clearance."

The fabricator opens a box of platinum leaf to show the Toyama
reporter. It costs three dollars for a 10-centimeter-square sheet.
Thinner than flaking skin, it blows into an unusable crinkle in
the wind. "The true unveiling will be in L.A. at MOCA," declares
Blum. "The platinum will create a significant change in impact.
We've never done platinum leafing of this complexity. That's a
big unknown."

Murakami walks over and adopts his dealers' posture. They
talk. Afterward the artist makes the rounds, having a word with
everyone. When he gets to me, I compliment him on the work's
sublime sense of humor. "I love this tension," he says as he looks
at the group circling around his work. "Not nervous, because I
saw it two weeks ago. Already in satisfaction that quality is good.
Each part has many stories."

In ten years' time, what will you remember most about today?
I ask.

"Head of factory. Old guy was very quiet. Just watching to our
job. But finally he's smiling," says Murakami. "Also old fabricator
tell me, 'Thank you so much. You gave us a really good experi-
ence.' And then the young fabricator, Mr. Iijima, the director of
the sculpture—for first time, his face has confidence."

Murakami looks at his work like a loving parent regarding a
child who didn't come in first. "But for me," he continues, "my
feeling is, 'Oh my god, it's so small!' I say to each fabricator, 'Hey,
next time, scale is double or triple, please.'" Murakami curves
his lips, self-consciously mimicking the expression of *Oval*'s front
face. "Do you know the Kamakura Buddha?" he asks. The Great
Buddha of Kamakura is a forty-four-foot-high bronze sculpture

cast in 1252. Buddhist statues tend to be housed in temples, but the Kamakura's buildings were washed away by a tsunami in 1495 and since then the Buddha has stood in the open air. "This sculpture is in the mentality of Japanese people," says the artist. "I'm happy with *Oval Buddha* but thinking to next change. Not ambition. Really pure feeling. Instinct. Next work must be much bigger. Much complicated. That is my brain."

PAOLA PIVI

Untitled (Donkey) (installation view), 2003

7

The Biennale

oon on Saturday the ninth of June. The Venice Biennale doesn't open to the public until tomorrow, but it's already over for the art world. A few guests lounge under white umbrellas while a waiter walks past with a tray of freshly squeezed blood-orange juice. The Cipriani is a luxurious hotel with a star-studded heritage; a short boat ride from the Piazza San Marco, it offers an escape from the swarms that descend on the city. I've just plunged into the hotel's deserted hundred-foot filtered saltwater pool. After a week of too much art and too many conversations, punctuated by intermittent rain, I relish the prospect of a meditative swim under a cloudless sky. Hindsight is essential to making sense of the contemporary.

When did this year's Biennale actually begin? The official press preview was on Thursday. VIPs had access on Wednesday, and those with particularly good connections managed to sneak in on Tuesday. Sometimes, however, one's "Biennial experience" starts before one even arrives. At the last edition of the outsized exhibition, mine got under way at Heathrow Airport, when I

spotted the artists Gilbert and George sitting across from each other in the lounge at the British Airways gate. With rosy cheeks and identical gray suits, the artistic duo sat perfectly still, stared into space, didn't exchange a word. They gained notoriety in the 1960s for performances called "living sculpture," so it felt as if I'd walked into the middle of a show. The Biennale, set in one of the most beautiful cities in the world, often feels strange and stagy.

Just arriving in Venice and bumping into people one knows can inaugurate the event. A few years ago I shared a water taxi from Marco Polo Airport with artists Grayson Perry and Peter Doig. The lagoon *superstrada* offers a rare encounter with speed—forty-five miles an hour if you don't hit a red light or have to give way to the *polizia locale*—so it was an exhilarating initiation to the aquatic theme park that is Venice. Throughout the ride, Doig, who often uses photographs as source material and whose most famous series of paintings features a canoe, snapped pictures with his digital camera, while Perry made wisecracks about the weather and his wardrobe. Of course, "Heat is the enemy of drag."

Many say that the business of the Biennale really only gets rolling with a Bellini, the Prosecco-and-peach-puree cocktail with which one anoints one's arrival in the Veneto region. After checking into my humble hotel, full of low-budget curators and critics (my swim at the Cipriani was made possible by a friend who can afford the exorbitant room rates), I met an acquaintance for this ritual drink at a hotel bar with a large terrace on the Grand Canal. Scattered among the outdoor tables were many familiar faces from the New York, L.A., London, and Berlin art worlds. "He's C list. She's B list," he said as he fingered people out of the crowd. "Nick Serota is A list," he added for clarification. "I used to stay at the Gritti Palace, but then I wondered,

where does François Pinault stay?" He then delivered a treatise on the unrivaled discretion of Bauer Il Palazzo, an eighteenth-century boutique hotel, not to be confused with the lesser but still deluxe five-star modern Bauer. With 34,000 VIP and press passes issued for the four-day event, the Biennale is the world's largest single assembly of art world insiders and their observers. As a result, the gatherings oscillate between the idiosyncratically inclusive and the callously exclusive.

Across the terrace I caught sight of David Teiger, the collector whom I'd shadowed at Art Basel. I wandered over and, when he insisted on pouring me a glass of champagne, sat down on a wrought iron chair. Teiger explained his strategy for the next four days. "I plan it out very carefully, then disregard the plan and go with the moment," he said. "The Biennale is like a high school reunion where everyone turned out to be a success. It's not the real world." In the past Teiger has bought major artworks at the Biennale, and on this occasion he was looking "seriously, discreetly, respectfully." At the Biennale, he explained, "you're on a marathon hunt for a new masterpiece. You want to see a new face and fall in love. It's like speed dating." Teiger gazed through the white balustrade at the row of gondolas docked out front, then cautioned, "In Venice, you can fall in love with a lamppost."

A couple of tables away, amid a scruffier entourage, sat John Baldessari. The sage L.A. artist was drinking a no-nonsense vodka on the rocks with his long legs stretched out in front of him. This year he was staying at the five-star Danieli, but he told me that the first time he came to the Biennale, back in 1972, he slept on the roof of a Volkswagen bus parked in the Giardini, a park characterized by a perpendicular axis of tree-lined avenues dotted with small, ornamental buildings owned and designed by different nations. The bus was accommodating a group video

show that included his half-hour black-and-white video *Folding Hat*. "My then wife and I climbed up with a couple of blankets. It was warm. It was okay," he said matter-of-factly. In those days Baldessari wasn't invited to the plush parties. "Now I receive a lot of invitations, but I usually say no," he said with some satisfaction. "In Venice, you can judge artists' stock prices based on how many parties they get invited to." Although he despairs of the social hierarchies and the "visual overload," Baldessari has come to like Venice, in part because he has a bad sense of direction. "I'll turn the wrong way coming out of the elevator every morning," he said. "In Venice, everybody is always lost, so you don't feel bad when you pass someone you know sitting at a café for the third time in ten minutes."

The Grand Canal was congested with early evening traffic; *vaporetti* (water buses) and sixty-euro-a-throw water taxis chugged and swished past silent black gondolas. The Romantic poet Lord Byron used to swim naked in the canals, but now there's a strict ban on swimming, whether you're nude or not.

Ten lengths of front crawl and the pool is still gloriously empty. At the last Biennale, I came here for a swim and saw Peter Brant, a major collector, and Alberto Mugrabi, a secondary-market dealer, lying on chaise longues smoking cigars. A New York property developer and another dealer, both with tanned bellies bursting out of white bathrobes, joined them. Larry Gagosian arrived, exchanged a few words, and left. It was as if those in the prime aisle seats of the Christie's salesroom had been collectively beamed over to Europe and lost their clothes in the process. Apparently, during the Biennale this gang of art world players refers to the Cipriani poolside as "the office."

A biennial is not just a show that takes place every two years; it
is a goliath exhibition that is meant to capture the global artistic
moment. Although institutions like the Whitney and the Tate
hold national surveys that they call biennials and triennials, a true
biennial is international in outlook and hosted by a city rather
than a museum. La Biennale di Venezia, which was first held in
1895, has its roots in world fairs and academic salons. Its inter-
nationalism, for many years more accurately described as pan-
Europeanism, grew out of the decaying city's desire to encourage
its only industry, tourism. São Paulo, Brazil, founded a biennial
modeled on Venice's in 1951, while Kassel, Germany, initiated
Documenta, a more intellectual, less object-driven exhibition
that takes place every five years, in 1955. A few new biennials
were established in the seventies and eighties (notably, Sydney
in 1973, Havana in 1984, and Istanbul in 1987), but the genre
really went into overdrive in the nineties: Sharjah (1993), Santa
Fe (1995), Lyon (1995), Gwangju (1995), Berlin (1996), Shang-
hai (2000), and Moscow (2005), to cite just a few. Unlike an art
fair, where the displays are organized by the participating gal-
leries, the underlying structures of biennials are determined by
national identity and other curatorial themes.

The Venice Biennale is like a three-ring—or three-*hundred*-
ring—circus. In the center spotlight is the master of ceremonies,
the director of the Biennale, a rotating position occupied by a
senior curator who oversees two international exhibitions where
the artists are meant to represent themselves rather than a coun-
try. One is located in the largest pavilion in the Giardini, a Beaux-
Arts building that was once called the Palazzo dell'Esposizione,
until Mussolini's aesthetic propagandists gave it a Fascist façade
and renamed it the Padiglione Italia, a label that has stuck
despite its non-Italian contents. (People are always confused by

the name. In English there is no linguistic distinction between this international pavilion and the new one showcasing Italian art; they are both called Italian pavilions. But the Italians refer to the latter as the *Padiglione italiano*.) The other, even bigger international show is held in the Arsenale, a sprawling shipyard that is a vestige of Venice's millennium as a naval power. This year, the director of the Biennale is Robert Storr, the first American-born curator to secure the challenging, high-profile position.

Battling for recognition in the second ring of the circus are seventy-six national pavilions that flaunt the work of the artists of their countries, usually in the form of solo shows. When contemporary art was a predominantly Western, first-world activity, these national representations were contained in the Giardini. Nowadays, however, with so many countries wanting to participate, the Biennale has spread out as government agencies (and occasionally private foundations) rent churches, warehouses, and palazzi all over Venice to showcase their artists. Finally, in the outer rings of the Biennale, upwards of a hundred official and unofficial sideshows—displays of private collections, special performances, and other ancillary events—vie for attention.

On VIP Wednesday, I walked briskly through the Giardini and straight into the Padiglione Italia for the first part of Robert Storr's international exhibition, "Think with the Senses—Feel with the Mind: Art in the Present Tense." In the lobby was a large, recently made mobile by the underexposed eighty-one-year-old artist Nancy Spero, titled *Maypole/Take No Prisoners*. It featured two hundred drawings of severed heads with their tongues hanging out. In the next room on this central axis was a series of bright, hard-edged acrylic abstractions by the Nigerian-born American resident Odili Donald Odita. Then, in a grand room with a pitched roof, a series of six large paintings and a

giant triptych by Sigmar Polke. The German artist had made his mark not only with paint but with pure violet pigment that turned gold when applied to the translucent polyester canvas. Collectors were oohing and ahhing. Artists and their dealers were inspecting how the works were made. Eagle-eyed curators and critics were expressing immediate reactions. "Sublime!" said one. "Ho-hum," said another.*

I wandered through orderly sky-lit rooms devoted to the paintings of Ellsworth Kelly, Cheri Samba, Gerhard Richter, and Robert Ryman. It would have been a contemplative experience had it not been for the lavish air-kissing and nonstop chatter. Then I sat through an eighteen-minute 35-millimeter film titled *Gravesend,* which was partly shot in a coltan mine in the Congo, by the British Turner Prize winner Steve McQueen, and stood through an eleven-minute shadow-puppet video installation about sex and slavery by American Kara Walker. Her lengthy title, a quote from Ralph Ellison's *Invisible Man,* included the line *calling to me from the angry surface of some grey and threatening sea.* After that I watched a black-and-white slide show by CalArts graduate Mario Garcia Torres. The thirty-two-year-old artist was a student in Michael Asher's Post-Studio crit on the day I was there. Ironically, the Garcia Torres work, titled *What Happens in Halifax Stays in Halifax (In 36 Slides),* documented the reunion of three students who'd participated in 1969 in a legendary seminar at the Nova Scotia College of Art and Design.

As I was leaving an installation, *Material for a Film,* by the twenty-seven-year-old Palestinian artist Emily Jacir, I happened upon Storr himself. The tall, fair, bespectacled curator was mean-

*I later learned that François Pinault had edged out several museums to buy all seven paintings in a deal brokered by Philippe Ségalot.

dering alone in a Panama hat and beige jacket, as if he were on safari in his own show. On leave from Yale University, where he is the dean of the School of Art, Storr looked exhausted and a little forlorn. "The vicissitudes of this particular Biennale, the back-stage politics and so on, have been extreme," he told me. "I cannot exaggerate how difficult it has been to just get to this day."

A few months ago I interviewed Storr when he was less weary, over dinner at Le Caprice in London. An accomplished painter and persuasive writer, he patiently fielded all sorts of basic questions, including What does a curator do? "Curators bring things to your attention that would not have otherwise come to your attention. Moreover, they bring works to you in a way that makes some kind of vivid sense." Until the Biennale, Storr was best known for his fluidly written monographs and for the elegant solo shows that he curated when he worked at MoMA in New York, so I asked him, What makes a good group show? "It's not about masterpiece displays; it's not about choosing the top forty," he said. "It's about creating some kind of texture out of the variety of art—against which individual works can mean more."

When I asked, Are biennials supposed to capture the zeitgeist? Storr frowned. "I'm a hardworking, fifty-seven-year-old, straight, Anglo-Saxon, American guy. I'm not temperamentally inclined to try to second-guess the times," he said. "I'm not trying to prove that I'm 'with it.' I'm just trying to keep moving and to deal with artists who are working at the top of their powers—who are in the heat of their own artistic moment—whether they're having their peak moment of reception or not."

Storr is more interested in what he calls "the present tense," and he evoked the longtime Venetian resident and modernist Ezra Pound, who said, "A classic is news that stays news." Then he added, "Great art is essentially work that has proven inex-

haustible in terms of the value it gives to those who pay attention to it. It says, 'I am in the present tense despite the fact that I was made five or fifty years ago.'"

Not entirely comfortable with the high profile bestowed on the "author" of the Biennale, Storr told me he thought that the curator's status was generally overinflated. "If you do it well and do it right, being a curator is an honorable and necessary profession," he explained. "But I think the curator as star, entrepreneur, or impresario is not a good thing for anybody." He paused, then added, "My job is to keep people focused on the work of the hundred and one artists that are in my show." However, he wasn't overly optimistic. "I figure I'm due for a good bruising. It has to do with objective factors that determine how the art world works, and one of them is the need people periodically feel to bring others down a peg or ten."

The directorship of the Venice Biennale is a particularly poisoned chalice. It's the top job on offer to curators who haven't abandoned the hands-on organization of shows by becoming museum directors, and the chosen one is often criticized brutally before, during, and after the opening of the Biennale. Curators often wax lyrical about collaboration, but although they cooperate on shows and curate together, they aren't any less competitive than, say, collectors bidding against each other in an auction room. In fact, some curatorial alliances can appear to be very aggressive cabals.

For Storr, the best thing about curating the Biennale was doing the research. "I traveled a lot. I saw a lot of places and a lot of art that I would never have seen otherwise, and for that I'm really grateful. Professionally, I am beholden to the Biennale because I will make shows out of what I've seen for some time to come." His conclusion after visiting five continents: "The dire

predictions of global homogenization are just not true. There's a lot of shared information, but people do wildly different things with it."

Later that evening of VIP Wednesday, Sir Nicholas Serota and the Tate International Council held a cocktail party at the Palazzo Grassi, which was featuring an independent show of more than eighty works from the collection of François Pinault. The owner of Christie's had bought and renovated the three-story palace—the last to be built before the fall of the Venetian Republic—so that its ornate painted ceilings, grand balustrades, and swirling pink-and-beige marble peeked out from behind twenty-foot-high white chipboard walls. The press release said that the white partitions engaged in an "understated, respectful dialogue with the building while establishing ideal conditions for displaying art." The press pack also contained a separate slip that said, "Takashi Murakami was commissioned to make a special monumental painting cycle entitled 727-272 *Plus* . . . The presentation of this work will take place at a later date."

Serota arrived by boat ten minutes after the appointed time, some twenty minutes late by the Swiss Railway watch that he sets ten minutes fast. He disappeared into the building to see the exhibition, then reappeared downstairs in the atrium, where champagne and canapés were being served. "We have a lot of supporters from around the world, many of whom come to Venice," he told me. "It was very kind of François Pinault to let us have the space. He has been very supportive of the Tate."

What do you look for when you come to the Biennale? I asked. "A few unexpected discoveries in the national pavilions, together with an intelligent view on the part of the Biennale director,"

said the Tate director. "Rob Storr was given almost three years to research his Biennale, so he has had the opportunity to set out, not just a piece of reportage, but a distinct point of view about what is significant about contemporary art now. There have been times when the Biennale has been undigested news—this is what struck me last week in Johannesburg or wherever." Serota stood with one hand on his hip, the other poised on his chin, and added, "I do wonder whether a single person can any longer curate a show meant to be globally inclusive."

The cocktail party was filling up. Over Serota's shoulder, I noticed a gathering of Turner Prize alumni. Tomma Abts and Mark Titchner were talking to a curator from Tate Britain. Across its four locations, the Tate employs a total of sixty-five curators. "Good curators attend very closely to artists and their concerns but are not bound by them," said Serota. "Good curators do not simply show the artists they like the most. They have an obligation to try to uncover the nerve endings of contemporary art. That means attending to where artists are looking, what they're making, even if you're not personally so engaged with it."

I asked Serota if he had ever wanted to curate a biennial. "There was a moment in the late 1980s when I thought I might like to do Documenta. If I'd not come to the Tate and been hanging around looking as though I needed proper employment . . . but that moment has passed," he said, as he expertly and almost imperceptibly surveyed the crowd. "I'm not sure anybody would be very interested in my view now. To some extent my view has a venue." Serota noticed someone he needed to greet and by way of conclusion said, "At the end of the day, the Biennale shouldn't be taken too seriously as a barometer of what's important."

Standing next to me was a well-fed six-foot-three Mexican curator named Cuauhtémoc Medina. An associate curator who

works on the Latin American collection at Tate Modern and a scholar at the Aesthetic Research Institute of the Universidad Nacional Autónoma de México, he'd been deep in conversation with an older man with an unusual gray bob and a cane, who turned out to be the radical Argentinean artist León Ferrari, whose sculpture of Christ crucified on a U.S. Air Force plane was commanding respectful attention in the Arsenale.

Medina had been commissioned to write a review of the Biennale for the prestigious Mexican newspaper *Reforma*. He hadn't seen many pavilions yet, but he already had strong views about Storr's international show. With a few important exceptions, such as the rooms that housed works by Ferrari, Francis Alÿs, Marine Hugonier, and Mario Garcia Torres, he was disappointed by its conservatism. "It is two things a biennial should never be— correct and boring," Medina declared. "It's a museum installation in which museum artists have been given the best spaces. It doesn't challenge the canon. It fails to develop an argument about contemporary art. Storr's taste still seems tied to MoMA."

According to Medina, the distinctions between museums and biennials were blurring for the worse. "A biennial is supposed to move things forward. It's supposed to bring some instability into the system, not replicate the consensus. It's supposed to be adventurous, not risk-adverse." Medina invoked the memory of the late Harald Szeemann, the globe-trotting curator who initiated the first exhibition of young artists in the Arsenale in 1980. Szeemann, who famously declared that "globalization is the great enemy of art," died in 2005 at the age of seventy-one. Specializing in large-scale exhibitions full of freshly executed site-specific work, Szeemann is generally considered the first freelance curator to become an art star. "Venice has been a major force of inclusion," explained Medina. "That is why Szeemann called the exhibition in the Arsenale the

Aperto. *Aperto* means 'open.' Storr's show closes rather than opens the field."

While Medina spoke, I noticed that his hair was damp and his sneakers were sodden. "I was in a tall service boat being used by a chap employed by the Mexican pavilion," he explained sheepishly. "He couldn't drive under an inland bridge, so he pulled up close to the edge and asked me to jump off." Medina, who is not light on his feet, missed his target and fell into the canal. "It was a little bit disgusting. I had to swim about eighty meters to access the steps. Venetian water has a reputation for being toxic sludge. People imagine that they might die instantly from infection. I swallowed a bit. It was salty. Nothing special."

Medina told me that he has a history of falling. One of his stumbles, done in front of the Belgian-born artist Francis Alÿs during a stroll through Hyde Park, inspired a series of paintings, dozens of drawings, and various video works, including a minute-long animation entitled *The Last Clown*. Alÿs's film depicts a man in a suit walking until he catches his leg in the tail of a dog and falls. Backed by a soundtrack of lighthearted jazz and punctuated with canned laughter, the Alÿs work is usually interpreted as a comment on the general public's view of artists as jesters or absurd characters. So it's revealing to note that the model for the work was in fact a curator.

Sometime after 8 P.M. I left the reception, got on the Number 1 *vaporetto* at the stop outside the Palazzo Grassi, and immediately encountered an assortment of *Artforum* people, including Tim Griffin and Charles Guarino. Griffin suggested that the Biennale and *Artforum* face the similar task of resisting "the cult of the latest," while Guarino informed me: "In Venice, a good curator is the one who survives. The Biennale is a para-

digm of Italy—disorganized, incomplete, rife with rumors of high
jinks. Italian directors seem to have an easier time, since they're
in familiar territory. Germano Celant can put a Biennale together
like a mechanic who owns his own Fiat. But sometimes you get
a curator without a manual or a clue." As the boat lumbered to
its next stop, Guarino continued, "Either way, you can be sure
that the international show subscribes to some vague curatorial
thesis that's impossible to confirm or deny and includes more
artists than anyone can possibly appreciate." Guarino hadn't
missed a Biennale in twenty-six years. What do you look for when
you're here? I asked. "Everybody has an agenda to brag about,"
he replied. "Usually, if I'm looking for anything, it's the people
I've invited to dinner."

The word *vaporetto* means "steamer," but this boat ride was per-
fumed with wafts of diesel. We slowly zigzagged across the canal,
passing the Peggy Guggenheim Collection, an odd, ground-floor-
only half-palazzo with a spectacular roof terrace, and then the
Hotel Gritti Palace, whose water-level *terrazza ristorante* is lined
with copious red geraniums. As I was getting off the Number 52
at the San Zaccaria stop, I saw Nicholas Logsdail waiting for the
Number 82. He and his Lisson Gallery staff were on their way
to Harry's Dolci for an al-fresco dinner, and he invited me to join
them. "At every Biennale," he explained, "there is a realignment
of the clans." With regard to the organization of the art, Logs-
dail quipped, "Museums are kinds of zoos, whereas biennials are
more like being on safari. You drive for a whole day and see doz-
ens of elephants when what you're really looking for is a lion."

Not far from where we stood was the gothic Palazzo Ducale,
home of the doge and the seat of the Venetian government until
its Napoleonic defeat but now one of the most visited tourist
sites in Venice. Inside it, and remarkably off the beaten track

for the Biennale crowd, were works by Venetian artists such as Titian, Tintoretto, and Veronese and the sinister Flemish painter Hieronymus Bosch.

Why are we so interested in the new? I asked Logsdail.

"It is very possibly a great commercial conspiracy," he said wryly. "The nowness of now, which is quite obsessive, is actually a reflection of the consumerism that you see in the whole culture." The gallerist was in a buoyant mood. "It can be a lot of fun if it is to your taste."

Over the years Logsdail's Lisson Gallery has had many artists exhibit in the Biennale. "If you put all your energy into something, amid all the confusion, you have a fifty percent chance of making a big splash," he explained. "And if you don't make a big splash, there isn't even a ripple."

Back at the Cipriani, a British collecting couple are having a dip. He floats; she performs a regal head-up breaststroke. She tells me, in the nicest way, that she finds it irritating when "sporty" Americans insist on pounding up and down the pool. I tell her that I'm Canadian and she quickly commends this year's Canadian pavilion as "the best since 2001." At the Biennale, everyone is vividly aware of national identities. According to Philip Rylands, the long-standing director of the Peggy Guggenheim Collection (which often acts as an ad hoc American consulate in Venice), "Nationalism is one of the things that gives the Biennale tension and longevity. Without the national pavilions and the dozens of countries that apply for participation, the Biennale would surely have floundered in the way that public things can do in Italy. It would have become a triennial or a quintennial or died out altogether."

Thursday started out drizzly. At 10 A.M. the Biennale staff guarding the gates of the Giardini admitted those with press passes. No stampede, just a steady flow of cotton and linen in comfortable shoes. The Giardini offers a Disneyesque anthology of architectural styles. The folkloric Hungarian pavilion sits across from the geometric Dutch structure. The airy glass volume constructed by the Scandinavians looks blankly at the mini-Kremlin that houses the Russian contribution. I strode up the gentle incline to a small plateau where a triumvirate of West European powers meet in a face-off: the French pavilion (a mini-Versailles), the U.K. pavilion (originally built as a tearoom), and the German pavilion, a Nazi wonder, renovated by Ernst Haiger in the official Fascist style. On this occasion, the structure had been cloaked in orange-netted scaffolding in a symbolic rejection of its architectural identity by artist Isa Genzken.

The geopolitical axes of the Giardini are very 1948. Two thirds of the pavilions are held by European countries; they tend to have the larger structures in the prime locations. Five are owned by North and South American nations (the United States, Canada, Brazil, Venezuela, and Uruguay). Two are claimed by the Far East (Japan and South Korea). Then there's Australia, in a location that might well be described as "down under"; Israel, in a tight spot next to the American pavilion; and Egypt, the only African and only Islamic nation, which is at the very back of the Giardini, in an area often missed by those who make insufficient use of their map.*

Beckoned by my adopted homeland, I marched up the steps of the neo-Palladian villa labeled GRAN BRETAGNA. The six-room

*The fact that rich countries like Saudi Arabia have not hosted pavilions makes it clear that having a developed art scene is not just about wealth.

exhibition space was full of new paintings, drawings, wooden stick sculptures, and neon poems by Tracey Emin as well as some previously unexhibited watercolors from a 1990 series about her abortion. The show included a smattering of her signature spread-legged self-portraits. The artist was holding court in a wide-leg white trouser suit and black bra. "Feminism happened thirty years ago," she said to a Swiss TV crew. "Thanks to the Guerrilla Girls, I can stand here in Yves St. Laurent and Alexander McQueen with my tits hanging out." About representing the U.K., Emin said it was "nationalism on a sweet, lovely level." Contrary to stereotypical British pride about "keeping oneself to oneself," Emin acknowledged, "my problem is that I can't keep a secret."

Stationed in almost every national pavilion are the dealers who represent the exhibiting artist. With some countries, selling is not officially supposed to happen. With others, the government body that owns the pavilion is supposed to receive a percentage of sales. Having found that dealers subvert the system by claiming that the art was sold after the Biennale closed, a third arrangement seems to have become most common. The dealers underwrite the fabrication, shipping, and celebratory party; in return, they can sell as freely as they would out of their own gallery space. Nonetheless, it's not something anyone likes to discuss openly with the press.

Tim Marlow, one of the directors of Emin's London gallery, White Cube, was hanging around in the front room of her pavilion, looking like he'd just walked off a page of GQ. Avoiding what would no doubt be an unpopular question about sales, I asked him, What is British about British art? "The dominant cultural paradigm is pluralism," he responded smoothly. "British art is amazingly diverse, but I guess British artists often deal with the

dominance of the literary in our culture. Tracey is a wonderful storyteller. In her own words, she is a 'raving expressionist.'" He paused. "I suppose there is also a wry humor in a lot of British art—Damien, Tracey, Gilbert and George, Jake and Dinos [aka the Chapman brothers]. It contrasts with the dry quality of a lot of German and American conceptual art."

When asked how Emin came to be chosen to represent the U.K., Marlow pointed to Andrea Rose, a woman with short brown hair wearing a more businesslike white suit than Emin's on the other side of the room. As the head of visual arts at the British Council, Andrea Rose has the job of promoting British art around the world. "I hate to employ the word *using*, but our job is to use art to serve Britain's foreign policy objectives overseas," she told me. "At the moment our priorities are China, Russia, the Islamic world, Africa. Western Europe comes very low down on the list, North America not at all. We're not pushing a political line, other than to say that the freedom to engage in debate is a very important freedom." The British Council is an organization of more than seven thousand employees working in over a hundred countries worldwide. Although visual arts are a small part of the organization, Rose is nevertheless in a position to say, "You name me a biennial—Istanbul, São Paulo, Shanghai, Moscow—and we are probably there." According to Rose, these biennials offer an opportunity for people away from the hubs of the art world to see what others see: "They plug people into the great international dialogue and connect people to ideas that are current elsewhere."

Venice, however, is the only place in the world where the British Council and most other governments' cultural departments have their own building. About nine months before every Biennale, Rose convenes a committee of eight experts with a particu-

lar interest in contemporary art to choose an artist to represent
the U.K. "Venice is a form of circus, and you've got to be able to
choose the right person to perform at any particular time," she
explained. "The Biennale is a very temporal thing. It doesn't suit
all artists. You put a finger in the air and choose the best artist
for Venice, which is not necessarily the best artist in Britain but
hopefully someone who reflects what is going on in Britain. The
conflict in Venice is, do you choose somebody to make history or
do you confirm history?"

Different countries have different bureaucratic mechanisms
by which they award the pavilion to an artist. The Germans,
rather like the British, have a national agency for culture, the
Goethe Institute, which presides over the pavilion. The Guggen-
heim owns the American pavilion, but it does not determine its
contents. The Department of State invites proposals and the
National Endowment for the Arts convenes a selection panel.
Occasionally a country that doesn't have the interest or finances
to promote contemporary art refuses an invitation from the Bien-
nale to host a pavilion. In 2005, for instance, a private dealer
underwrote a semiofficial Indian pavilion, but this year, as in
previous years, India has no pavilion at all. This year, "mem-
bers of the Lebanese community" funded the first-ever Leba-
nese pavilion, an exhibition of five artists living in Beirut, which
enjoyed the official but not the financial support of the Lebanese
government.

I left the British pavilion with its giveaway goods—a tote bag, a
catalogue, some temporary tattoos, and a white hat embroidered
in pink with the words ALWAYS WANTING YOU . . . LOVE TRACE X—and
headed over to the American pavilion, which looks like a little
state capitol building. Nancy Spector, the pavilion's curator, was
standing in the lobby, basking in the warm glow of a luminous

sculpture called *"Untitled" (America)* by Felix Gonzalez-Torres. The Cuban-born Gonzalez-Torres died of complications due to AIDS in 1996. Some people were lamenting the fact that the pavilion show had taken so long to come; others complained that the pavilion should celebrate the work of a living artist. One irate curator even exclaimed, "Maybe next time the U.S. will decide to show Whistler!" The consensus seemed to be that the timing was wrong; the pavilion was beautiful but funereal.

Certainly the reception was not as overwhelmingly upbeat as that accorded to Ed Ruscha's 2005 pavilion, in which five black-and-white paintings from his 1992 Blue Collar series were hung with five new color canvases depicting the same Los Angeles locations. On show shortly after the invasion of Iraq and entitled "Course of Empire," the exhibition had a freshness and a sense of history that satisfied many people's expectations. Ruscha had the benefit of having shown in the pavilion once before; he had made hundreds of chocolate-on-paper silkscreens and then hung them on four walls to create a strong-smelling installation called *Chocolate Room* as part of a group show in 1970. When the artist was awarded the pavilion for a solo show in 2005, he had a vivid sense of the connotations and dynamics of the space. He also had an intelligent rapport with curators Linda Norden and Donna De Salvo, who had applied for the pavilion on his behalf. "I'm terrible at hanging works," Ruscha told me in his midwestern drawl. "I might walk in and take the one painting that I consider to be the best and put it on the quickest, easiest wall. Among other things, those smart ladies helped me out by hanging those works right." Ruscha didn't pretend to understand the process that singled him out to represent the United States that year. "It involves some politics," he said. "It certainly entails

factors that are beyond the talent of the artists that they're considering. Functionaries from the federal government turned up at the receptions. Nice guys, but kinda gray suits, you know."

Upon exiting from the American pavilion, I receive a warm greeting from Paul Schimmel. The curator was taking a short European break from working on his Murakami retrospective. About the American pavilion's awarding process, he sighed and said, "My MOCA colleague Ann Goldstein put forth Felix Gonzalez-Torres with his cooperation in 1995. I put in Chris Burden that year. Then I applied for Charley Ray and Jeff Koons. When it comes down to it, it's not a question of (a) the quality of artist or (b) the ability to pull it off. It's ultimately about the perception of how the show will fit into the greater theme and who is politically useful at the moment. With these kinds of competitions, I'm always a bridesmaid."

The drizzle turned into a downpour and we dispersed. I scurried to a café and stood in a soggy line for a *panino*, my white trousers splattered with mud. When the rain subsided, I realized that I'd missed the Canadian pavilion, which is tucked behind the British pavilion "like a gardener's shack or outhouse to the mother country," as one curator put it. Built in 1954, the pavilion is a delicate wigwamlike space with slanting walls that often defeat the artists who exhibit there. I entered the building with low expectations and was completely taken aback by the strange, mirror-clad installation created by artist David Altmejd. The thirty-two-year-old Québécois had mastered the space by creating a total environment that was half northern woodland, half glittering boutique. I lost my bearings in a positive sense until I encountered Andrea Rosen, Altmejd's New York dealer, then Stuart Shave, his London dealer, then Dakis Jouannou, the

Greek supercollector, who was evidently trying to acquire the work.* I looped back, to recapture the experience of being *in* something rather than looking *at* something, taking refuge in a mirrored closet with ledges upon which sat taxidermied birds and phallic fungi.

On the way out I met Iwona Blazwick, director of London's Whitechapel Gallery, who was ticking the Canadian pavilion off her map of the Giardini. With long blond hair and a bright smile, Blazwick challenges the easy assumption that curators are the dowdiest players in the art world. What did you think? I asked her. "Extraordinary!" she said intensely. "Altmejd transformed the pavilion into a *wunderkammer*, a cabinet of curiosities." Blazwick tucked her map in her bag and continued: "I love stepping out of the everyday into the space of art. I love to be immersed in an idea or an aesthetic or something phenomenological. Frankly, I get enough of everyday life."

Many see the pavilions as anachronistic; they posit quaint ideas of nationhood that are collapsing under the weight of globalization. While Blazwick admits that the notion of national schools or styles is meaningless, she adores the pavilions because they have the potential to be "utopian propositions." The pavilions stand alone. "They have no function," she explained, "which means artists are free to create something that has autonomy." Blazwick nodded at acquaintances as they traipsed into the pavilion. "Shows that should be called 'Here's my latest year of work' are often disappointing," she continued. "But when artists take on the pavilion and make a propositional statement, when

*The pavilion contained two works. George Hartman bought one as a gift for the Art Gallery of Ontario, while Jouannou purchased the other.

they use its dynamics, architecture, and history, then you can get something really interesting."

Blazwick tendered a list of legendary pavilions. In 1993, Hans Haacke chopped up the floor of the German pavilion. "It was the first time an artist took on the whole pavilion as an ideological, symbolic structure," she explained. In 2001 in the Belgian pavilion, Luc Tuymans premiered a series of acclaimed paintings about the Congo to make a statement about colonial history. In 2003, Chris Ofili transformed his U.K. pavilion into "an oasis of Africanness, a lost paradise of his imagination." In 2005, Annette Messager covered up FRANCIA, the Italian word for France that is inscribed on the front of the French pavilion, with a sign saying CASINO, recasting the nation as a lawless territory of risk and pleasure. "These pavilions were unforgettable because they were immersive," concluded Blazwick. "They weren't windows on the world. They were worlds in their own right."

Seduced by Blazwick's enthusiasm, I wondered how, as a professional, she managed to give the art her full attention. "Venice is a big party, and the preview is a networking experience," she confessed. "You skim across the art and you really run, but you prepare. You get a lot of prenotice in the form of press releases. I take notes about things I want to follow up on later." Still, the volume of art means that one will probably fail to pay attention to something that could have changed one's life. "I walked into the Hungarian pavilion and walked straight out again," admitted Blazwick. "I thought, 'Six black boxes. I can't be bothered. I haven't got the time.'" Thankfully, she returned to the pavilion, by thirty-year-old Andreas Fogarasi, and discovered that each black box contained a video that was "a very quiet, complex, poetic, and funny meditation on the failure of utopia."

Having had my fill of representations from relatively stable democratic countries, I left the Giardini. Just outside the gates and beyond the kiosk selling postcards and carnival masks, a white-faced mime stood on a box and adopted a series of saintly poses associated with Baroque sculptures. Next to him, a local was selling T-shirts emblazoned with the faces of different artist stars, like Paul McCarthy and Richard Prince. I managed to jump into a water taxi that had just dropped others off and sped across the lagoon toward the Ukrainian pavilion. Although the art world seemed to have overtaken Venice, some regular sightseers were still to be found. As we drove up the Grand Canal, we whizzed past a flotilla of five gondolas full of Japanese tourists with parasols and cameras. Their gondoliers, wearing traditional black-and-white-striped shirts, were talking animatedly among themselves as they absentmindedly poled their boats forward. No one here for the Biennale has time for such leisurely rides.

The Ukrainian pavilion, whose exhibition was titled "a poem about an inland sea," was housed in the rotting grandeur of the Palazzo Papadopoli and privately funded by the art world newcomer and billionaire oligarch Victor Pinchuk. Its curator, Peter Doroshenko (American-born of Ukrainian descent), faced with the problem of drawing attention to the artists of a country better known for exporting vodka, steel, and fashion models, decided on a mix of four Ukrainian and four relatively well-known Western artists, including British-born and -based Mark Titchner. I tried for a glimpse of the works but was thwarted by officious guards, who ushered me in the canal-side front entrance only to escort me out the back door, as the pavilion was closing. I found Titchner in the grassy garden out back, standing under one of his works, a billboard that shouted, WE ARE UKRAINIANS, WHAT ELSE MATTERS? He had been fielding questions from the press for seven

hours and all he could muster was "I'm all talked out." Pinchuk, who had been busy ordering a photographer to take pictures of him and his family, dragged Titchner into one of the shots. The artist brandished a smile for the camera, then returned to my side. With a pen poised on my little blue notebook, I looked at him expectantly. He stood, shuffled his feet, shrugged. "The problems of representing another country," he offered, "are as numerous as representing your own."

After swimming several more lengths, I take another break. I've been sharing the pool with a fifty-year-old businessman with a well-studied backstroke. A Roman who collects contemporary Italian art, he has many complaints about the Biennale. First he laments the fact that the most important international art event takes place in a country with little public support for contemporary art. "We have no British Council or Goethe Institute. We have few *kunsthalles*, and most cities have no museum of contemporary or even modern art." The Biennale, he implies, lets the *gerontocrazia* (the aged government) off the hook. Second, the Venice Biennale isn't Italian enough! "Until this year we didn't even have a properly Italian pavilion, because the Padiglione Italia was given over to the international show," he says. "There are so few opportunities for artists that they have to move to New York or Berlin. Italy's best-known contemporary artists—Maurizio Cattelan, Vanessa Beecroft, Francesco Vezzoli—they all live abroad." The collector tells me that he buys most of his art in Milan, where there are some very good dealers, but few succeed in exporting their artists. "The problem with Milano . . . and even Torino . . . and particularly Roma," he says, "is that any statement an artist makes there stays there!"

The new Italian pavilion (the *Padiglione italiano*, showcasing Italian art) is located ten minutes' walk away from the Giardini, in the Arsenale. These old naval yards are given over to what feels like a kilometer of exhibition space during the Biennale. Booths staffed by Biennale workers who give out free cups of cold water and the availability of a handful of chauffeur-driven golf carts tacitly acknowledge its marathon quality. Although the Arsenale is mostly filled with art of Rob Storr's choosing (an extension of his international exhibition), this year it also hosts one regional (Africa) and three national (China, Turkey, and Italy) pavilions. The *Padiglione italiano* features two artists: Giuseppe Penone, an older artist associated with the Arte Povera movement, and a young star named Francesco Vezzoli. When I arrived at the far end of the Arsenale, where the Italian pavilion is situated, the handsome Vezzoli, sweaty and bedraggled, was in the midst of an interview with Charlotte Higgins from the *Guardian*. The international press loved Vezzoli's *Democrazy;* reports were appearing not just in the arts sections of national newspapers but in their political pages.

Certainly *Democrazy* made a good story. The artist had enlisted the collaboration of two of Washington, D.C.'s most important political spin doctors, Mark McKinnon and Bill Knapp, to write hypothetical scripts for the advertising campaigns of two U.S. presidential candidates. Vezzoli then recruited the Hollywood actress Sharon Stone to "run" for one party and the French philosopher Bernard-Henri Lévy to represent the other. Once the videos were complete, Vezzoli installed them in a circular room with red carpet and navy walls in such a way that the candidates seemed to shout at each other. Vezzoli had opted for what Blazwick might have called a "dystopian proposition." In his words, "The notion of choosing somebody to represent your country for

art is not so dissimilar from choosing someone who represents your country for politics." Moreover, he saturated the "Italian" pavilion with overtly American content. "We've been governed for years by Silvio Berlusconi—a man who grew his business selling American soap operas to the Italian audience," Vezzoli told me. "In this way, my installation is actually more Italian than what is stereotypically Italian. It's 'glocal.'"

Italian *Vanity Fair* (the nation's best-selling weekly) ran a ten-page cover story. "To have the message 'Sharon for President' on all the newsstands in Italy—not only was it hilarious, for me it was the complete short-circuit," said Vezzoli. "It was an aggressive advertising campaign that I almost consider to be part of the work." Vezzoli's art often addresses the dynamics of celebrity and manipulation. "If I had had the funds," he added, "I would have covered the whole of Italy with posters and bought ads on television saying 'Sharon for President.'" The attention was fantastic, but the highlight for Vezzoli came from elsewhere. "The most surreal, sublime moment came when Italy's vice president and minister of culture, Francesco Rutelli, came to visit the pavilion," said Vezzoli. "He is known as *er piacione*, 'the hunk' of Italian politics. He's incredibly handsome, and he is married to a famous Italian journalist. He is the real living instance of what I had just created as a fiction."

Vezzoli thinks that the Venice Biennale is like the Cannes Film Festival. "The thin boundary between art and entertainment is slowly vanishing," he explained. "The two fields are probably proceeding more and more with the same strategies. Maybe artists are greedy for more attention or more funding for our projects. Perhaps if I fail as an artist I'll end up as a second-rate media mogul." While many artists are most comfortable making work for the initiated, Vezzoli admits, "I have one weakness. I am

obsessed by the audience—not in a stupid, commercial sense, but I am hypersensitive to my works' wider readability." At the Venice Biennale in 2001 Vezzoli presented the performance *Verushka Was Here,* and in 2005 his film *Caligula* was one of the most talked-about works of the festival, so Vezzoli understands the Venetian viewing context well. "The challenge when you're invited to a Biennale is dealing with people's short attention span," he explained. "For the type of art education some of us have received, it's absurd, because we have been taught to build projects for long, slow analysis."

Although Vezzoli still goes back to visit his parents in the province of Brescia, he is one of an increasing number of itinerant artists. "I gave up my house and my studio. I'm using all the money I have to travel. It is stressful, but it is the only way for me to be in all the places I need to be for my chain reaction of projects." I ventured that living in foreign countries enhances an artist's education. Not only does it help them think beyond their native cultural horizons, but they can gain a more intimate understanding of the foreign reception of their work. Vezzoli nodded and added, "The really serious judges travel all the time—they see all the biennales and gallery shows. So, I'm sorry, in order to make a work that is up to their expectations, I have to keep myself updated by seeing all the same things. It's horrible, but it's true. I think artists do this unconsciously to survive—we do it for the survival of our ideas."

From the deep end of the Cipriani pool, one can see the steeple and dome of San Giorgio Maggiore, the subject of one of J.M.W. Turner's most celebrated watercolors. Despite his prolific output depicting the city, Turner made only three short visits,

spending a total of less than three weeks in Venice. Even with a superb visual memory, he needed to be efficient with his sketch-book, making nimble pencil drawings to document the shapes of the architecture and quick watercolors to evoke the pigmenta-tion of the sky and sea.

The swiftest conversation I had in Venice was with Hans Ulrich Obrist. A Swiss-born curator who travels constantly, he cocurated "Utopia Station," a controversial section of the 2003 Venice Biennale; some thought the exhibition was a benchmark in innovative curatorship, others thought it was a mess. He is now codirector of the Serpentine Gallery in London and, as one colleague put it, "official freelance curator to the world." The first time I met Obrist, I thought he was a manic visitor from another planet, but now I relish his creative common sense. Full of energy and generous to a fault, he occasionally sees exhi-bitions that make him "so agitated" that he "can't sleep for a week." Although Obrist believes that the national pavilions are old-fashioned, he wouldn't abolish them, because he likes their constraints. "I always thought it would be so fantastic if England and France or perhaps Germany and Switzerland swapped build-ings one year," he told me. "That would be my suggestion."

We met for cappuccino one morning in an open-air café in a quiet *campo*, disturbed only by the distant sound of church bells. I switched on my digital recorder and off he went. Obrist believes in interviewing others, not just as a research tool but as a written format. He has published some two hundred and fifty interviews and conducted public twenty-four-hour interview marathons (and mini-marathons of eight to twelve hours) in various cities around the world.

Obrist had recently visited Eric Hobsbawm, the ninety-year-old British historian. "Hobsbawm said that he would summarize his

life as a 'protest against forgetting.' I think that might be the best
definition for what curating could be—'a protest against forget-
ting.'" Obrist smiled. "The criterion for the success of an exhibi-
tion is about what it produces in the long term." A good Biennale
is remembered. "It defines a decade," he said. "There have been
so many biennials, but at the end of the day, the ones that really
matter are not so numerous. One of the best remains—even if
none of us saw it because we were all too young, but looking at
the catalogue and listening to older artists—the legendary 1976
Biennale of Germano Celant. His Biennale hasn't been forgot-
ten, because he had an interesting rule of the game—he restaged
entire installed exhibitions rather than individual works."

When Obrist attends a biennial, he looks for its "rules of the
game." He sees themes as boring, because "you simply illustrate
them." There has to be "some tie or link, almost like a musical
score." Otherwise, he said, "We just say there were five or seven
great pieces in the show." Obrist started reading his BlackBerry,
but his speech decelerated only slightly. "We remember exhibi-
tions that invent a new form of display. It's a new rule or it's a
display feature or it's some form of invention." He looked up
intently. "Georges Perec wrote a novel without the letter *e*," he
added. "I think we can learn from that.

"A good Biennale crystallizes heterogeneity," continued Obrist.
"I think Deleuze said, 'To be in the middle of things, but to be in
the center of nothing.' Part of curatorial effort has to be to con-
tribute to the polyphony of centers, to make a more diverse and
richer art world." Obrist wrote an e-mail as he spoke; his ability
to multitask was impressive. If it were anyone else, you'd think he
was rude, but he pulled it off with endearing obliviousness.

"Venice is about a sudden moment of synthesis," he contin-
ued. "China, the Middle East, Latin America—we start to dis-

cover their different modernities, their different pasts, which is
something the art world has ignored until recently. I think Fran-
cesco Bonami, director of the 2003 Biennale, took into account
this new condition."* Rather than filling the spaces himself,
Bonami enlisted the support of eleven associate curators, includ-
ing Obrist, to put together his show, entitled "Dreams and Con-
flicts." Bonami's Biennale had the misfortune of opening during
an extreme heat wave, and this, combined with the inclusion of
more than four hundred artists, contributed to scathing criticism
in *Artforum* and many other art magazines about Bonami's abne-
gation of curatorial responsibilities and the disorder and excess
of his exhibition. However, since then, many have reevaluated
his Venetian extravaganza; they look back on it with admiration
and nostalgia. "How can a single curator still grasp everything?"
continued Obrist. "When you win territory, you lose concentra-
tion. For over ten years I have been going back and forth to
China, and during the past eighteen months I have started doing
intensive research into the Middle East, making many trips to
the emirates, Cairo, and Beirut. It is not something you can do
all over the world."

That night I met Amy Cappellazzo of Christie's at the
U.S. pavilion party on the grand first floor of the Palazzo Pisani
Moretti. The façade of the palazzo is fifteenth-century Gothic,
but the inside was sumptuously redecorated in the eighteenth
century. Its painted rococo ceilings, huge chandeliers, and ter-

*Francesco Bonami, an Italian-born American citizen, is a freelance curator with many
institutional affiliations. In 2009, he co-curated the exhibitions of François Pinault's collection
in the Punta della Dogana and Palazzo Grassi.

razzo floors witnessed many masked balls during the hedonistic height of the Venetian Repubblica Serenissima. On this night, however, the guest of honor, Felix Gonzalez-Torres, was dead, so the party was subdued. Cappellazzo was standing near a large open window looking out onto the blackened evening waters of the Grand Canal. I asked her, as someone who feels like she is "holding up the sky" in this ever-escalating art market, how a pavilion influences an artist's market. "It is less clear-cut than you would think," she said. "With Felix, for example, it reinforces his greatness and the scarcity of his work, but it doesn't affect his status per se. With younger, living artists, however, it can have a huge impact. It gives a local hero an international platform." Cappellazzo waved her hand out into the night air. "Look at this place. There are no cars, no fire hydrants. Every building is surrounded by a moat. It is about how location colors experience. Art in a well-staged show in an exotic setting—what could be more persuasive?" According to Cappellazzo, the Biennale is about unfulfilled fantasies. "It's not just that people hope that they'll have a moving experience with an artwork or a chance meeting with their favorite artist in a hotel bar . . . Everyone is secretly expecting that something beautiful will happen to them."

Back at the Cipriani, I have finished my quota of lengths. Scott Fitzgerald described writing as "swimming underwater and holding your breath." Lawrence Alloway portrayed the Venice Biennale as "the avant-garde in a goldfish bowl." I lie down on the side of the pool and enjoy the colliding currents of the two thoughts. While staring up into the blue void, I recall one more encounter.

When I was in the Giardini, I ran into the artist Anish Kapoor. He represented the United Kingdom in 1990, so I asked him,

What do you recollect most vividly from your year? "Hmm. I felt
as if they were taking a risk with me," he said. "I wasn't British. I
held an Indian passport, although I'd lived in the U.K. for how-
ever many years. I must have been among the youngest artists
ever given the pavilion. It was a time when the obsession with
youth was in its infancy. Of course, now it's the way things are
done, but it wasn't then." Kapoor looked pensive, then smiled.
"I remember . . . It might have been the first day of the previews
that year. There were thousands of people, as there always are."
He paused. "At lunchtime I went into one of the nicer restau-
rants near the Giardini and . . . everybody in the restaurant got
up and started clapping." Kapoor looked at me with genuine
amazement. "It was completely spontaneous," he said. "I was
just a young guy. It was bizarre. It was wonderful."

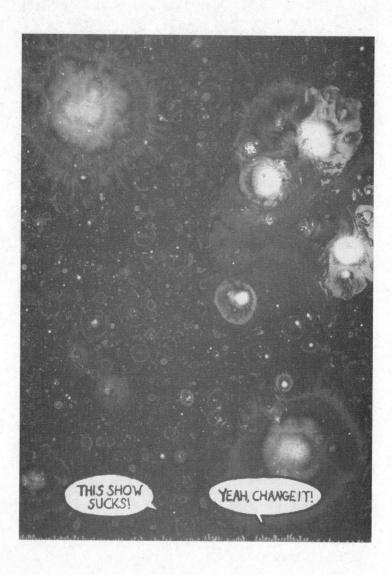

DAVE MULLER

Monochrome #17 (detail), 2002

Author's Note

The actual seven days on which the chapters take place were: "The Auction," Wednesday, 10 November 2004; "The Crit," Friday, 17 December 2004; "The Fair," Tuesday, 13 June 2006 (with some scenes from Tuesday, 15 June 2004); "The Prize," Monday, 4 December 2006; "The Magazine," Wednesday, 14 February 2007; "The Studio Visit," Friday, 6 July 2007; "The Biennale," Saturday, 9 June 2007.

With the exception of three collectors and one consignor (of artworks at auction) who requested pseudonyms, everyone else in *Seven Days in the Art World* is referred to by his or her real name. Ethnographies don't usually name names, but after doing my first couple of batches of interviews, I decided that I couldn't make sense of the art world without identifying the artists because, first, artworks are not interchangeable and, second, whether they like it or not, artists are caught up in a game of recognition. In a kind of domino effect, it then became necessary to identify dealers, collectors, curators, and critics too. In naming names, this ethnography became a social history of the present or, upon publication, a social history of the recent past. It made

sense to me, having studied both sociology and art history—and having long felt betwixt and between the two disciplines—that *Seven Days in the Art World* should be a readable hybrid of their different concerns.

Social history is widely understood, but what is ethnography? It is a genre of researching and writing with its roots in anthropology. Its main investigative method is "participant observation"—a cluster of qualitative modes, which include firsthand experience of the environment, careful visual observation, attentive listening, casual on-the-hoof interviewing as well as formal in-depth interrogation, and the analysis of telling details and key documents. Participant observation is a self-conscious formalization of the naturalistic modes through which we learn generally; toddlers learn to walk and talk through a similar form of wide-eyed questioning and involvement. The participation part of the exercise usually transforms the researcher; we don't wear a white lab coat and latex gloves to protect ourselves from what we're studying. We don't cling rigidly to old values but go into our chosen milieus with an open mind. In so doing, we usually change it.

Value neutrality is an important discipline for many ethnographers who see the overt judgment, moral indignation, and showy "outrage" prevalent in certain sectors of the press and tabloid television as obstacles to understanding. From the earliest use of ethnography, anthropologists and sociologists have had to be careful not to be perceived as missionaries or social workers. It is difficult, if not impossible, to explore and campaign at the same time. It was as a nonjudgmental participant observer that I gained access to the art world, sought to understand its milieus thoroughly, and handled myself "in the field." The art world is so full of warring factions that I have no idea how I would have managed the conflict if it were not in this role.

Some people confuse good access with being an insider. Any good ethnographer has to flirt with "going native," but she can't forget her original spy-like mission. As a writer, the obvious way for me to have become an insider was to adopt the role of the critic. But, despite many tempting offers, I have not written catalogue essays or reviews.

Being an ethnographer is part of my sense of self as a writer. It has influenced all the little decisions that I've made and affected the texture of my writing in several ways. First, ethnography is an experiential way to learn and gather evidence. It's a figurative form, which contrasts with the more abstract data brought forth by the archival research of historians or the statistics of economists. *Seven Days* mimics this experiential mode in attempting to give the reader a strong sense of being there, so he can understand these art spheres by going through them vicariously.

Second, my choice of verbal and visual details is driven by whether they seem to reveal social structures, institutional frameworks, or cultural patterns. As a result, a fair amount of salacious and sensational material was left on the cutting room floor because it seemed anomalous or distracting. Although some may perceive the book to be gossipy, my intent was to recount the incidents in a way that is much more reliable than hearsay and has a longer shelf life than chitchat.

Third, I see the book as ethnographic in its multi-vocal quality. Many ethnographers are fundamentally interested in other people's voices and feel a sense of responsibility to represent the perspectives of their "subjects." I hope that one of the strengths of the book lies in its quotations. Each chapter is a group portrait with multiple voices and points of view. I worked hard on getting people to articulate their positions as clearly and completely as possible. I would often pester my interviewees (or at least those

who appear as characters in the narratives) in follow-up phone calls or e-mail exchanges to finish a thought, complete a sentence, or come up with a metaphor that made their point clear to outsiders.

I also practiced something called "reflexive ethnography," a process by which a researcher requests feedback that she can use or ignore as she sees fit. No one depicted in the book was given the right to alter what I said about them. On the contrary, the feedback greatly improved the factual accuracy of the book and helped me to fine-tune its insights. Journalists almost never practice this partly because they don't have the time when they're on deadline and partly because their principal back-and-forth is with an editor who is likely to have an agenda of his own. Indeed, some editors don't like the facts to get in the way of a good story.

Finally, the structure of *Seven Days in the Art World* emerges from the social structure of the art world. As I mentioned in the Introduction, I don't see the art world as a system or smooth-functioning machine but as a bunch of squabbling subcultures, which embrace very different definitions of art and often feel a measure of hostility toward each other. Many of the chapters are not only a day in the life of a different institution but a day spent with a different social group or subculture. Ethnography is a multi-perspectival method ideally suited to understanding the way art gathers meaning as it moves through a conflicted world. It can contribute to a richer history of the present.

One last thought. In chapter 5, Jack Bankowsky, the editor at large of *Artforum*, explains how "seriousness" is a commodity in the art world, adding, "Certain kinds of gallerists may want the magazine to be serious even if they have no real coordinates for distinguishing a serious article from the empty signifier of seri-

ousness abused." Indeed, the codes of seriousness are important in academe, literary circles, and even journalism. As a lapsed academic, I hope *Seven Days in the Art World* is relatively free of these rhetorical gestures, but I trust that my readers will allow me this indulgence in an endnote.

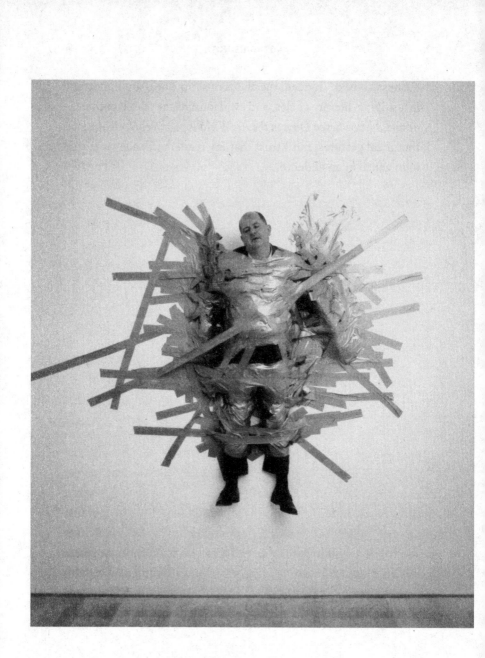

MAURIZIO CATTELAN

A Perfect Day (installation view of the artist's gallerist), 1999

Afterword
Seven Questions

Since the first publication of *Seven Days in the Art World* in English and its translation into several foreign languages, I've given many interviews to newspapers and magazines from around the world. I have also had the opportunity to speak to different kinds of audiences—general museum-goers, art history and sociology students, and artists at a wide range of art schools. What follows are answers to the questions that I am most frequently asked.

1. How has the economic recession affected the spheres you describe in the book?
Since the economic crisis hit in September 2008, sales volume has plummeted and record prices are relatively rare. At the peak of the art market boom, an evening auction unfolded like a Hollywood drama with billionaires in cameo roles and astronomical prices in lieu of stunts. Nowadays, auctions unfold more like low-budget soap operas.

At art fairs, transactions are slower and the power relationship between dealers and collectors has flipped. Collectors no longer have to wait in queues to buy the work of much-coveted artists.

We no longer hear of so many "hard buys" and there are fewer meltdowns in the VIP room.

While the market has shrunk, the structures and dynamics of the larger art world are relatively stable. Artists continue to make their work, dealers and curators show it, critics comment. Although the advertising pages in *Artforum* have declined dramatically, the mindset of the magazine's editors evolves at its own rate. Similarly, the curricula of art schools such as CalArts are like supertankers; they are not blown about in the wind. So, with regard to the chapter "The Crit," the most significant change is that graduating artists will find it more difficult not only to acquire representation from a gallery, but even to obtain jobs as installers or assistants.

The art market is a complex beast that is mutating all the time. It is murky and inefficient, social and global. My latest thoughts are always available on the Articles page of www.sarah-thornton.com.

2. Should student-artists think about the art world or ignore it?
The art world and market are practically taboo subjects in some art schools, which is a shame because thinking about an issue is not the same as pandering to it or being driven by it. We all have our own creative strategies, but, personally, I don't think that willful ignorance or self-delusion is ever a good thing. Most artists who have gained recognition of some kind have a pretty clear picture of the world that first receives their art. They have tactics of engagement or avoidance that suit their temperament and their work.

3. What is the real status of the artist in the art world?
Ideologically, the artist is supposed to be at the top, but practically, this is not always the case. In chapter 6, on the flight

with Murakami, his assistants, his dealers, and various museum people, I observe an instance when the strata are made unusually explicit. At that moment, the artist was in the power seat, literally 1A. Usually it is much more ambiguous than that. The hierarchies of the art world are complicated and volatile and dependent on the perspective of the beholder. Any individual artist can have many nebulous places within them.

Hierarchies among artists are often disavowed but they can be brutal. Perhaps many artists love to loathe the art world because they hate dealing with their position in it. Every gallerist with a large roster of artists is acutely aware of the sensitivities of status. They have the artists who pay the bills, the ones who bring credibility, the sleepers who they hope will gain some recognition. And they have to handle them all without inciting sibling rivalry.

In the Introduction, I quote John Baldessari's joke that artists could wear stripes like generals, so everyone would know their rank. This is funny, in part, because artist hierarchies are nothing like military ones; they are much more complex. They rely on diverse forms of validation, legitimation, and endorsement, which all basically come down to a belief in value.

4. Did your "subjects" perform for you?
When I started researching the book, I was a nobody sociologist for whom most art-world insiders couldn't be bothered to perform. As my writing gained momentum and my profile rose (particularly after *The New Yorker* published an abridged version of chapter 4), I may have encountered more masks and more spin. But the people who became characters in the book (rather than simply remaining interviewees) did so, in part, because of their comfort with being honest, revealing, even raw. Of course,

certain kinds of bullshit can be fascinating—such as when people really believe what they're saying—so sometimes I leave it in and let the reader be the judge.

5. *Who is responsible for the success of an artist?*

There is no one all-powerful player and it is not even a system per se. Since the 1970s, BA and MFA degrees have become the first legitimator in most artists' careers (significant exceptions include Maurizio Cattelan, whose work serves as the frontispiece to this section and who never attended art school). After that, in no particular order, artists' work is endorsed through: representation by a primary dealer; grants, awards, and residencies; media coverage in the form of reviews and features in art magazines; inclusion in prestigious private collections (one of the strange things about art is that the owner of the work affects the reputation of the work); museum validation in group shows; international exposure at biennials; solo shows in public spaces (particularly major museum retrospectives); and the appreciation signaled by strong resale interest at auction. Despite this list, "success" is not a straightforward process, but one that is fraught with conflict because each of these accolades is controlled by a different subculture of the art world. Passing the test in an auction house or art fair is quite different from getting a great review in a local art magazine or representing one's country at the Venice Biennale.

Validation often appears paradoxical because the art world is a social sphere where rule-breaking is the official rule—not just for artists but also for curators, dealers, collectors, and, to a lesser extent, auction houses. Curators talk of breaking the mold and moving things forward, not replicating the consensus. Collectors see themselves as acquiring creatively through their adventurous

"eye." Almost every dealer I have ever interviewed sees him or
herself as a maverick.

In all of this, it is vital not to forget the work of art itself. What
it is, how it captures people's imaginations and travels intellectu-
ally is crucial.

6. *After doing this research, do you still believe in contemporary art?*
Yes. I feel particular confidence in it when I am in a room with
art that is working on me, that delivers the buzz of an epiphany
or a bang of discomfort. Of course, derivative or tired art tends
to have the opposite effect; it brings out my agnosticism. Over-
all, however, cynicism doesn't appeal to me and disbelieving in
contemporary art (as a category) strikes me as either nihilistic or
retrograde.

One of the reasons there is such a poor dialogue between art
historians and sociologists is that the latter do not give enough
credence to the work itself. It is a basic premise of *Seven Days in
the Art World* that the work is important, but it is obvious to me,
as a sociologist, that the work alone does not determine the way
it moves through the world. Despite the fact that formalism is no
longer dominant, there is still a relatively strong, somewhat self-
righteous orthodoxy—held less by art historians than by dealers
and critics—that you should think and write only about the work.
So, ironically, it was somewhat heretical to insist on observing
what swarms and swirls around art.

7. *How do you know when outlandish work is art and when it is
nonsense?*
Sometimes you don't, but often you feel it in your bones. Art is
not science, so some art explores the world through irrational
means, and therefore "nonsense" can be a productive avenue

of investigation. Also, the antithesis is not really between art
and non-art. It's more a distinction between brave, eye-opening
work versus illustrative, dull work. It frequently helps to know
who made the work because artists have their own vocabular-
ies, and new pieces can make richer, fuller sense in the light of
older pieces. Finally, appreciation can be very personal. After
looking at a lot of art, you ask yourself: Is this intriguing? Deeply
amusing? Do I want to spend time with it? Does it become more
compelling the more I think about it?

Acknowledgments

Ethnographic research is a collaborative endeavor. During the course of my fieldwork, I would often speak to someone for ten minutes with my notebook in hand. It wasn't a proper interview, but I might still learn a lot. I had revealing chats with hundreds of people whom I never interviewed formally, from Nan Goldin and Richard Prince to Charles Saatchi and Larry Gagosian. Some of these encounters are recounted in this book, but the vast majority remain scrawled in one of my forty-seven blue notebooks.

I am particularly indebted to my interviewees (more than 250 of them, listed below) for being so generous with their thoughts. A handful of interviews were done on the phone, but most of them were conducted face-to-face in sessions lasting about an hour. Some people were kind enough to indulge me with repeated conversations (three to five interviews), gracious follow-up telephone calls, and patient replies to e-mails requesting that they answer just one more question. Also, as part of a practice called "reflexive ethnography," the people who were quoted in a particular chapter had the opportunity to read what I wrote. Their feedback often led to a richer and more accurate account of their

art world, and I'm exceptionally appreciative of those who took
this extra time.

For letting me intrude upon their workplaces, many thanks
to Michael Asher and the students of "Post-Studio Art" at the
California Institute of the Arts (CalArts); Tony Korner and the
entire staff of *Artforum International*; and Takashi Murakami and
his Kaikai Kiki team, particularly Yuko Sakata and Joshua Weeks.
Thanks also to the PR people who went beyond the call of duty
to ease my access to or understanding of their spheres: Erica
Bolton in London, Flavio Del Monte in Milan, Sara Fitzmaurice
and Peter Vetsch with regard to Basel. Many thanks also to Toby
Usnik and his staff at Christie's.

I'm especially grateful to Victoria Miro, who, out of munif-
icence rather than need, found me work in her gallery, which
included the pleasure of cocurating a photography group show.
I am also thankful for the support of the magazine editors for
whom I've freelanced over the course of researching this project:
Robert Violette and Bruce Millar (formerly of *Tate* Magazine),
Rebecca Wilson and Charlotte Edwards (formerly of *ArtReview*),
Patricia Bickers and Frederika Whitehead (of *Art Monthly),* Jack
Bankowsky and Brian Sholis (at *Artforum.com*), and Susan Mor-
rison of *The New Yorker*.

With regard to the editing of *Seven Days in the Art World*, I
am extremely lucky to have had the intelligent attention of Tom
Mayer at W. W. Norton and Sara Holloway at Granta Books.
Many thanks also to the people at these two excellent indepen-
dent publishing companies who lent their talents to the copy-
editing, proofing, design, marketing, sales, and international
distribution of the book. Moreover, I wouldn't be writing these
acknowledgments if it weren't for my agent, David Kuhn, and his
assistant, Billy Kingsland, at Kuhn Projects in New York.

This book was half written by the time it was signed to a publisher, so I am truly indebted to friends (and acquaintances who became friends) for their comments on various drafts. The following people were kind and helpful in several ways; many sank their teeth into the nitty-gritty of the arguments, characterizations, and language of different chapters. Thank you to Jennifer Allen, Andrew Berardini, Amy Cappellazzo, Caroline Cohen, Nikki Columbus, Charles Guarino, Vicky Hughes, Fiona Jack, Liz Jobey, Knight Landesman, Thomas Lawson, Nicholas Logsdail, Erin Manns, Angela McRobbie, Philippa Perry, Jeff Poe, Janet Sarbanes, Kitty Scott, Glenn Scott Wright, Lucy Soutter, John Thompson, Louise Thornton Keating, Philip Watson, and Mika Yoshitake. I expect that they are as relieved as I am that the book is finished.

Perhaps no one is more pleased than my parents, Glenda and Monte Thornton, whose emotional and financial backing was vital at every stage. My mother, who transcribed a few interviews, was often the first to read a desperately rough draft. I'd also like to thank my remarkably understanding children, Otto and Cora, who can only dimly remember a time when I was not working on this book. Finally, two people really got me through this project: my highly literate best friends, Helge Dascher and Jeremy Silver, who read every word, sometimes twice.

In alphabetical order, my interviewees were Matt Aberle, Tomma Abts, Rupert Adams, Florian Maier Aichen, Michael Allen, Chiho Aoshima, Matthew Armstrong, Michael Asher, Josh Baer, Wayne Baerwaldt, John Baldessari, Fay Ballard, Jack Bankowsky, Eric Banks, Lynn Barber, Oliver Barker, Harry Blain, Iwona Blazwick, Tim Blum, Tanya Bonakdar, Francesco Bonami, Stefania Bortolami, Daniel Buchholz, Louisa Buck,

Melva Bucksbaum, David Bunn, Chris Burden, Christopher Burge, Victor Burgin, Katharine Burton, Dan Cameron, Amy Cappellazzo, Janet Cardiff and George Bures Miller, Mariuccia Casadio, Sylvia Chivaratanond, Frank Cohen, Sadie Coles, Matthew Collings, Phil Collins, Stuart Comer, Nigel Cooke, Andree Coroon, Michael Craig-Martin, Martin Creed, Thomas Crow, Stuart Cumberland, Elizabeth Porter Daane, Thomas Dane, Adrian Dannatt, Corinne de Beche, Massimo De Carlo, Maria de Corral, Jeremy Deller, Thomas Demand, Bea de Souza, Ziba de Weck, Leslie Dick, Anna Katrina Dolven, Marlene Dumas, Sam Durant, Cliff Einstein, Inka Essenhigh, Stuart Evans, Russell Ferguson, Darren Flook, Sasha Weld Forester, Carl Freedman, Jose Freire, Joe Friday, Simon Frith, Charles Gaines, Anya Gallacio, Gary Garrels, Jeff Gibson, Massimiliano Gioni, Mark Gisbourne, Barbara Gladstone, Nicholas Glass, Teresa Gleadowe, Ingvild Goetz, Will Gompertz, Marian Goodman, Peter Goulds, Cornelia Grassi, Tim Griffin, Giulio Gropello, Charles Guarino, Lotta Hammer, Jan Hashey, Shane Hassett, Margot Heller, Sandy Heller, Dave Hickey, Charlotte Higgins, Matthew Higgs, Stefan Hildebrandt, Damien Hirst, Jens Hoffman, Laura Hoptman, Vicky Hughes, Fiona Jack, Marc Jacobs, Alison Jacques, Christian Jankowski, William E. Jones, Dakis Jouannou, David Juda, Isaac Julien, Anish Kapoor, Francesca Kaufman, Samuel Keller, Mary Kelly, Martin Kersel, Idris Khan, Franz Koenig, Tony Korner, Richard Koshalek, Knight Landesman, Brandon Lattu, Steven Lavine, Thomas Lawson, Edward and Agnes Lee, Janet Lee, Simon Lee, Dominique Lévy, Jeremy Lewison, Rhonda Lieberman, Miriam Lloyd-Evans, Joseph Logan, Nicholas Logsdail, Loushy, Honey Luard, Daniella Luxembourg, Michele Maccarone, Tim Maguire, Loic Malle, Gio Marconi, Flavia Fossa Margutti, Tim Marlow, Danielle McCon-

nell, Tom McDonough, Scott McFarland, Kate McGarry, Keir McGuiness, Cuauhtémoc Medina, Tobias Meyer, Jake Miller, Victoria Miro, Dominic Molon, Shamim M. Momin, Dave Muller, Iain Munroe, Takashi Murakami, Valeria Napoleone, Judith Nesbitt, Helena Newman, Seamus Nicolson, Hans Ulrich Obrist, Yoko Ono, Julian Opie, Francis Outred, Maureen Paley, Cornelia Parker, Martin Parr, Hirsch Perlman, Grayson Perry, Philippa Perry, Paola Pivi, Jeff Poe, Kelly Poe, Tal R, Michael Raedecker, Andrew Renton, Olivier Richon, Catsou Roberts, Emma Robertson, Polly Robinson, Andrea Rose, Andrea Rosen, Scott Rothkopf, Don and Mera Rubell, Perry Rubenstein, Kati Rubinyi, Ed Ruscha, Philip Rylands, Analia Saban, Yuko Sakata, Jerry Saltz, Elizabeth Schambelan, Paul Schimmel, Peter Schjeldahl, Kim Schoen, Barry Schwabsky, Jonathan Schwartz, Glenn Scott Wright, Kitty Scott, Adrian Searle, Zineb Sedira, Philippe Ségalot, Sir Nicholas Serota, Stuart Shave, George Shaw, Andrew Silewicz, Ross Sinclair, Debra Singer, Johanne Sloan, Matthew Slotover, Roberta Smith, Irit Sommer, Emet Sosna, Lucy Soutter, Nancy Spector, Lisa Spellman, Rochelle Steiner, Robert Storr, Jeremy Strick, Beth Swofford, David Teiger, Mark Titchner, Meg Troha, Keith Tyson, Dean Valentine, Christophe Van de Weghe, Francesco Vezzoli, Robin Vousden, Sheena Wagstaff, Jeff Wall, Rebecca Warren, Scott Watson, James Welling, Jack Wendler, Richard Wentworth, Damien Whitmore, Anthony Wilkinson, Christopher Williams, Andrew Wilson, Michael Wilson, Ari Wiseman, Nancy Wood, Bill Woodrow, Greville Worthington, Sharon Ya'ari, Ken Yeh, Shizuka Yokomizo, Mika Yoshitake, Linda Zuck, and a few people who wish to remain anonymous.

Selected Bibliography

Adler, Judith. *Artists in Offices: An Ethnography of an Academic Art Scene*. London: Transaction, 1979/2003.

Alloway, Lawrence. *The Venice Biennale 1895–1968: From Salon to Goldfish Bowl*. London: Faber and Faber, 1969.

Asher, Michael. *Writings, 1973–1983 on Works 1969–1979*. Edited by Benjamin Buchloh. Halifax: Press of the Nova Scotia School of Art and Design, 1983.

Becker, Howard. *Art Worlds*. Los Angeles: University of California Press, 1982.

———. *Outsiders: Studies in the Sociology of Deviance*. London: Collier-MacMillan Ltd, 1963.

Bourdieu, Pierre. *Distinction: A Social Critique of the Judgement of Taste*. London: Routledge, 1984.

———. *The Field of Cultural Production: Essays on Art and Literature*. Cambridge: Polity, 1993.

Bowness, Alan. *The Conditions of Success: How the Modern Artist Rises to Fame*. London: Thames and Hudson, 1989.

Buck, Louisa, and Judith Greer. *Owning Art: The Contemporary Art Collector's Handbook*. London: Cultureshock Media, 2006.

Button, Virginia. *The Turner Prize.* London: Tate Publishing, 2005.

Crane, Diana. *The Transformation of the Avant-Garde: The New York Art World, 1940–1985.* Chicago: University of Chicago Press, 1987.

Crow, Thomas. *Modern Art in the Common Culture.* London: Yale University Press, 1996.

De Coppet, Laura, and Alan Jones. *The Art Dealers.* New York: Cooper Square, 2002.

FitzGerald, Michael C. *Making Modernism: Picasso and the Creation of the Market for Twentieth-Century Art.* New York: Farrar, Straus and Giroux, 1995.

Foster, Hal, et al. *Art Since 1900: Modernism, Antimodernism and Postmodernism.* London: Thames and Hudson, 2004.

Fraser, Andrea. *Museum Highlights: The Writings of Andrea Fraser.* Edited by Alexander Alberro. London: MIT Press, 2005.

Greenberg, Reesa, et al., eds. *Thinking About Exhibitions.* London: Routledge, 1996.

Haacke, Hans, and Pierre Bourdieu. *Free Exchange.* Cambridge: Polity, 1995.

Haden-Guest, Anthony. *True Colors: The Real Life of the Art World.* New York: Atlantic Monthly, 1996.

Halle, David. *Inside Culture: Art and Class in the American Home.* Chicago: University of Chicago Press, 1993.

Helguera, Pablo. *Manual of Contemporary Art Style.* New York: Jorge Pinot, 2007.

Hertz, Richard, ed. *Jack Goldstein and the CalArts Mafia.* Ojai, CA: Minneola, 2003.

Jones, Caroline A. *Machine in the Studio: Constructing the Postwar American Artist.* London: University of Chicago Press, 1996.

Lindemann, Adam. *Collecting Contemporary.* London: Taschen, 2006.

Lubow, Arthur. "Tokyo Spring! The Murakami Method." *New York Times Magazine,* April 3, 2005.

Malcolm, Janet. "A Girl of the Zeitgeist I." *The New Yorker,* October 20, 1986.

———. "A Girl of the Zeitgeist II." *The New Yorker,* October 27, 1986.

Mason, Christopher. *The Art of the Steal: Inside Sotheby's-Christie's Auction House Scandal.* New York: Putnam, 2004.

McCarthy, Kevin, et al., eds. *Portrait of the Visual Arts: Meeting the Challenges of a New Era.* New York: RAND: Research in the Arts, 2005.

Millard, Rosie. *The Tastemakers: UK Art Now.* London: Thames and Hudson, 2001.

Moulin, Raymonde. *The French Art Market: A Sociological View.* Translated by Arthur Goldhammer. London: Rutgers University Press, 1987.

Murakami, Takashi. *Little Boy: The Arts of Japan's Exploding Subculture.* New York: Japan Society/Yale University Press, 2005.

Newman, Amy. *Challenging Art:* Artforum *1962–1974.* New York: Soho, 2000.

Obrist, Hans Ulrich. *Dontstopdontstopdontstopdontstop.* London: Sternberg, 2006.

O'Doherty, Brian. *Inside the White Cube: The Ideology of the Gallery Space.* Santa Monica, CA: Lapis, 1986.

Rewald, John. "Theo van Gogh as Art Dealer." In *Studies in Post-Impressionism.* Edited by Irene Gordon and Frances Weitzenhoffer. London: Thames and Hudson, 1986.

Schimmel, Paul, ed. © *Murakami.* Los Angeles: Museum of Contemporary Art/New York: Rizzoli, 2007.

Serota, Nicholas. *Experience of Interpretation: The Dilemma of Museums of Modern Art.* London: Thames and Hudson, 2000.

Singerman, Howard. *Art Subjects: Making Artists in the American University.* London: University of California Press, 1999.

Stallabrass, Julian. *High Art Lite.* London: Verso, 1999.

Sylvester, David. *Interviews with Francis Bacon.* London: Thames and Hudson, 1993.

Szántó, András. "Hot and Cool. Some Contrasts between the Visual Art Worlds of New York and Los Angeles." In *New York and Los Ange-*

les: Politics, Society, and Culture. Edited by David Halle. Chicago: University of Chicago Press, 2003.

Thornton, Sarah. "An Academic Alice in Adland: Ethnography and the Commercial World." *Critical Quarterly* 41, 1 (1999): 58–68.

———. *Club Cultures: Music, Media and Subcultural Capital.* Cambridge: Polity, 1995, and Middletown, CT: Wesleyan University Press, 1995.

Tomkins, Calvin. *The Bride & the Bachelors: The Heretical Courtship in Modern Art.* London: Weidenfeld and Nicolson, 1965.

Velthuis, Olav. *Talking Prices: Symbolic Meanings of Prices on the Market for Contemporary Art.* Princeton, NJ: Princeton University Press, 2005.

Warhol, Andy. *The Philosophy of Andy Warhol: From A to B and Back Again.* London: Verso, 1977.

Watson, Peter. *From Manet to Manhattan: The Rise of the Modern Art Market.* London: Hutchinson, 1992.

White, Harrison C., and Cynthia A. White. *Canvases and Careers: Institutional Change in the French Painting World.* Chicago: University of Chicago Press, 1965/1993.

Wolfe, Tom. *The Pump House Gang.* New York: Bantam, 1968.

———. *Radical Chic & Mau-Mauing the Flak Catchers.* London: Bantam, 1970.

Wolff, Janet. *The Social Production of Art.* New York: St. Martin's, 1983.

Illustration Credits

Introduction

John Baldessari, *Beach Scene/Nuns/Nurse (with Choices)*, 1991, color photographs, acrylic paint, 91½ x 144 inches. Courtesy the artist.

Chapter 1

Marlene Dumas, *Jule-die Vrou*, 1985, oil on canvas, 49¼ x 41⅜ inches. Courtesy the artist and Christie's Images Ltd. 2008.

Chapter 2

Chris Burden, *Shoot*, November 19, 1971. © Chris Burden. Courtesy the artist and Gagosian Gallery.

Chapter 3

Sophie Calle, *Room with a View*, 2003, black-and-white photograph. ©Actes Sud.

Chapter 4

Phil Collins, *shady lane productions presents the return of the real*, 2006. Press conference, Café Royal, London, 22nd November 2006. Production still. Courtesy the artist and Victoria Miro Gallery.

Chapter 5

April 2006 double cover of *Artforum* featuring details of: Christopher Williams, *Kodak Three Point Reflection Guide, ©1968 Eastman Kodak Company, 1968. (Meiko Smiling), Vancouver, BC, April 6, 2005*, color photograph, 20 x 24 inches. And *Kodak Three Point Reflection Guide, ©1968 Eastman Kodak Company, 1968. (Meiko Laughing), Vancouver, BC, April 6, 2005*, color photograph, 20 x 24 inches.

Chapter 6

Takashi Murakami, *Oval Buddha*, 2007, aluminum, platinum leaf, 5680 x 3190 x 3100mm, Photograph by Miget. Courtesy of Blum & Poe, Los Angeles, © 2007 Takashi Murakami/Kaikai Kiki Co., Ltd. All rights reserved.

Chapter 7

Paola Pivi, *Untitled (Donkey)* (installation view), 2003, inkjet print on PVC, 1020 x 1230cm. Photograph by Hugo Glendinning, Courtesy Galleria Massimo De Carlo, Milano.

Author's Note

Dave Muller, *Monochrome #17* (detail), 2002, acrylic on panel, 17 x 15½ inches. Courtesy the artist.

Afterword

Maurizio Cattelan, *A Perfect Day* (installation view of the artist's gallerist), 1999, Massimo De Carlo, adhesive tape. Photograph by Armin Linke, Courtesy Galleria Massimo De Carlo, Milano.

Index

Page numbers in *italics* refer to illustrations.